Drawing
ANIMALS 101

Drawing Animals 101

Original Title: Drawing Animals with a Veterinarian's Eye
© 2009 Mari Suzuki
© 2009 Graphic-sha Publishing Co., Ltd.

This book was first designed and published in Japan in 2009 by Graphic-sha Publishing Co., Ltd. The first English language edition was produced by Graphic-sha Publishing Co., Ltd. in 2011 for distribution in Asia. This English edition was published in the U.S.A. in 2020 by Mixed Media Resources, LLC.

Original edition creative staff
Author: Mari Suzuki
Photography: Yasuo Imai
Planning and composing: Motofumi Nakanishi
Editor: Hideko Miyamoto
Assistance with planning: Satoru Ota
Layout: Shinichi Ishioka
Production and project management: Kumiko Sakamoto (Graphic-sha Publishing)
This edition was coordinated by LibriSource Inc.

Library of Congress Cataloging-in-Publication Data

Names: Suzuki, Mari, 1948- author.
Title: Drawing animals 101 : how to draw animals with a veterinarian's eye
 / Mari Suzuki.
Other titles: Jūisan ga egaita dōbutsu no egakikata. English | Drawing
 animals one hundred and one
New York : Get Creative 6, 2020. | Translation of: Jūisan ga
 egaita dōbutsu no egakikata. |
Identifiers: LCCN 2019030717 | ISBN 9781684620050 (paperback)
Subjects: LCSH: Animals in art. | Drawing--Technique. | Anatomy, Artistic.
Classification: LCC NC780 .S8913 2020 | DDC 743.6--dc23
LC record available at https://lccn.loc.gov/2019030717

Manufactured in Singapore

1 3 5 7 9 10 8 6 4 2

Drawing ANIMALS 101

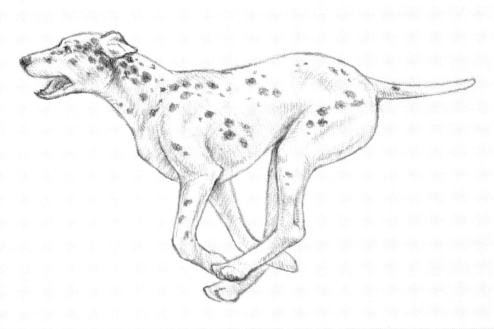

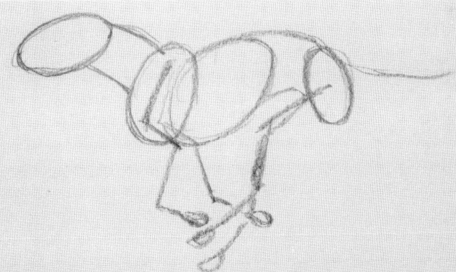

HOW TO DRAW WITH A VETERINARIAN'S EYE

MARI SUZUKI

 Get Creative 6

New York

Fulfilling a Dream by Drawing That Beloved Family Member-Your Pet

Drawing a Dog Seated

①

First, consider how large you want to draw the dog. Next, in pencil and using light strokes, draw an oval that encompasses the entire figure.

②

Draw a circle to mark the head's position and capture the general figure. This breed (Welsh Corgi) has short legs, so its head will appear somewhat large compared to its body.

③

Next, draw a circle to denote the chest and then draw the neck to connect the head and the chest. Also draw circles for the trunk and the hips.

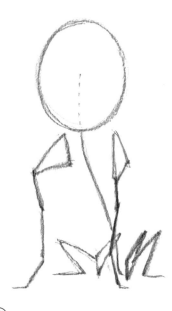

④

Lay another sheet of paper over the one used in Step (3) and sketch a stick figure showing the basic skeletal structure.

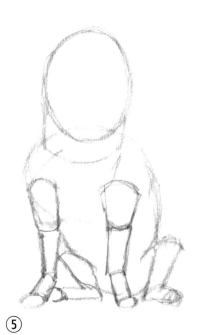

⑤

Next, place the paper used in Step (4) underneath that used in Step (3) and add the front and hind legs to the sketch produced in Step (3). Now the figure appears to be sitting.

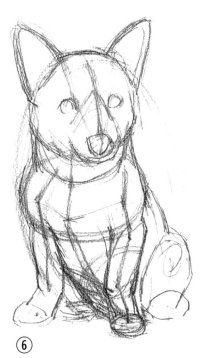

⑥

Give the facial features and other body parts shape. At this stage in the sketch, you can tinker with the dog's features to create a range of different atmospheres.

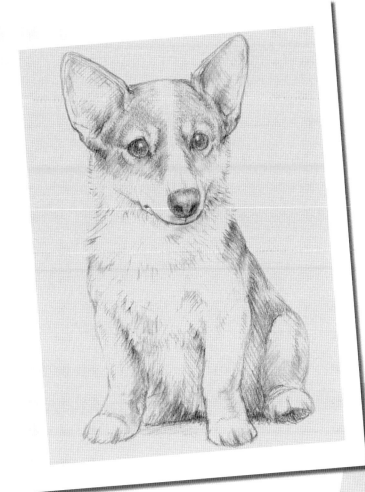

Incorrect

Why?

If you solely pay attention to the contour lines when you draw, then the image could end up lacking a sense of volume.

⑦
This final image is a realistic portrait that includes even the fur texture.

You can create a sketch of an adorable animal just like this one, using only a single 4B pencil and a kneaded eraser.

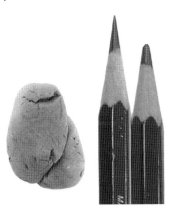

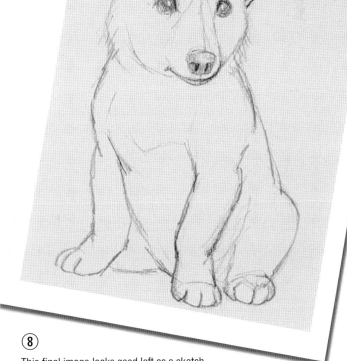

⑧
This final image looks good left as a sketch.
*See pages 30-33 for the steps to drawing a Welsh Corgi.

Drawing Common Dog Body Language

Animals displaying happiness with their entire bodies are truly adorable, and animals displaying various emotions with their entire bodies make interesting subject matter for drawings. These next pages discuss the rich and varied body language that dogs use and what they mean.

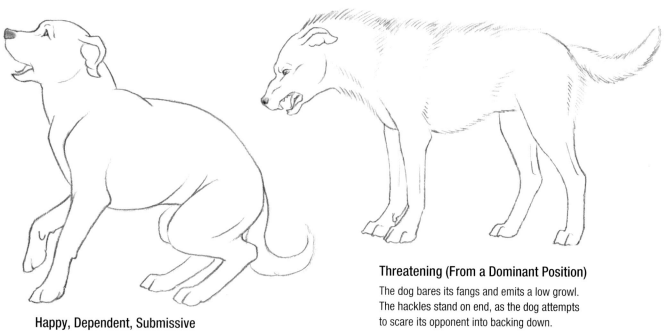

Threatening (From a Dominant Position)

The dog bares its fangs and emits a low growl. The hackles stand on end, as the dog attempts to scare its opponent into backing down.

Happy, Dependent, Submissive

The dog lays back its ears, while the eyes overflow with love and affection. The mouth hangs loosely open. The dog might be making a begging sound with its voice. The hips are lowered, while the tail curls and makes short, tiny wags.

Happy, Expectant

The dog holds its ears erect. (Even dogs with floppy ears prick up their ears to some extent.) The eyes twinkle. The mouth might hang open. The entire body seems brimming with tension. The dog holds its tail up and wags it from side to side.

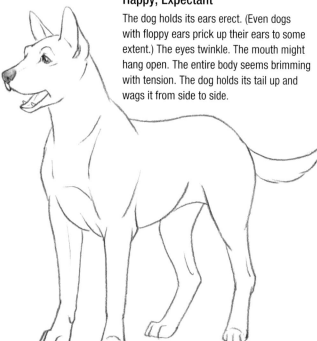

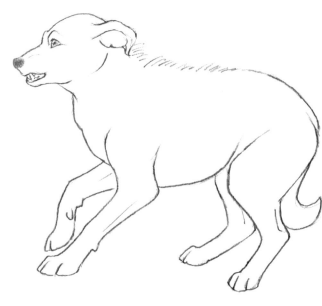
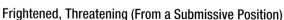

Frightened, Threatening (From a Submissive Position)

The dog lays its ears back. The hackles stand up from the neck to the shoulders, and down the back. The dog's entire body teems with tension, while the dog makes itself appear as small as possible. This is a defensive posture. The dog lowers its hips and curls its tail between its legs.

Submissive

Here, the dog displays the most vulnerable part of its body, his belly, to a stronger dog or to a human. This dog is showing that it poses absolutely no threat.

Inviting to Play

The dog extends its front paws and gives a sprightly bark to invite another animal or human to play.

Alert and Cautious

The dog holds its ears erect but rolled back slightly. The eyes and entire body are held stiff with tension.

Sad, Dejected

The ears droop slightly, while the eyes and body become limp. The tail also hangs limply.

A Day in the Life of Tamao

Tamao is a tomcat who turns three this year. Tamao leads a lazy life in the same house as this book's author, Dr. Mari Suzuki. Here, we examine Tamao to see how a cat spends his days.

❶

Well, I guess I should get up.

❷

Good morning! I'm hungry. Is my breakfast ready yet? Purr. Purr.

❸

I feel great again today. This food is scrumptious. Munch, munch, crunch, crunch, munch, munch.

❹

What a tasty meal. I feel good.

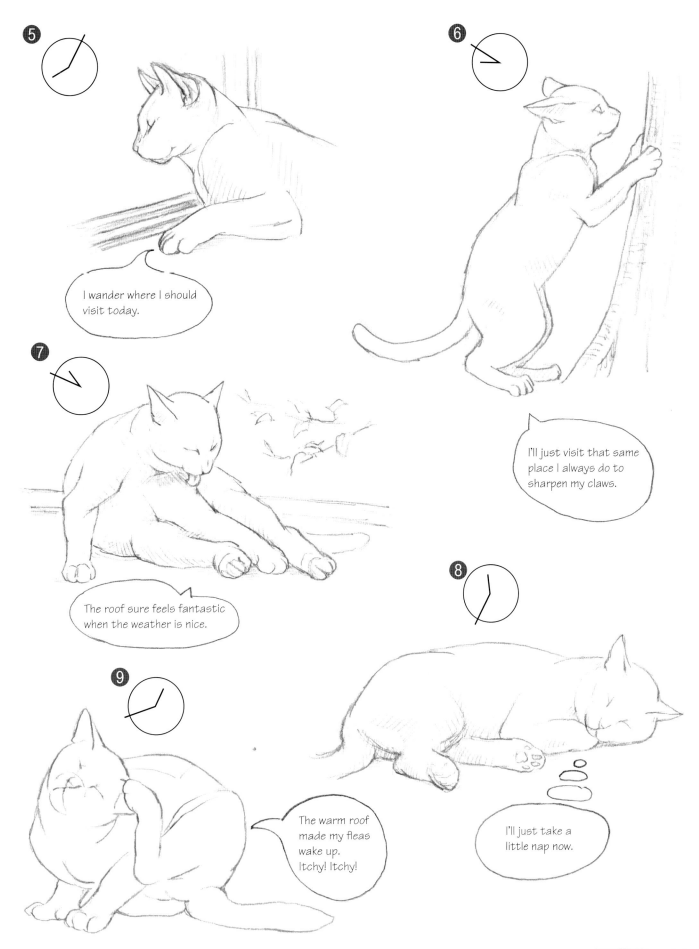

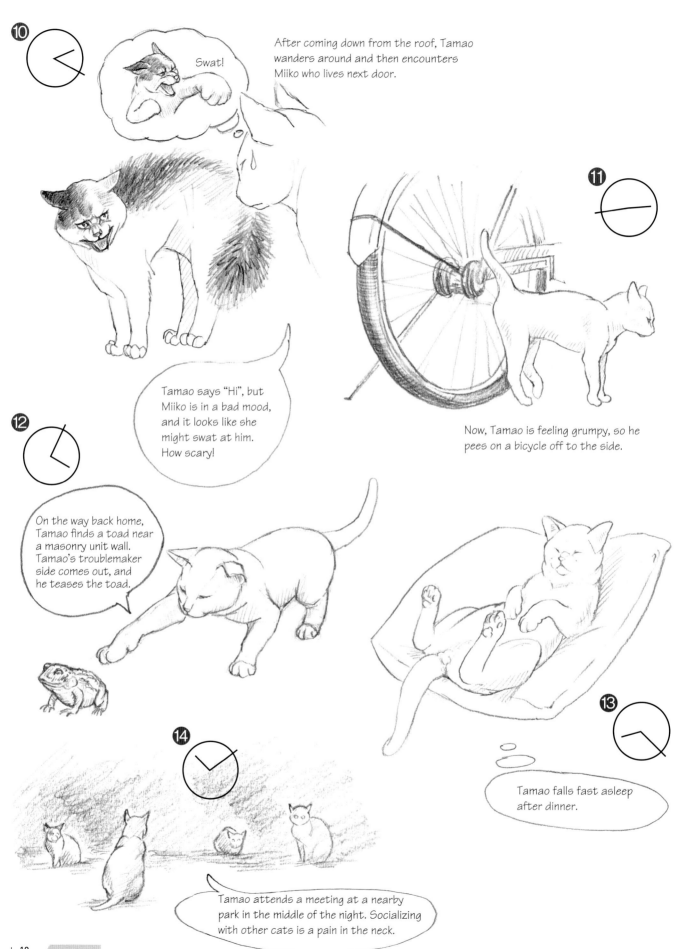

10 After coming down from the roof, Tamao wanders around and then encounters Miiko who lives next door.

Swat!

Tamao says "Hi", but Miiko is in a bad mood, and it looks like she might swat at him. How scary!

11 Now, Tamao is feeling grumpy, so he pees on a bicycle off to the side.

12 On the way back home, Tamao finds a toad near a masonry unit wall. Tamao's troublemaker side comes out, and he teases the toad.

13 Tamao falls fast asleep after dinner.

14 Tamao attends a meeting at a nearby park in the middle of the night. Socializing with other cats is a pain in the neck.

Contents

Introduction

Sketching lies at the root of a work of art. For that reason, I drew all of the illustrations in this book using a 4B pencil. Once you become able to draw in monochrome, then all you should need is later to learn how to apply color and to acquaint yourself with how to use color media in order to produce truly wonderful artwork.

When you create a work of art, what you actually saw and then drew or painted touches people's hearts, even if you are not all that particularly skilled. When using animals as your subject matter, nothing beats being able to look at the actual animal. However, since animals are animated creatures, they move, so we are forced to use photographs as reference. Still, you should practice by observing the animal and then drawing it or by just observing the animal with the intention to draw it, even if all you are able to produce is a single line.

Since the contents I present within this book are still just my personal way of looking at and conceiving these animals, you, the reader, should interpret the contents from the perspective "How is she looking at this animal?" or "How is she conceiving this animal?" While you read this book over and over again and copy the images within multiple times, you will experience the incredible feeling of becoming able to draw something you were not able to previously. I sincerely hope that you will soon be able to experience this wonderful feeling.

Mari Suzuki

How to Use this Book

- This book discusses techniques in portraying moving animals in pictorial form.
- "Animals" means all living creatures, including jellyfish, octopus, insects, fish, amphibians, and reptiles. This book only covers four-legged mammals.
- I use a substantial amount of anatomical jargon. However, unless the word was a name, I tried to use its vernacular alternative. For example:
 - Instead of "ossa," I use "bone."
 - Instead of "musculi," I use "muscle."
 - Instead of "anterior limb," I use "foreleg."
 - And instead of "posterior limb," I use "hind leg."

- I include explanations of proportioning and head sizes for various animals. However, body sizes and proportions vary according to the sex and the individual. Also, the same species could vary in size depending on the habitat. Consequently, I only discuss figures in general terms.

Rabbit

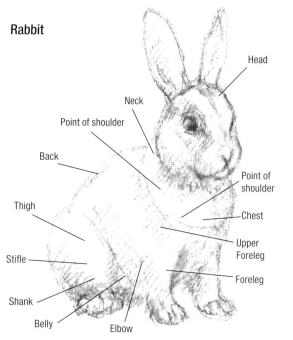

Head
Neck
Point of shoulder
Back
Thigh
Stifle
Shank
Belly
Elbow
Point of shoulder
Chest
Upper Foreleg
Foreleg

Leporine Skeletal Structure

Dorsal vertebrae
Cervical vertebrae
Skull
Ribs
Lumbar vertebrae
Femur
Scapula
Sacral vertebrae
Hipbone
Humerus
Great trochanter
Fibula
Patella (kneecap)
Manubrium of sternum
Cervical vertebrae
Ulna
Radius
Carpal
Caudal vertebrae (tailbones)
Tarsal bone
Metatarsal bone
Phalanx (Of the foot)
Metacarpal
Phalanx (Of the front paw)

Chapter 1
Where People and Animals Differ and Where We Are the Same

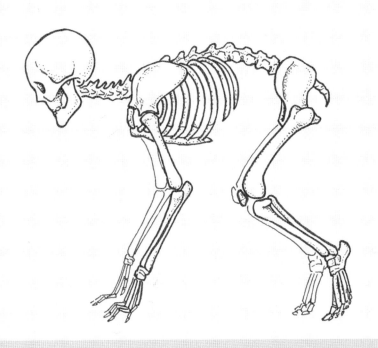

Where People and Animals Are the Same

Understanding the body's composition is vital to portraying a lifelike animal. Since it would be asking too much to suggest actually studying anatomy, instead let's start by comparing the human figure to that of an animal.

1. Looking at the Body from the Outside

The human figure appears with both hands touching the ground so that the figure is on "all fours," thereby mimicking a four-legged animal's posture. While the heads and limbs are shaped differently, the bodies' basic structures remain the same.

Human

Note the names of the major body parts.

Check

This page shows the names of human and animal body parts. Compare the images with your own body. If you have access to an animal close to you, touch that animal to check out the major body parts. Once you have become familiar with how the body is structured, then when you see a moving animal, you will also picture yourself moving. This will make your artwork snap to life.

Dog

Compare the names of the dog's body parts with those of a human.

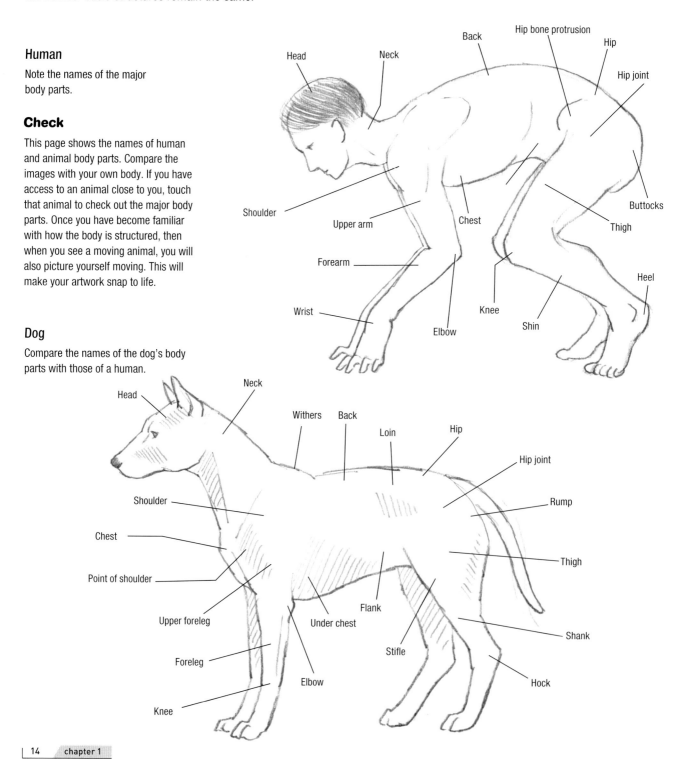

Human labels: Head, Neck, Back, Hip bone protrusion, Hip, Hip joint, Shoulder, Upper arm, Chest, Buttocks, Thigh, Forearm, Knee, Shin, Heel, Wrist, Elbow

Dog labels: Head, Neck, Withers, Back, Loin, Hip, Hip joint, Shoulder, Rump, Chest, Point of shoulder, Thigh, Flank, Shank, Upper foreleg, Under chest, Stifle, Foreleg, Elbow, Hock, Knee

2. Looking at the Body from the Inside

The skeleton not only supports the body from the inside, but it also constitutes a key point in portraying the distinct forms and movements of a given animal.

Human Skeletal Structure

Check

The names of the bones in a human and a canine skeleton are virtually identical. All that differs are the bones' shapes and sizes. The basic way that the bones fit together remains the same. Comparing bones with the same names allows us to see which bones developed and which bones degenerated. While a human find it uncomfortable to stand on "all fours," this is the normal position for a dog, and it becomes obvious to us that the dog supports his weight on his toes.

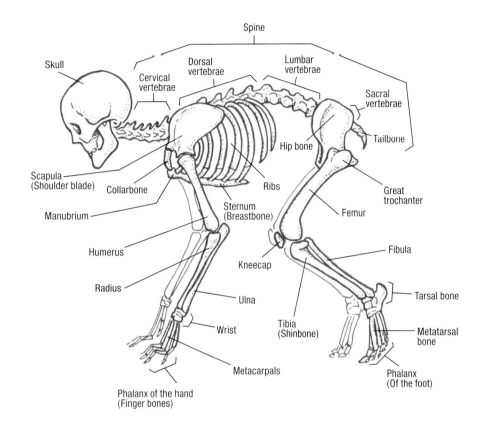

Canine Skeletal Structure

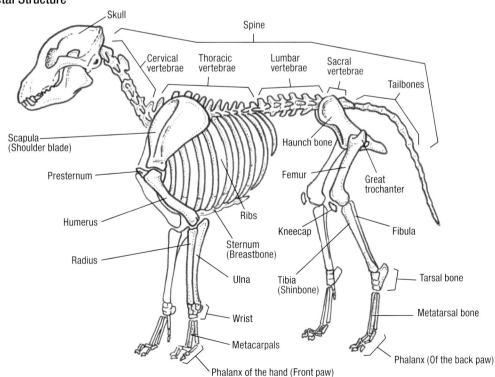

Contrasting the Bodies and Skeletons of Different Animals

Let's look at the forms and skeletons of a cat and a horse. While externally, the animals appear quite different, the cat's skeleton looks significantly like that of the dog appearing on page 15. The horse's legs appear relatively narrow and long compared to the horse's trunk. The horse's legs evolved to allow it to run farther and faster. As a result, the horse now has legs so fragile that they can be likened to glass. These legs form exquisite lines. If you intend to portray an animal that looks like it might move at any moment, then you must become familiar with the individual bones and how they connect.

Cat

The head is more roundish than that of a dog.

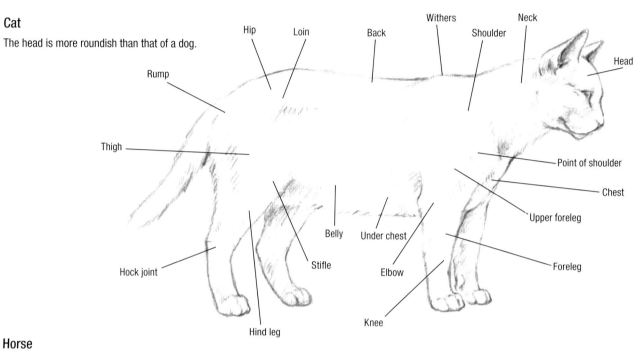

Horse

The long legs distinguish the horse.

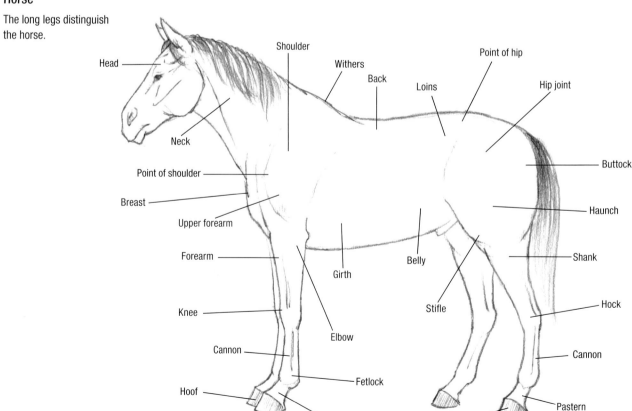

Feline Skeleton

The cat's skeleton is very similar to that of a dog.

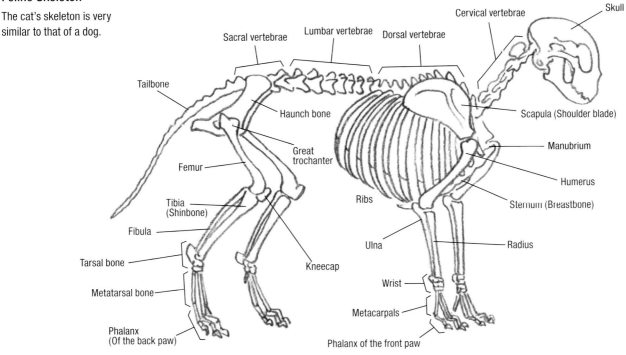

Sacral vertebrae
Lumbar vertebrae
Dorsal vertebrae
Cervical vertebrae
Skull
Tailbone
Haunch bone
Scapula (Shoulder blade)
Great trochanter
Manubrium
Femur
Humerus
Tibia (Shinbone)
Ribs
Sternum (Breastbone)
Fibula
Tarsal bone
Ulna
Radius
Metatarsal bone
Kneecap
Wrist
Metacarpals
Phalanx (Of the back paw)
Phalanx of the front paw

Equine Skeleton

The horse's leg bones are distinctive.

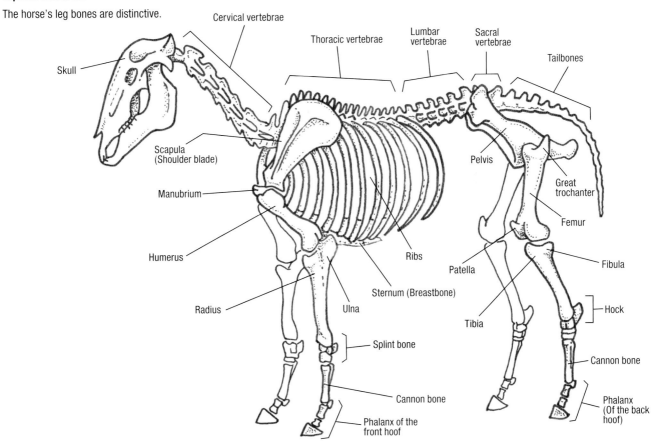

Cervical vertebrae
Thoracic vertebrae
Lumbar vertebrae
Sacral vertebrae
Tailbones
Skull
Scapula (Shoulder blade)
Pelvis
Great trochanter
Manubrium
Femur
Humerus
Ribs
Fibula
Patella
Radius
Ulna
Sternum (Breastbone)
Hock
Tibia
Splint bone
Cannon bone
Cannon bone
Phalanx (Of the back hoof)
Phalanx of the front hoof

Where People and Animals Differ

People and animals share an enormous number of commonalities in their physical makeup. However, the reader should take note of the following differences. These are key points that portray an animal's distinguishing features pictorially.

1. Presence or Absence of Clavicles (Collarbones)

Human have clavicles. However, excepting primates, the majority of other animals either have vestiges of clavicles or have none at all. Because clavicles do not restrict the animals' front legs, the front legs have great range of motion.

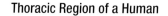

We have all seen on TV or the like cheetahs and lions chasing their prey on the savannah. The explosively dynamic, forward-and-back motion that the front legs and shoulders of these cats display is because their skeletal make-ups lack clavicles.

Thoracic Region of an Animal

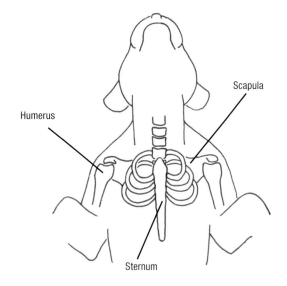

Thoracic Region of a Human

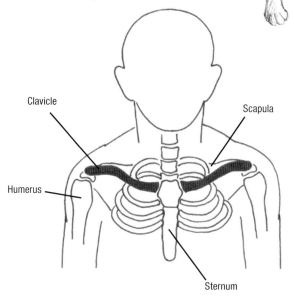

Head View of the Thoracic Region of an Animal

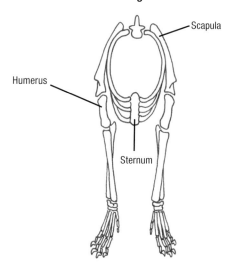

Head View of the Thoracic Region of an Animal

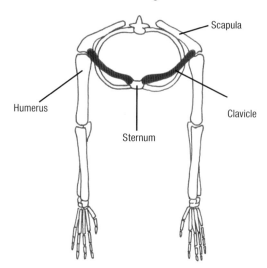

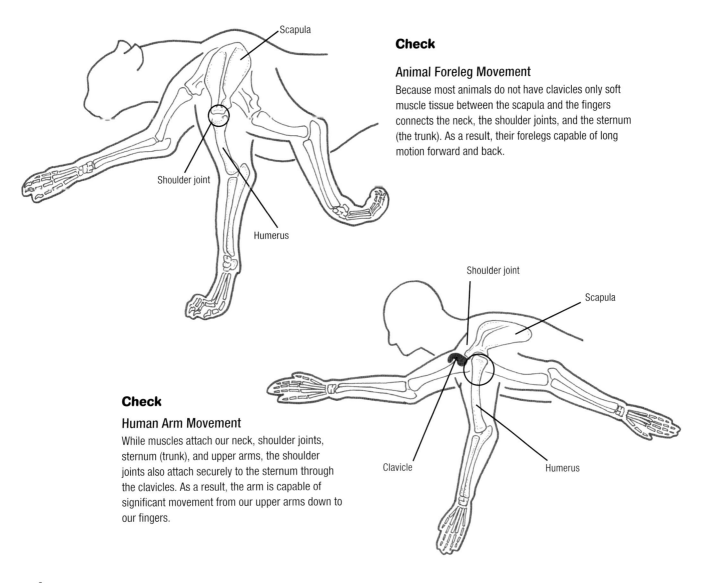

Scapula

Shoulder joint

Humerus

Check

Animal Foreleg Movement

Because most animals do not have clavicles only soft muscle tissue between the scapula and the fingers connects the neck, the shoulder joints, and the sternum (the trunk). As a result, their forelegs capable of long motion forward and back.

Shoulder joint

Scapula

Clavicle

Humerus

Check

Human Arm Movement

While muscles attach our neck, shoulder joints, sternum (trunk), and upper arms, the shoulder joints also attach securely to the sternum through the clavicles. As a result, the arm is capable of significant movement from our upper arms down to our fingers.

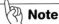 **Note**

Below are simplified sketches of the thoracic regions of an animal and a human as seen looking down.

Animal

Since the forelegs move in their entirety, the right and left shoulders appear to alternate moving up and down.

The shoulders appear to alternate moving up and down.

Human

Motion occurs from the upper arm, down. The scapula hardly moves, making its position stable.

The scapulae have stable positions.

2. Walking on Four Legs

These pages show both the front and rear views of an animal walking on all fours, the trademark of an animal. Not only do the forelegs and shoulders discussed on page 19 have a distinct manner of movement, but so do the head, hind legs, and hips.

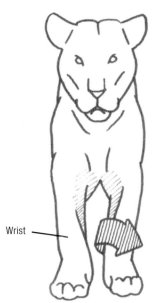

Wrist

As the first foreleg begins to move, it does not merely extend straight outward. Rather, the portion below the wrist curls back slightly, swinging from inside to out as the arrow indicates.

This line connects the right and left shoulders.

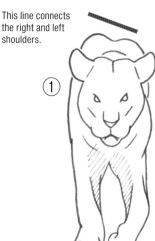

① As the foreleg begins to move, the same-side shoulder appears to drop, while the other rises. The head lowers more than it is held when standing.

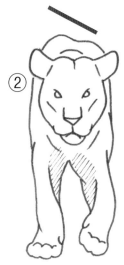

② The foreleg then extends dramatically forward.

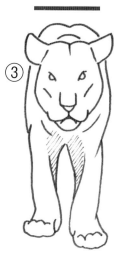

③ The front paw touches the ground, and the shoulders shift to a horizontal position.

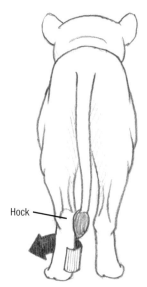

Hock

When the hind legs begin to move, the hocks gently pull inward and then shift outward as the arrow indicates. While both hips lower, they do not shift as much as the shoulders.

This line connects the right and left hips.

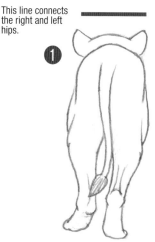

① The hind legs shift dramatically forward.

② The extended hind paw touches the ground while the opposite paw rises off the ground. At this point, the two shoulders lie along a tilted line.

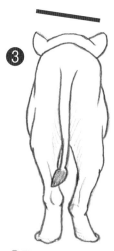

③ The raised hind paw then shifts past the hind paw touching the ground.

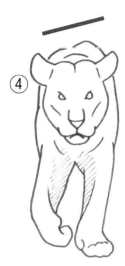

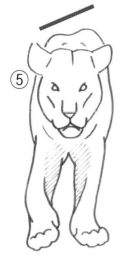

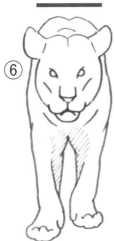

Paw Legend

Paw touching the ground

Paw rising off the ground

Paw completely not touching the ground

Paw lowering to touch the ground

④ Now the foreleg opposite the one that moved in steps ① to ③ begins to move. At the same-side shoulder begins to lower, and the shoulders lie along a tilted line with a slant opposite the previous.

⑤ The foreleg that began to move in step ④ extends forward dramatically.

⑥ The extended front paw touches the ground, and both shoulders lie parallel.

Note

Human Legs vs. Animal Hind Legs

The lower halves of the human and animal bodies share essentially the same construction. The hind legs (legs of a human) move with the hips as the pivot point.

Human Leg Motion

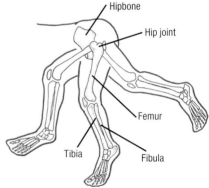

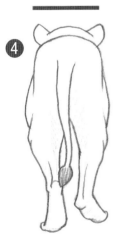

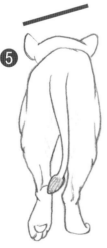

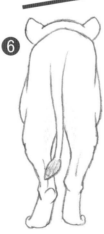

④ The same-side hind leg extends forward even farther. The line returns to a horizontal position.

⑤ As the paw of the extended hind leg touches the ground to support the animal's body, the opposite hind leg rises off the ground.

⑥ The hind leg not touching the ground passes by the hind leg touching the ground.

Animal Hind Leg Motion

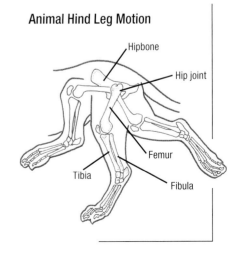

3. Eye Positioning

This page discusses the distances between the eyes of humans, cats, dogs, and horses. Horses' eyes are almost as far apart as their heads are wide; however, humans, cats, and dogs have eyes that are positioned apart closer than the heads' widths.

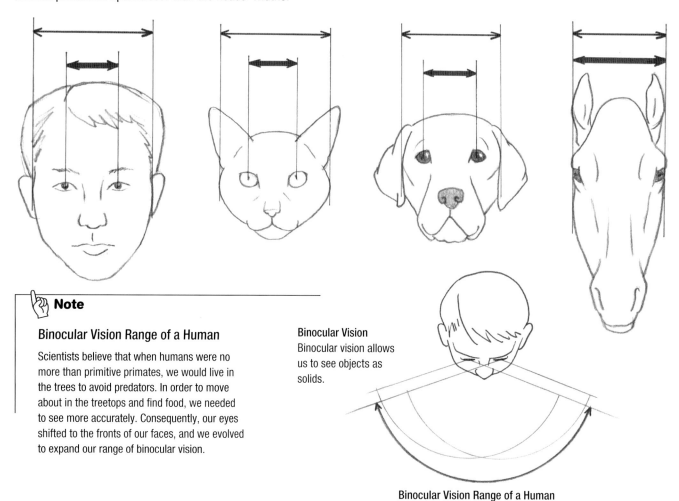

Note

Binocular Vision Range of a Human

Scientists believe that when humans were no more than primitive primates, we would live in the trees to avoid predators. In order to move about in the treetops and find food, we needed to see more accurately. Consequently, our eyes shifted to the fronts of our faces, and we evolved to expand our range of binocular vision.

Binocular Vision
Binocular vision allows us to see objects as solids.

Binocular Vision Range of a Human

Diagrams Contrasting the Vision Ranges of the Right and Left Eyes of a Cat and a Horse as Seen from Above

The cat has a wide range that it is able to see with both eyes, giving the cat a high degree of the ability to see an object as a three-dimensional solid. This enables the cat to execute complex actions such as estimate with accuracy how far away it is from its prey, chase down its prey while adjusting its speed, determine where on its prey to make the kill, and attack.

The horse has a significantly wider range of vision than the cat. For the horse, it is more important to decide whether or not to run away from a predator than to establish what species the predator is. Consequently, scientists believe that evolution sacrificed the horse's binocular vision in order to expand the horse's range of vision.

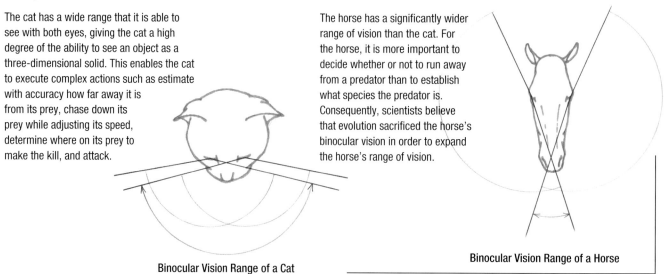

Binocular Vision Range of a Cat

Binocular Vision Range of a Horse

4. Head Shapes

This page contrasts the profiles of the human, the cat, the dog, and the horse. Below are animal heads in profile overlapping a human head in profile with the eyes of both aligned.

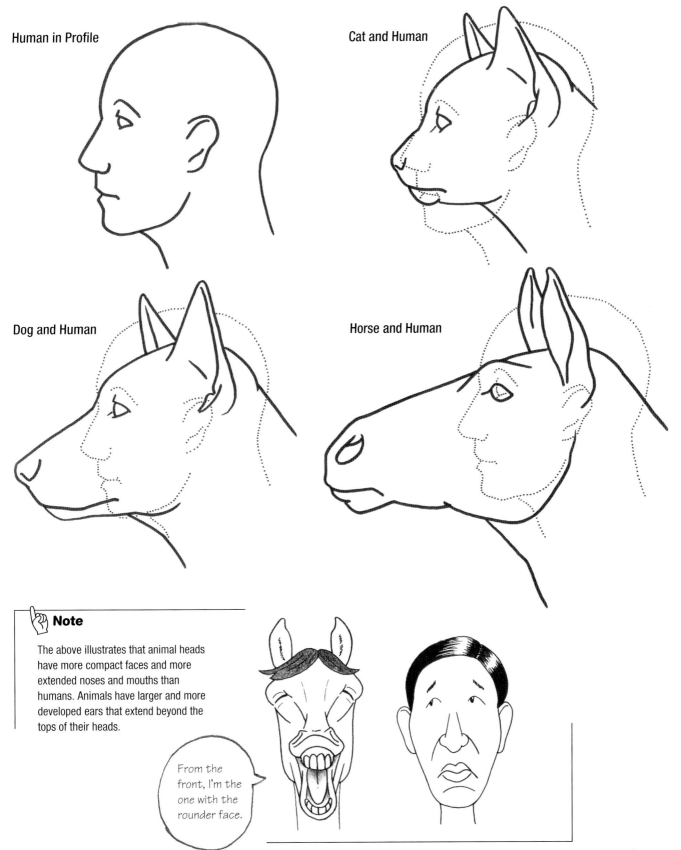

Human in Profile

Cat and Human

Dog and Human

Horse and Human

Note

The above illustrates that animal heads have more compact faces and more extended noses and mouths than humans. Animals have larger and more developed ears that extend beyond the tops of their heads.

From the front, I'm the one with the rounder face.

5. Eye Shapes

One might assume that humans and animals have differently shaped eyes. This is because the upper and lower eyelids surrounding animals' eyes are not as long as those of a human, making the eyes appear rounder and allowing view of practically only the irises and pupils. Because so much of the white of the eye is visible in human eyes, we can clearly see how the iris is shaped, which makes our faces more expressive. When animals shift their eyes to the side, then the whites of the eyes become somewhat visible, and that is when their faces look particularly cute.

Human Eyes

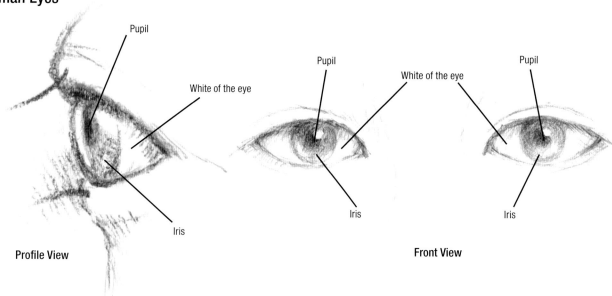

Profile View

Front View

Animal—Typical Eye Shape

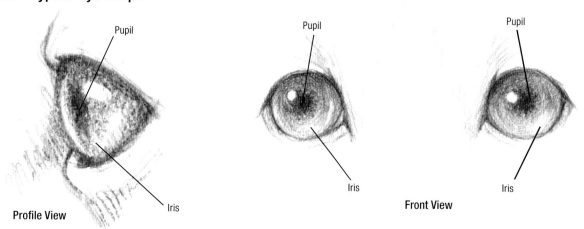

Profile View

Front View

Check

When viewing from the front, we see the white of the eye to the iris's right and left of a human. However, when looking at an animal, all we see is the iris. We scarcely see any of the white of the eye.

Human

Animal

How the Eye Is Constructed

The eye consists of a spherical eyeball embedded within the orbital cavity, which is a sunken part of the skull. Most animals share virtually the same eye construction. Since from the exterior, all we see are the pupil, the iris, and the white of the eye, let's take a look at the following cross section.

Check

A healthy eye has transparent conjunctiva, cornea, lens, and vitreous fluid. Subtle changes in light appear on the eye's surface in much the same way as if you were to put water into a glass sphere and then hold it up to a light. Meticulously drawing these subtle light reflections allows you to portray lifelike eyes.

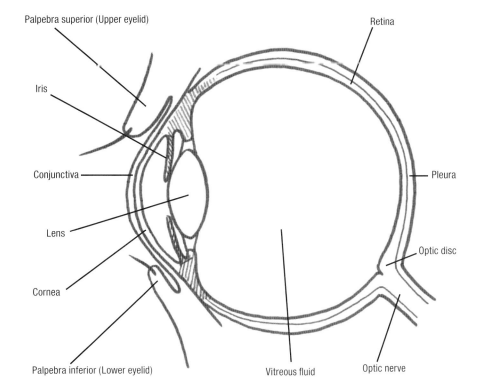

Palpebra superior (Upper eyelid)

Retina

Iris

Conjunctiva

Pleura

Lens

Cornea

Optic disc

Palpebra inferior (Lower eyelid)

Vitreous fluid

Optic nerve

Tips in Drawing Animals' Eyes

Tip

The eye is a sphere. Remember that the portion encircled by the upper and lower eyelids is curved. Making the eyelid rims and pupils uniformly black will make the eyes appear flat. Use light and dark shading to make the eyes appear three-dimensional.

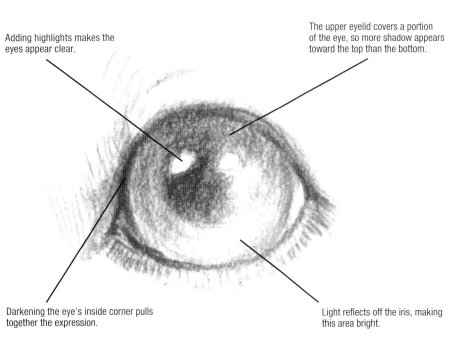

Adding highlights makes the eyes appear clear.

The upper eyelid covers a portion of the eye, so more shadow appears toward the top than the bottom.

Darkening the eye's inside corner pulls together the expression.

Light reflects off the iris, making this area bright.

6. Hands, Feet, and Paws

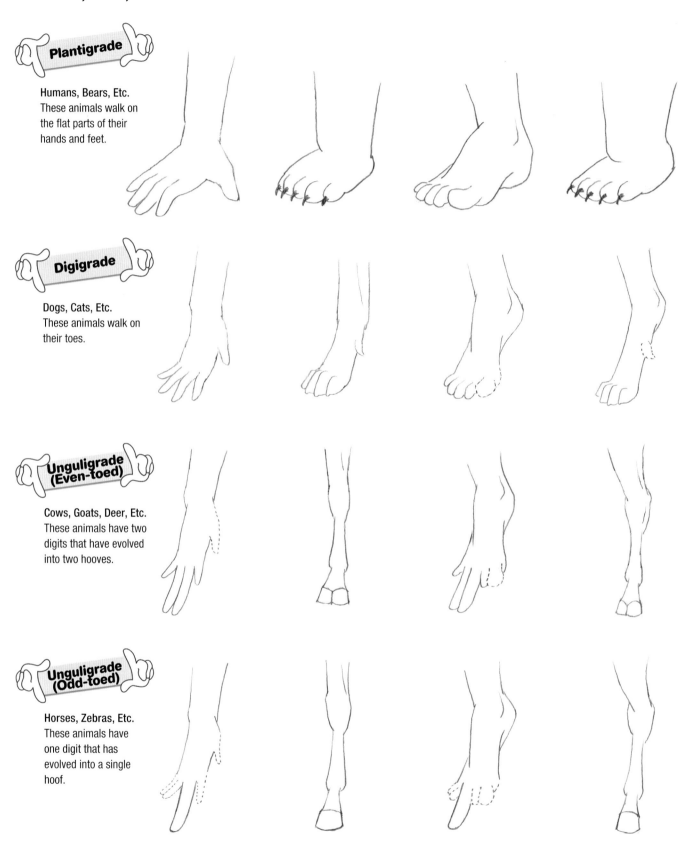

Plantigrade

Humans, Bears, Etc. These animals walk on the flat parts of their hands and feet.

Digigrade

Dogs, Cats, Etc. These animals walk on their toes.

Unguligrade (Even-toed)

Cows, Goats, Deer, Etc. These animals have two digits that have evolved into two hooves.

Unguligrade (Odd-toed)

Horses, Zebras, Etc. These animals have one digit that has evolved into a single hoof.

Chapter 2
Drawing Dogs and Cats

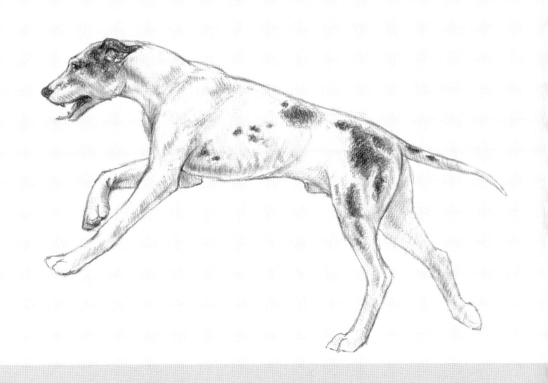

How to Use Art Materials

All the materials you need to sketch are a soft lead pencil (4B), a kneaded eraser, and some drawing paper. Any thin paper, such as copier paper or the like, makes useful practice sheets. Go ahead and use plenty of strokes when practicing until you get used to the pencil.

1. Materials to Collect Before You Start

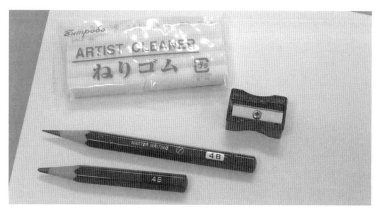

A pencil sharpener will allow you to sharpen your pencil quickly, easily, and safely.

Fixative: Fixative is a liquid you can spray onto your artwork to prevent the pencil strokes from smudging or becoming removed from the paper.

Art Materials: You will need pencils (4B), a kneaded eraser, a pencil sharpener, drawing paper, and thin paper (copier paper, a pad of paper, or something similar should work well).

The above shows the pencil being grasped from above. Hold the pencil at a low angle relative to the paper so that your hand surrounds its pivot point. This allows you to create rough hatching strokes. Short pencils tend to be easier to hold, so I recommend using them.

This shows the pencil being grasped from below. Hold the pencil erect, as if you were going to write words. This method of holding a pencil works well when making detailed hatching strokes or when filling in (or coloring in) spaces.

Resource Materials: Ideally, you would have your actual subject matter in front of you while sketching it. However, an animal would not hold still for you. Photographs lend themselves well to sketching details, etc.

Check

The kneaded eraser works better than a regular eraser, because it can be molded into an easy-to-use shape.

To make the kneaded eraser easier to use, tear it into one-third to one-half its original size.

Use your fingertips to knead the eraser thoroughly. Mold the eraser to match the shape of the area you intend to erase. Make the tip round, and then erase.

You could also make the tip pointed to create a "white line" when you apply the eraser.

Tracing Paper: This is semitransparent paper to use to trace an under drawing (rough sketch). See page 32 for information on how to use tracing paper.

Check

Using a Window to Trace: You may use a window to trace a drawing. Produce a rough under drawing (sketch) on a sheet of thin paper (copier paper). Next, overlay the rough under drawing with a new sheet of paper (fig. 1). Now that the under drawing is visible through the top sheet of paper, trace the under drawing using cleaner lines. This allows you to produce a drawing of the subject in an identical pose (fig. 2).

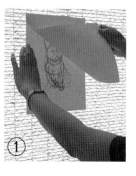

①

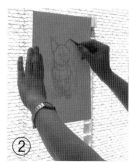

②

2. Relaxing the Shoulders When Practicing

Practice holding the pencil from above when drawing circles, straight lines, curved lines, etc. Do not just move your wrist to draw. Instead, raise your elbow off your drawing table and use your entire arm when drawing.

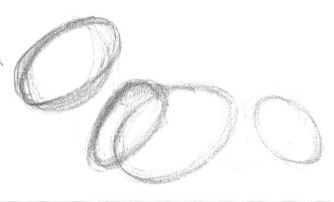

Lesson 1

The first topic is spiral shapes, circles, and ovals. Do not worry about making the shapes perfect. Repeat the strokes over and over again.

Lesson 2

The next topic is straight lines. First, establish where the pencil strokes should end. Next, drag the pencil from the start to the finish using a single stroke. Practice drawing straight lines using both of the pencil holding techniques.

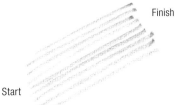

Finish

Start

These strokes were drawn while holding the pencil from above.

Finish

Start

These strokes were drawn while holding the pencil from below.

Lesson 3

Next, try combining straight lines with circles. Now our subject is starting to look like a dog.

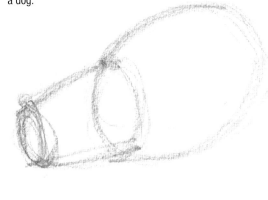

Lesson 4

Modulating the pressure you apply to the pencil as you draw allows you to create more expressive strokes.

Light pressure applied

Strong pressure applied

Light pressure applied

Strong pressure applied

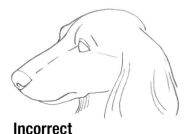

Incorrect

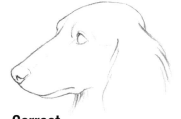

Correct

The Miniature Dachshund head appearing to the left was drawn using clearly delineated strokes that were even from start to finish. The Miniature Dachshund head appearing to the right displays modulated strokes. The strokes were drawn with great variety, and even start and finish points shift. When drawing, modulate your strokes as seen in the figure to the right. This will allow you to portray your subject with energetic strokes.

3. Assorted Hatching Techniques

Hatching is applied for a specific purpose.

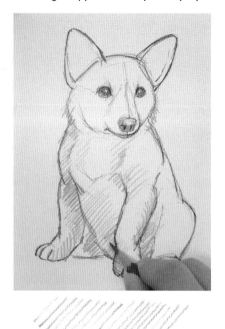

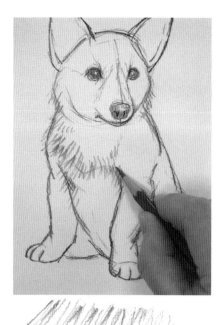

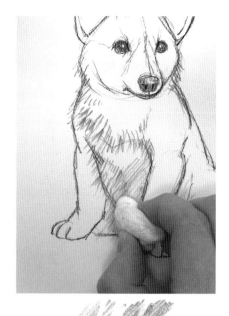

The above shows cleanly spaced, diagonal lines. These are primarily used for shading.

Slightly shifting the direction of the strokes allows you to use hatching to suggest soft fur.

Using a kneaded eraser to erase lines within a hatched area allows you to suggest brighter areas. Apply hatching over these erased lines and adjust the forms as you sketch your subject.

4. Sketching Process: Drawing a Seated Welsh Corgi

This section covers the entire process from start to finish.

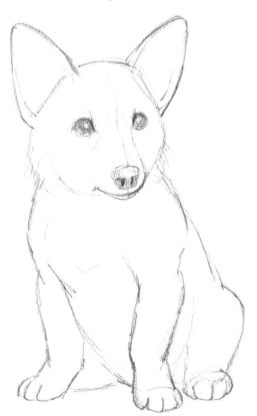

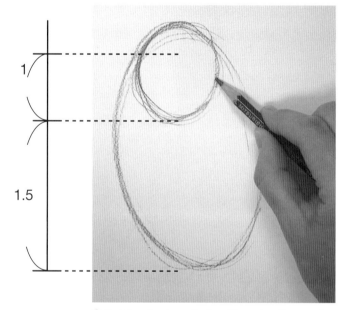

① Sketch a simple, vertical oval to capture the overall figure. Make the oval large, so that the animal ends up centered on the paper. Add another circle on top to suggest the head.
Welsh Corgis have short legs. Their head-to-body ratio is 1:1.5, while the typical ratio for a dog is approximately 1:2.

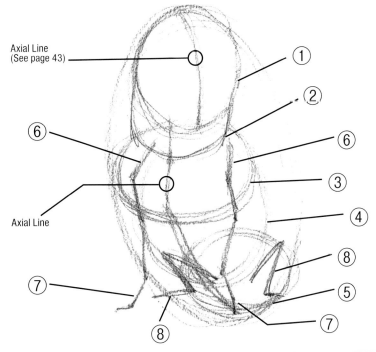

Axial Line
(See page 43)

① ② ⑥ ③ ④ ⑧ ⑤ ⑦

⑥

Axial Line

⑦ ⑧

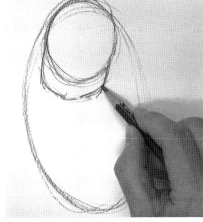

② Draw the neck. Hold the pencil from above to produce rough, sketchy strokes.

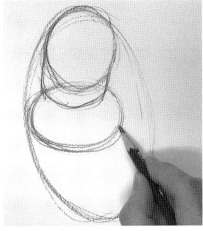

③ Draw an oval for the area that will become the dog's shoulders.

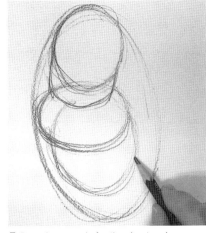

④ Draw large ovals for the chest and stomach.

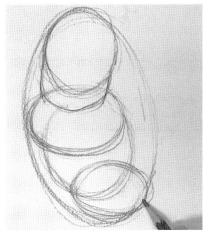

⑤ Draw an oval for the hips.

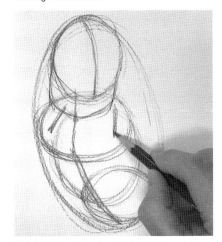

⑥ Add a line (axial line) to indicate in which directions the head and body face. Establish where to position the shoulders. Picture in your head where the spine and the shoulder blades should be located to help you draw.

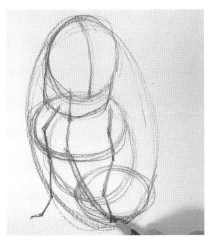

⑦ Draw the right and left forepaws using only lines. Check to make sure the lines reflect how the dog's forelegs are positioned from his elbows to his toes.

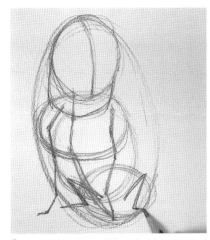

⑧ Draw the hind legs. When drawing a seated animal from a front view, the positions of the knees and the hocks become particularly important.

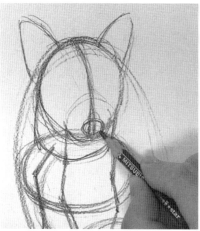

⑨ To create the mouth, add another circle below the head's circle. Make the diameter of this new circle approximately half that of the head's. Reinforce the axial line that shows the face's center. Draw a nose close to the mouth. Determine where to position the ears as well.

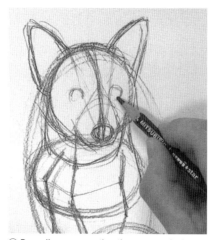

⑩ Draw lines connecting the nose and where the ear's inner contours end. Draw eyes outside these lines.

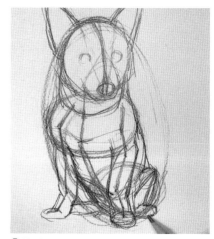

⑪ Flesh out the entire figure.

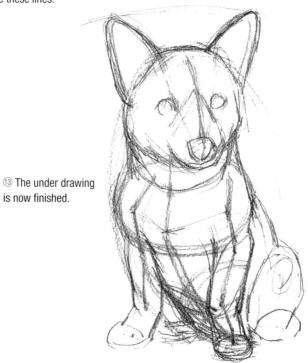

⑬ The under drawing is now finished.

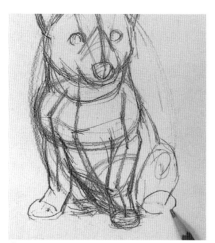

⑫ One foreleg looked too short when I made this sketch, so I adjusted its shape.

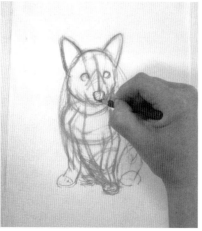

⑭ Lay a sheet of tracing paper over the under drawing and transfer the sketch.

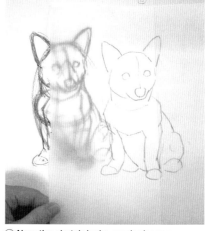

⑮ Transfer to the tracing paper from the under drawing only those lines that are necessary.

⑯ Now the sketch looks much cleaner.

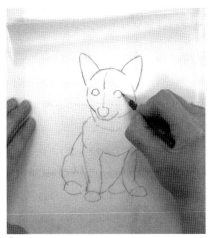

⑰ Using stronger strokes, trace the clean sketch onto the tracing paper's flip side.

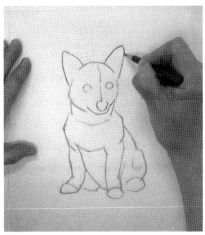

⑱ Flip the paper over again so that it is right side up. Lay a new sheet on top, and trace the lines, modulating the pencil strokes.

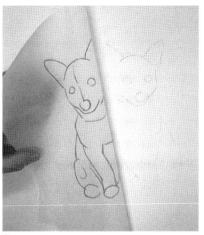

⑲ Firmly press down on the tracing paper's edge and then roll it back slightly. The image should be transferred to the new sheet of paper.

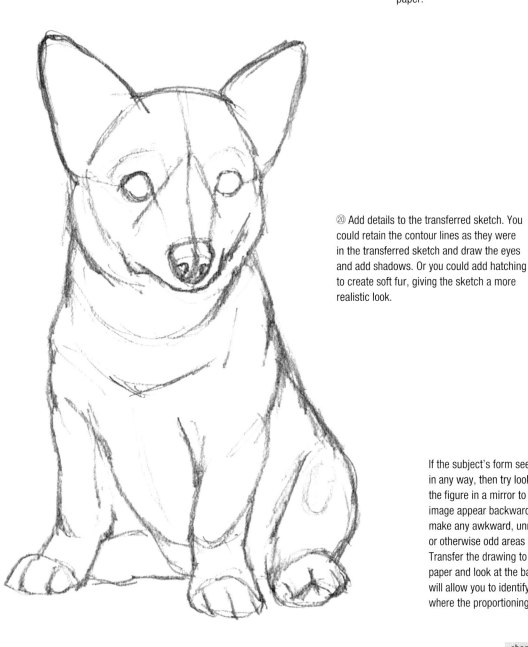

⑳ Add details to the transferred sketch. You could retain the contour lines as they were in the transferred sketch and draw the eyes and add shadows. Or you could add hatching to create soft fur, giving the sketch a more realistic look.

If the subject's form seems odd in any way, then try looking at the figure in a mirror to make the image appear backwards. This will make any awkward, unnatural, or otherwise odd areas stand out. Transfer the drawing to tracing paper and look at the back. This will allow you to identify if and where the proportioning is off.

Light and Shadow Effects

Study how light touches objects and creates bright and dark areas, and then add shades of light and shadow to the forms you draw. Adding hatching in pencil allows you to create a wide range of shades from light to dark. Adding grey shades to areas of shadow gives objects a sense of volume.

Portrayal Using Brightness

Shifts in the shades you create in pencil are connected to brightness, which refers to the degree of light or dark. When sketching, strategically apply subtle tones of light and dark. This will allow you to portray volume and texture.

5 Shades from Light to Dark Made Using a 4B Pencil

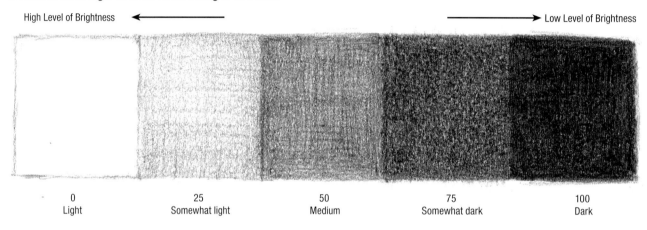

High Level of Brightness ← → Low Level of Brightness

0	25	50	75	100
Light	Somewhat light	Medium	Somewhat dark	Dark

Let's set the white of the paper as "light" or 0% saturation, and pitch black created from intense hatching "dark" or 100% saturation. 50% would then indicate grey or midway between "light" and "dark." Between these lie 25% grey ("somewhat light") and 75% grey ("somewhat dark").

Brightness increases the more the shade becomes closer to the white of the paper. Brightness decreases the more the shade becomes closer to black. Use a bright value shade for areas touched by light. For areas in shadow, use a dark value shade.

Tip

The Interplay of Light and Dark

Assuming light from a light source located above shines down at an oblique angle and touches the side of a cylinder, the opposite side will be in dark shadow. Making the cylinder become gradually brighter in stages moving away from the shadow allows you to portray the cylinder as a three-dimensional solid. Use this interplay of light and shadow when giving your animals form.

The brighter the light touching the object, the darker shadows should appear. Note how the cylinder to the right displays a darker shade than the one to the left. This is because light reflected off walls, a table, and other objects surrounding the left cylinder causing the shadow at the cylinder's center to become slightly lighter.

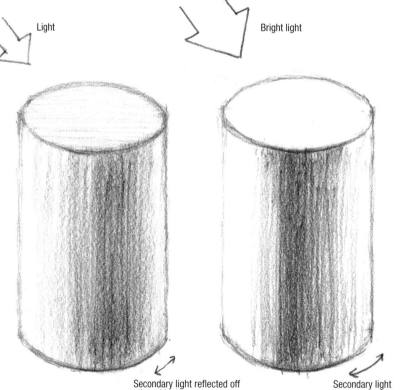

Light

Bright light

Secondary light reflected off other objects

Secondary light

Using Light and Shadow to Portray an Animal as Three-Dimensional

In this section, we shine light on the dog sketched on page 33. Omit details. Conceive of the Corgi's overall figure as a cylinder. For this sketch, I assumed a light source located to the upper left and added shadows accordingly. Once you have gasped the overall flow of shadows, start thinking about shadows on the heads, legs, and other body parts.

Check

Draw the head. Make it round and chado it as a sphere. The right half should be in shadow. The left sides of the snout, neck, shoulders, right foreleg, pastern, and paw should likewise be bright, while the right sides should be in shadow. This will make the Corgi appear three-dimensional.

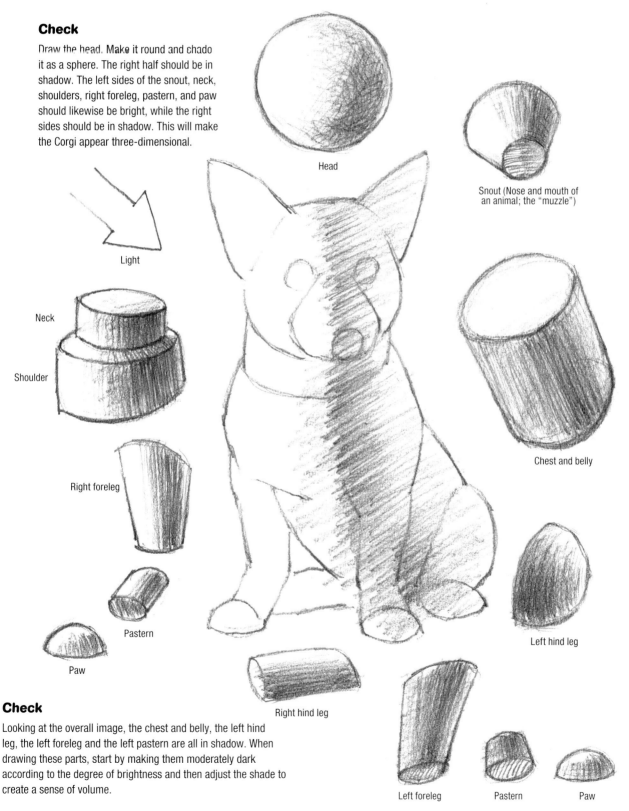

Light

Head

Snout (Nose and mouth of an animal; the "muzzle")

Neck

Shoulder

Chest and belly

Right foreleg

Left hind leg

Pastern

Paw

Right hind leg

Left foreleg　　Pastern　　Paw

Check

Looking at the overall image, the chest and belly, the left hind leg, the left foreleg and the left pastern are all in shadow. When drawing these parts, start by making them moderately dark according to the degree of brightness and then adjust the shade to create a sense of volume.

Check the Overall Balance When Adjusting Shadow Values

Once you have determined how bright individual body parts are, look over the figure as a whole once again. Below is an image of the original Corgi sketch and the shadow sketch, combined.

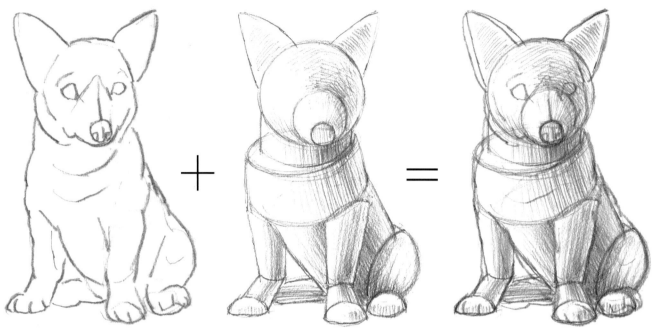

Original Welsh Corgi sketch

This is the figure conceived as cylinders and captured in varying shades of shadow. Non-trunk body parts have also been shaded. The dog was rendered in robot-like geometric shapes to make it easier to capture as a solid object.

Overlaying the two sketches results in this three-dimensional sketch.

Tip

Avoid simply identifying how bright or dark to make each body part and shading it accordingly. The overall composition is also important.

For example, attaching the left foreleg cylinder to the chest and belly cylinder causes the foreleg visually to meld with the chest and belly, because they have similar shade values. However, making both sides of the left foreleg cylinder just a hair brighter clarifies the shape, visually offsetting the leg. Check the flow of shading over the entire figure and make minor adjustments where needed.

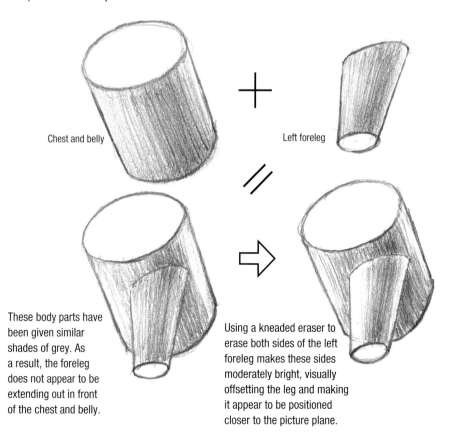

Chest and belly

Left foreleg

These body parts have been given similar shades of grey. As a result, the foreleg does not appear to be extending out in front of the chest and belly.

Using a kneaded eraser to erase both sides of the left foreleg makes these sides moderately bright, visually offsetting the leg and making it appear to be positioned closer to the picture plane.

Light and Shadow Make a Variety of Portrayals Possible

Once you understand the relationship between light and shadow, you will find yourself able to vary your artistic portrayals. Master a post you particularly like and then use your ingenuity and play around with shading to produce a host of different artistic styles.

Technique 1

This sketch shows contours used to define forms.

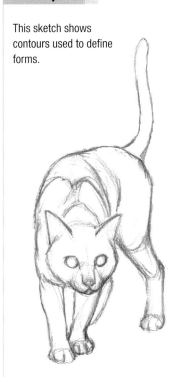

Lay a sheet of tracing paper over the initial sketch and play around with adding different shade values.

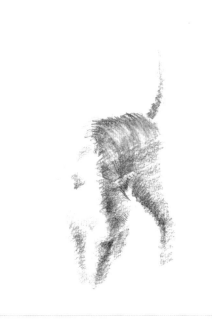 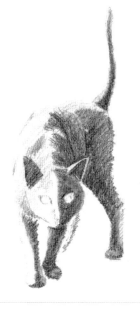

Technique 2

This sketch shows roughly applied shading.

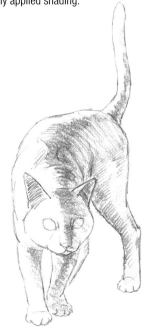

Technique 3

This sketch shows hatching applied in layers and even on detailed parts.

Technique 4

This sketch shows shadows boldly rendered in black. The result has a graphic-design feel.

Developing a Musculature Mock-up

When sketching a moving animal, first producing a "musculature mock-up" on paper to function as the foundation for the work you will create will help you produce a more realistic representation.

1. Capturing How the Front and Rear Legs Attach

The basic movement of any for-legged animal is walking on four legs. The issue you face is how to draw an animal so that it appears natural. Let's discuss how the legs attach.

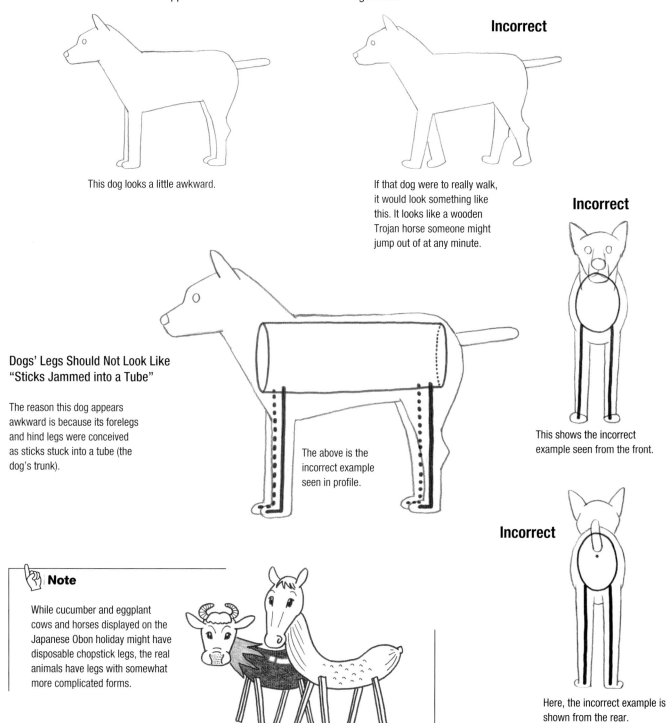

This dog looks a little awkward.

Incorrect

If that dog were to really walk, it would look something like this. It looks like a wooden Trojan horse someone might jump out of at any minute.

Incorrect

This shows the incorrect example seen from the front.

Dogs' Legs Should Not Look Like "Sticks Jammed into a Tube"

The reason this dog appears awkward is because its forelegs and hind legs were conceived as sticks stuck into a tube (the dog's trunk).

The above is the incorrect example seen in profile.

Incorrect

Here, the incorrect example is shown from the rear.

☞ Note

While cucumber and eggplant cows and horses displayed on the Japanese Obon holiday might have disposable chopstick legs, the real animals have legs with somewhat more complicated forms.

How Forelegs and Hind Legs Really Attach

Animals' front and hind legs look like they were pasted onto the sides of the animal's trunk, and the joints bend in a set direction.

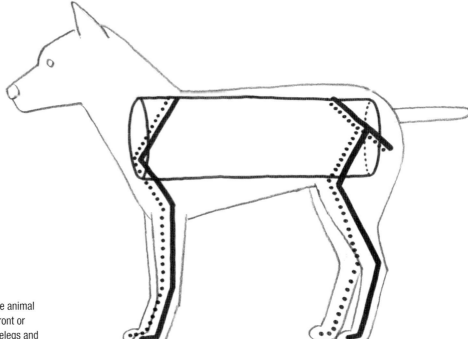

This shows a correct example seen in profile.

Correct

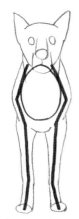

Tip

When viewing the animal from either the front or the back, the forelegs and hind legs bend slightly in an established direction. I exaggerated this slightly in the diagrams. While some animal species and postures might cause the legs to appear straight, there are other occasions when the legs appear even more bent.

Here is a correct example seen from the front.

Correct

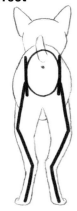

Tip

Joints have predetermined forms according to the shapes of the bones that comprise them, the direction they bend and the extent to which they bend. Make an effort to draw joints so that they bend in a natural direction.

This shows a correct example seen from the rear.

Note

Drawing a dog with correctly attached legs and then making it walk yields much more natural results, doesn't it?

Correct

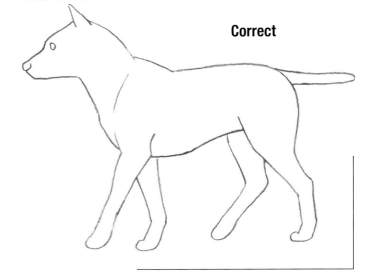

2. Adding Bones and Muscles to Complete a Mock-up

When we move our bodies, we first extend and contract our muscles and then move our joints. Knowing the positions and movements of the joints in an animal is vital to rendering its smooth movement. I drew a skeletal structure mock-up to discuss just those points needing attention concerning the joints when sketching.

Drawing a Dog Skeletal Structure Mock-up

Adding ovals to represent simplified, abstracted muscles to a skeletal structure mock-up makes it much easier to capture an animal's movements.

Skeletal Structure Mock-up

Musculature Mock-up

Canine Body, Skeletal Structure, and Musculature

Look at the diagram showing the body parts of note and see to which bones those parts correspond on the skeletal diagram.

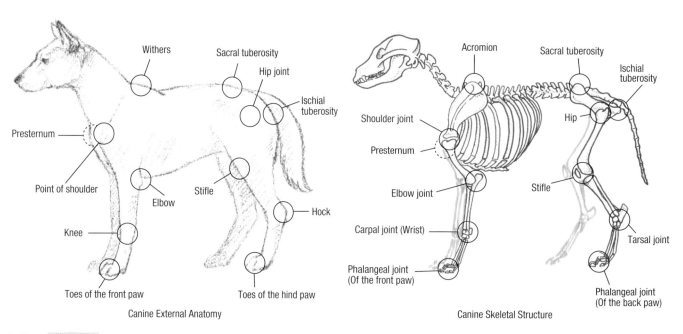

Canine External Anatomy

Canine Skeletal Structure

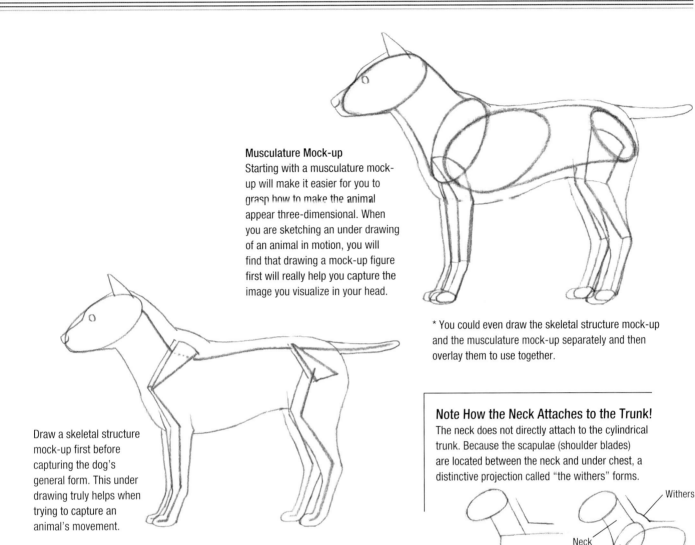

Musculature Mock-up
Starting with a musculature mock-up will make it easier for you to grasp how to make the animal appear three-dimensional. When you are sketching an under drawing of an animal in motion, you will find that drawing a mock-up figure first will really help you capture the image you visualize in your head.

Draw a skeletal structure mock-up first before capturing the dog's general form. This under drawing truly helps when trying to capture an animal's movement.

* You could even draw the skeletal structure mock-up and the musculature mock-up separately and then overlay them to use together.

Note How the Neck Attaches to the Trunk!
The neck does not directly attach to the cylindrical trunk. Because the scapulae (shoulder blades) are located between the neck and under chest, a distinctive projection called "the withers" forms.

Withers

Neck

Shoulder

Under chest

Check

The figure below shows the dog's musculature mock-up overlying the canine musculature diagram. The trunk, which comprises head, neck, shoulder, under chest, belly, and hips, is rendered as simplified ovals and lines to connect them. Adding the four legs makes the animal recognizable as a dog.

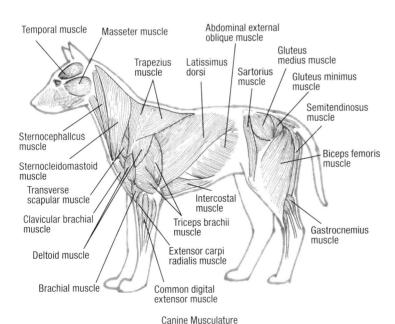

Temporal muscle
Masseter muscle
Abdominal external oblique muscle
Trapezius muscle
Latissimus dorsi
Sartorius muscle
Gluteus medius muscle
Gluteus minimus muscle
Semitendinosus muscle
Sternocephallcus muscle
Sternocleidomastoid muscle
Transverse scapular muscle
Clavicular brachial muscle
Deltoid muscle
Brachial muscle
Intercostal muscle
Triceps brachii muscle
Extensor carpi radialis muscle
Common digital extensor muscle
Biceps femoris muscle
Gastrocnemius muscle

Canine Musculature

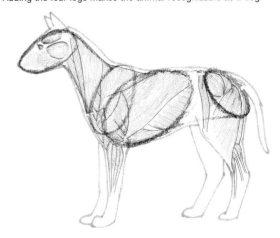

Mock-up Seen from the Front and Rear and How the Hind Legs Attach

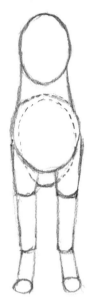

Musculature mock-up
seen from the front

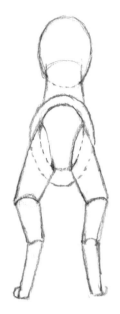

Musculature mock-up
seen from the rear

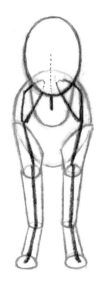

Mock-up (skeletal structure +
musculature) seen from the front

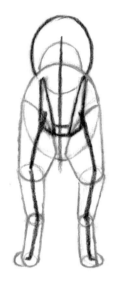

Mock-up (skeletal structure +
musculature) seen from the rear

Dissecting the Hips

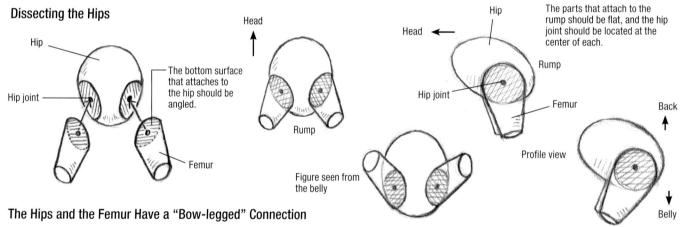

Hip

Hip joint

Head

The bottom surface
that attaches to
the hip should be
angled.

Femur

Rump

Figure seen from
the belly

Head

Hip joint

Hip

The parts that attach to the
rump should be flat, and the hip
joint should be located at the
center of each.

Rump

Femur

Profile view

Back

Belly

The Hips and the Femur Have a "Bow-legged" Connection

Draw a simplified hip as a ball
and the femur as an upside-
down cone. Once you connect
the hip joint, it should become
clear what shapes the animal's
skeleton takes from the hips to
the femur. Drawing the legs so
that the knees slightly turn out,
making the legs "bow-legged"
will give the animal a more
authentic atmosphere.

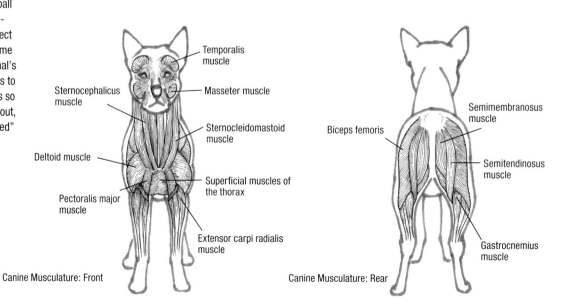

Temporalis
muscle

Sternocephalicus
muscle

Masseter muscle

Sternocleidomastoid
muscle

Deltoid muscle

Superficial muscles of
the thorax

Pectoralis major
muscle

Extensor carpi radialis
muscle

Canine Musculature: Front

Semimembranosus
muscle

Biceps femoris

Semitendinosus
muscle

Gastrocnemius
muscle

Canine Musculature: Rear

3. Drawing the Axial Line

An imaginary line that divides a human or animal vertically down the center drawn on the figure's surface is called an "axial line."

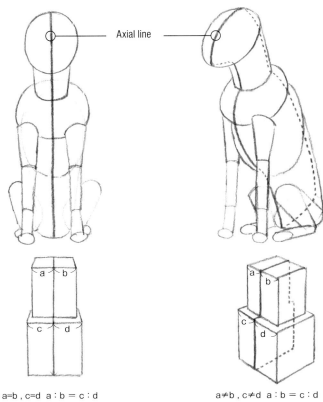

Axial line

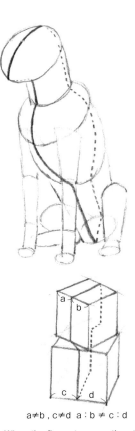

a=b , c=d a : b = c : d

A ¾ view, as reflected in the block diagram beneath, causes the distances from the axial line to the right and left body parts no longer to be equidistant.

a≠b , c≠d a : b = c : d

When the figure torques, then the axial line appears to shift directions from the chest up and from the chest down. When drawing, double-check how key body parts should become positioned with respect to the axial line.

a≠b , c≠d a : b ≠ c : d

Viewing the seated dog mock-up from the front causes the axial line to appear perfectly straight. Distances from the axial line to the right and left shoulders, the elbows, the wrists, and down to the knees are all regarded equidistant.

When drawing an animal in a reclined pose, draw a provisional axial line from the chest to the belly. Establish the positions of the shoulders, elbows, stifles (knees), and other key body parts, and connect the right and left sides. If the lines connecting the right and left sides lie parallel to one another, then the animal will appear comfortably reclining.

This shows an animal with its hind legs kicked out from underneath its body. The trunk torques, causing the belly's axial line to become visible. The long axis of the oval portraying the hips is lying horizontally. Adding horizontal ovals to the hind legs makes a difficult pose become easy to sketch.

The Axial Line Helps Envisioning the Legs and Eyes as Well as the Trunk

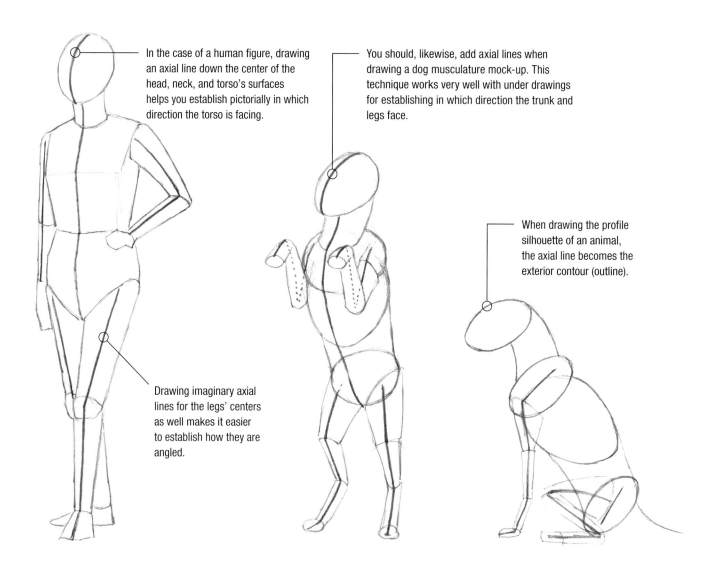

In the case of a human figure, drawing an axial line down the center of the head, neck, and torso's surfaces helps you establish pictorially in which direction the torso is facing.

You should, likewise, add axial lines when drawing a dog musculature mock-up. This technique works very well with under drawings for establishing in which direction the trunk and legs face.

When drawing the profile silhouette of an animal, the axial line becomes the exterior contour (outline).

Drawing imaginary axial lines for the legs' centers as well makes it easier to establish how they are angled.

Using Axial Lines to Capture the Directions of the Eyes and Nose

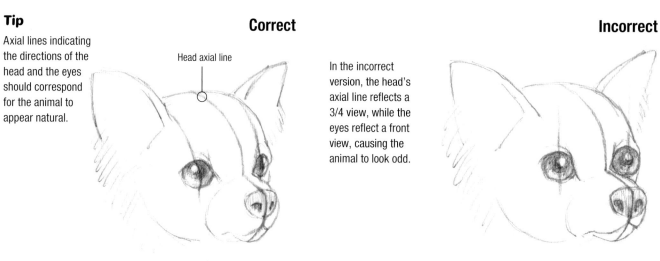

Tip

Axial lines indicating the directions of the head and the eyes should correspond for the animal to appear natural.

Correct

Head axial line

In the incorrect version, the head's axial line reflects a 3/4 view, while the eyes reflect a front view, causing the animal to look odd.

Incorrect

4. Using Bones to Capture Movement, Using Muscles to Capture Form

Using a skeletal structure mock-up and a musculature mock-up to sketch an under drawing enables you to draw animals in a host of poses. Use either the skeletal structure mock-up or the musculature mock-up or both. Try using them to form an image of how the animal is moving.

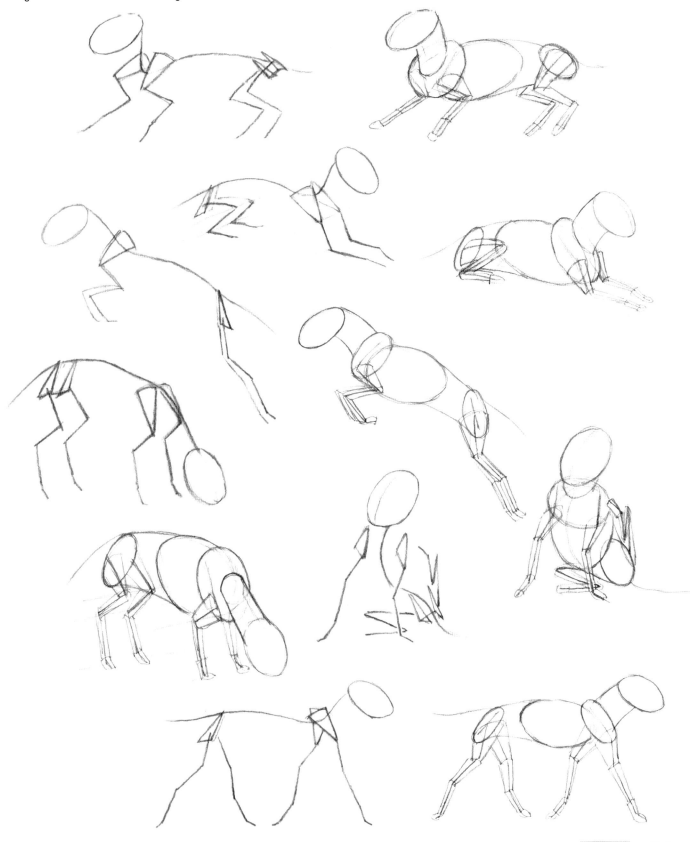

Actually Using a Sketch Mock-up to Draw an Animal

This section discusses using sketch mock-ups to capture dogs and cats in various motions.

1. Running Dog: Bent Legs

step 1-1

Draw a musculature mock-up to capture the form of an animal running. Use points to establish the joints' positions and lines to capture the legs, just as when you would draw a skeletal structure mock-up.

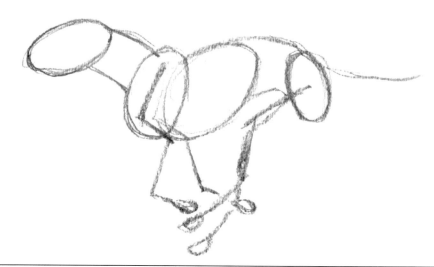

step 1-2

Flesh out the figure and add distinguishing features that make the animal look like a dog. See pages 140 to 141 for motion sequence sketches of running.

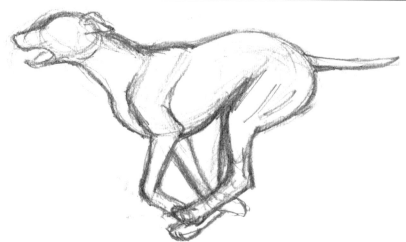

step 1-3

This shows the final image. Add shadows to create a three-dimensional figure.

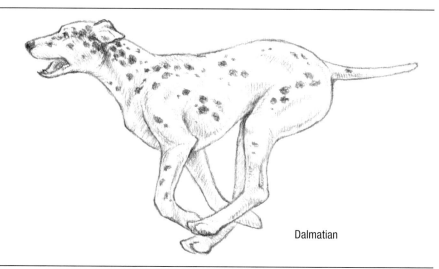

Dalmatian

2. Running Dog: Legs Extended

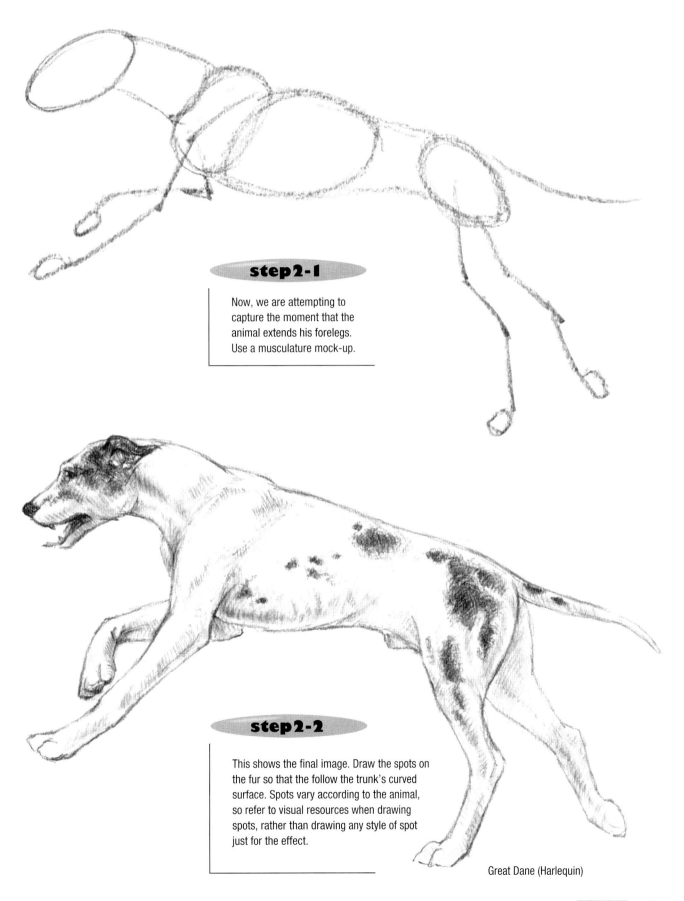

step2-1

Now, we are attempting to capture the moment that the animal extends his forelegs. Use a musculature mock-up.

step2-2

This shows the final image. Draw the spots on the fur so that the follow the trunk's curved surface. Spots vary according to the animal, so refer to visual resources when drawing spots, rather than drawing any style of spot just for the effect.

Great Dane (Harlequin)

3. Falling Cat: Rotating

The cat begins by falling while facing up (fig. ①). However, the cat soon shifts his head and forelegs to a normal position (fig. ②), and then does the same with his hind legs (fig. ③). He then safely touches the ground (fig. ④).

① Facing up

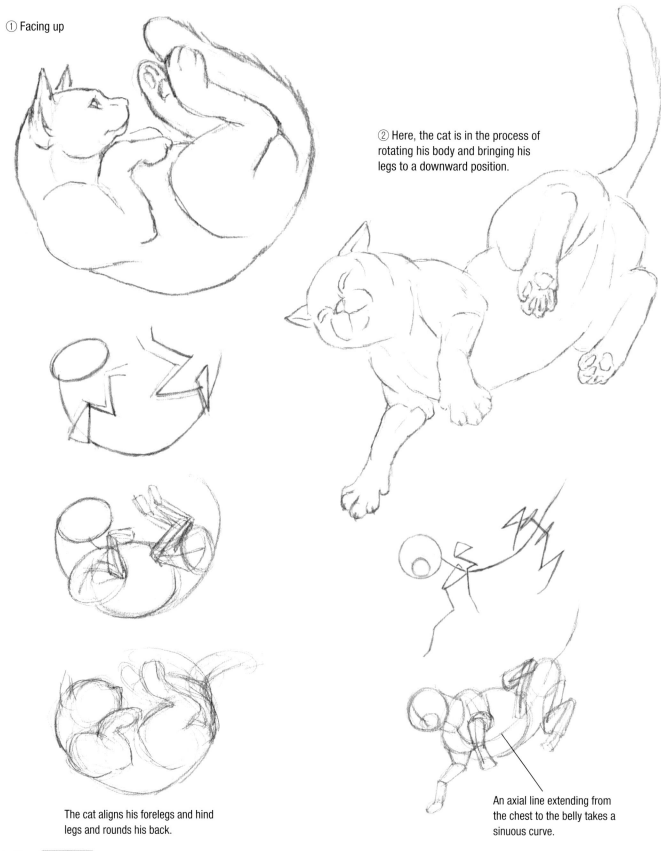

② Here, the cat is in the process of rotating his body and bringing his legs to a downward position.

The cat aligns his forelegs and hind legs and rounds his back.

An axial line extending from the chest to the belly takes a sinuous curve.

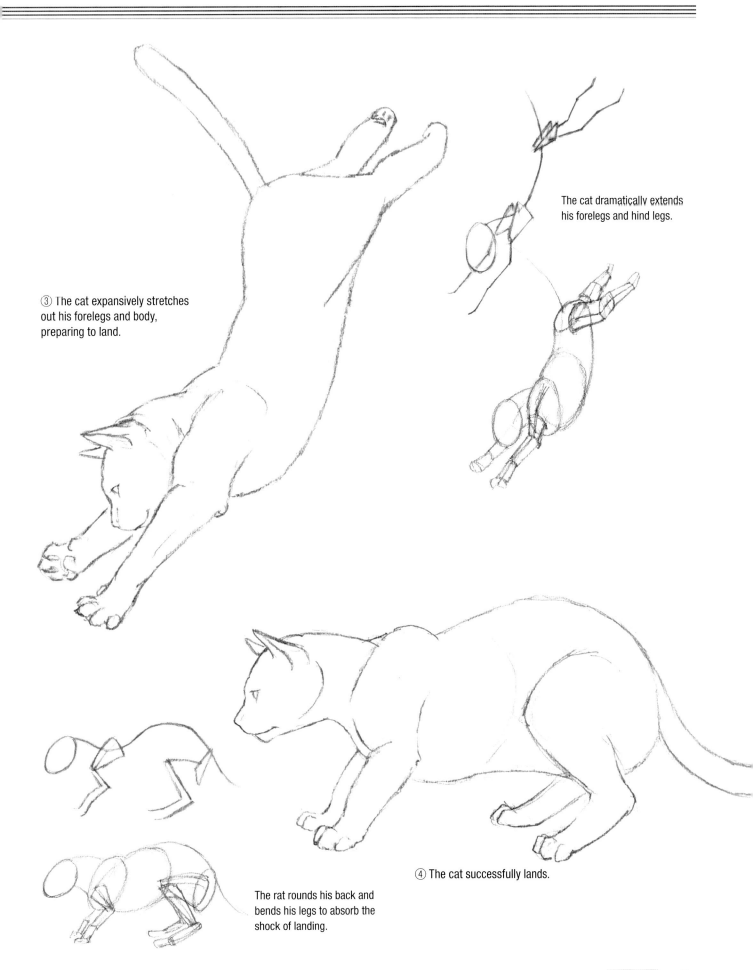

③ The cat expansively stretches out his forelegs and body, preparing to land.

The cat dramatically extends his forelegs and hind legs.

④ The cat successfully lands.

The rat rounds his back and bends his legs to absorb the shock of landing.

4. Assorted Cat Actions

Moving Quickly
The right foreleg and the left hind leg touch the ground. The left foreleg and the right hind leg are raised. Note that the left shoulder is lower than the right shoulder.

Stalking Cat

Cat Walking Slowly
The right foreleg and the right and left hind legs touch the ground. The left foreleg is raised off the ground. The left shoulder drops, while the right shoulder rises.

Cat about to Jump Up

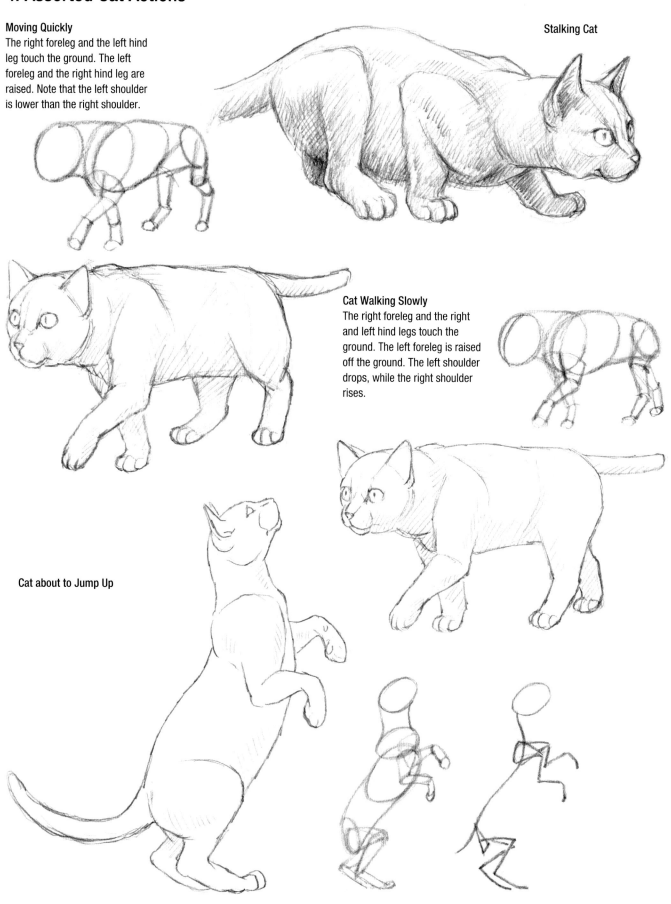

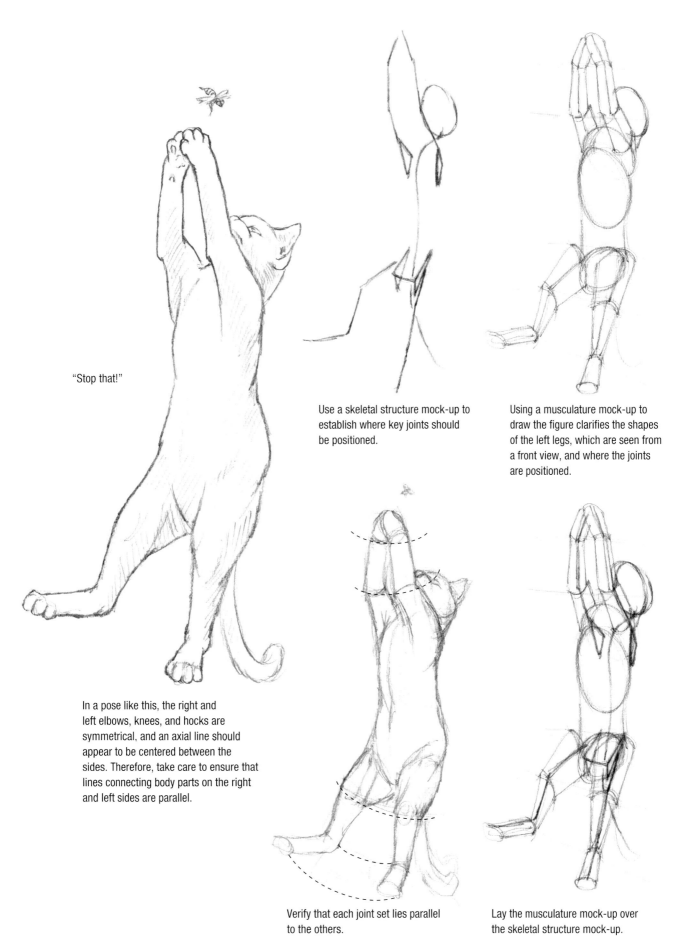

"Stop that!"

Use a skeletal structure mock-up to establish where key joints should be positioned.

Using a musculature mock-up to draw the figure clarifies the shapes of the left legs, which are seen from a front view, and where the joints are positioned.

In a pose like this, the right and left elbows, knees, and hocks are symmetrical, and an axial line should appear to be centered between the sides. Therefore, take care to ensure that lines connecting body parts on the right and left sides are parallel.

Verify that each joint set lies parallel to the others.

Lay the musculature mock-up over the skeletal structure mock-up.

Proportioning

If you intend to capture an animal's distinguishing characteristics and make that animal look authentic, then it is vital that you are familiar with the proper proportioning that serves as the measurement base for drawing the animal. You must consider how large to make each body part and what proportions to use in order to draw a beautiful animal with a well-proportioned figure. Let's take a look at proportioning for the dog and cat, our standard examples.

1. Body

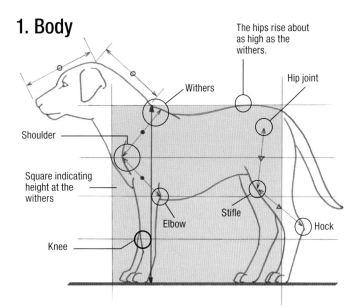

The hips rise about as high as the withers.

Hip joint

Withers

Shoulder

Square indicating height at the withers

Elbow

Stifle

Hock

Knee

If you use the head's length as a standard of measurement, you will uncover other body parts with the same length. These serve as natural proportioning standards to use when the animal is standing naturally. When the dog's posture changes or the angle of perspective changes, the proportions will also automatically change. In addition, these proportions also change according to the animal drawn.

Canine Proportions

Look at the square indicating the dog's height (height from the ground to the top of the withers). A dog's body, excluding the head, will almost fit into this square. Draw the withers, shoulders, elbows, knees, and other joints along lines running parallel to the ground plane. This will cause the body parts to fall into similar positions to those depicted in the figure shown.

Feline Proportions

The cat's hips extend considerably outside of the square indicating the cat's height at the withers.

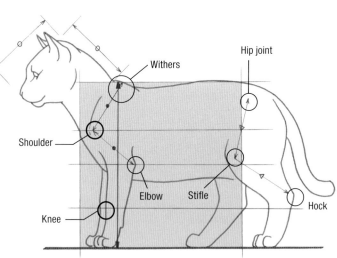

Withers

Hip joint

Shoulder

Elbow

Stifle

Hock

Knee

 Note

Proportions when an animal is seen from a front view differ from those when an animal is seen in a 3/4 view.

Eye level

This dog's head is slightly raised.

This angle shows the dog's face from a front view.

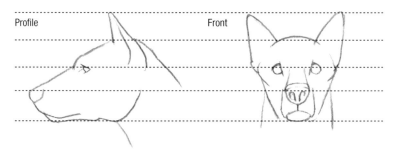

Profile

Front

2. Face

The eyes and nose lie along lines drawn from the interior bases of the ears, extending to the chin, and divided into three equal parts.

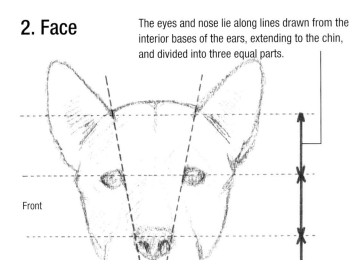

Front

The inner corners of the cat's eyes lie just outside of lines connecting the interior bases of the ears and the sides of the nose.

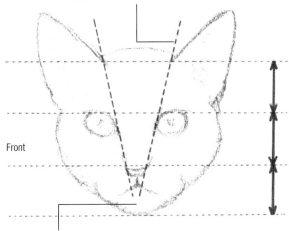

Front

The mouth should be drawn approximately 1/3 or 1/2 the length of the distance from the nose to the chin. It should expand to the right and left line an inverted "V".

The eye lies about halfway between the nose to the back of the ear.

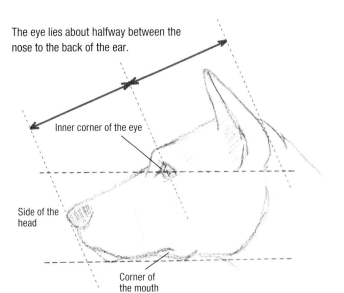

Inner corner of the eye

Side of the head

Corner of the mouth

Lines connecting the eye to the underside of the ear and connecting the chin to the throat lie virtually parallel to each other on both the dog and the cat. In addition, the mouth lines straight down from two lines dawn from the eyes' interior corners.

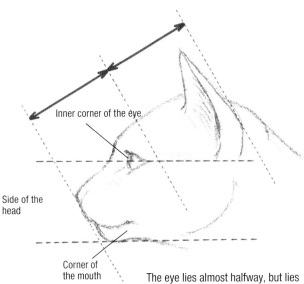

Inner corner of the eye

Side of the head

Corner of the mouth

The eye lies almost halfway, but lies slightly closer to the nose, along the distance between the nose and the back of the ear.

A lowered dog head shown in 3/4 view is a common way to depict a dog. The face appears somewhat long, because the entire snout is visible.

Eye level

Common Head Angle of a Dog

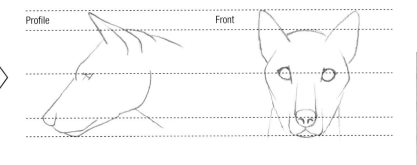

Profile

Front

3. Changes in Proportions

Changes in an animal's posture or the angle of perspective of the viewer cause changes in proportioning. Let's use the figures showing the rows of cubes below to discuss the principles behind this.

Side View

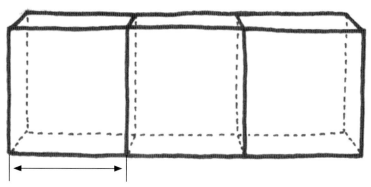

The cubes' closest sides are the same.

3/4 View

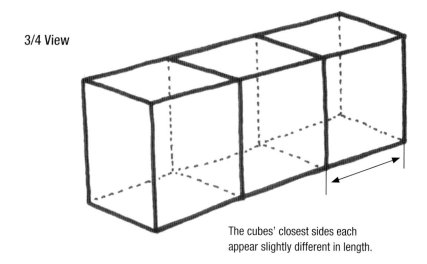

The cubes' closest sides each appear slightly different in length.

Tip

How to Measure Proportions

First, use your pencil or other such object to measure the length of whichever body part you plan to use as your base measurement (typically, the head). Align your pencil point with the nose's tip and mark where the head's back lies with your thumb. You can then use the head's length as a measurement to determine how long to make the body. If the sketch you produce has the same proportioning, then you have correctly captured the animal's form.

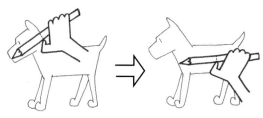

Almost Front View

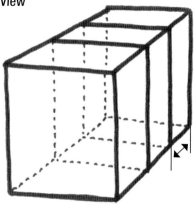

The farther away the cube, the shorter its side appears.

The Same Applies to Animals' Bodies

Side View

3/4 View

Almost Front View

Compared to the front view, the distance from the cat's shoulders to its hips now seem extremely shortened.

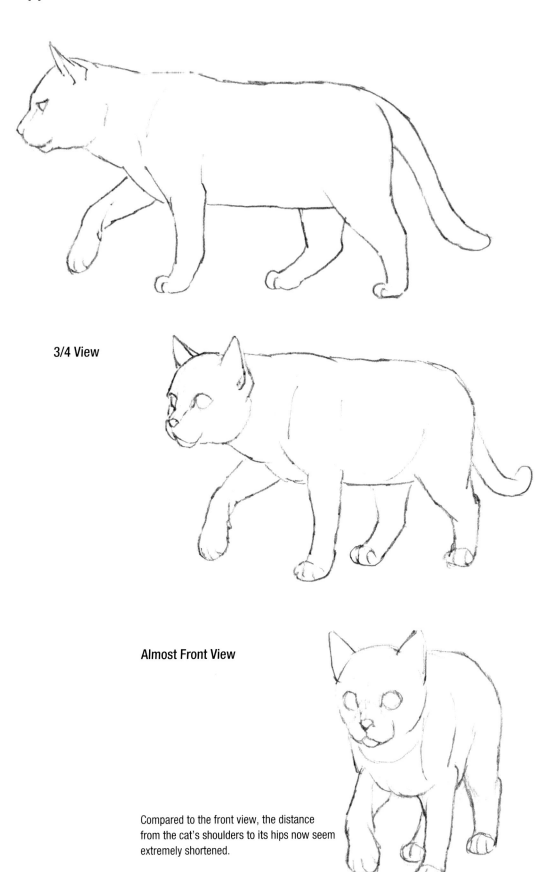

4. Changes in the Body and Face According to Age

These pages show changes that appear in the body and face from birth to old age.

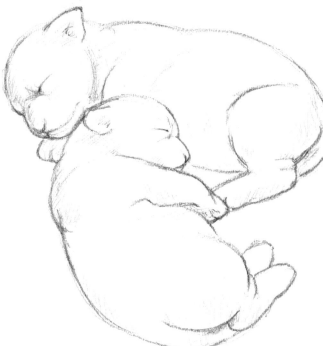

Juvenile animals have disproportionally thick forelegs compared to their overall body lengths.

This shows puppies approximately ten days after birth. The eyes are closed, the legs are short, and their bodies seem somewhat amorphous. Only their mouths seem large to allow them to take in plenty of nourishment. Puppies and kittens both tend to open their eyes about ten days after birth, and they begin to romp around.

These show puppies between one and one-and-a-half months old. The eyes and noses seem positioned properly, but the eyes still lie low on the face compared to an adult dog. This trait makes puppies' eyes (as well as those of other baby animals) appear large, which gives them adorable facial expressions.

Check

Changes in a Cat's Face

Approx. 10 days after birth

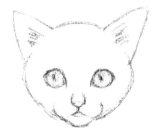

1 to 1½ months

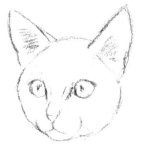

3 to 4 months

Mature cat

Mature Dogs
After a year, dogs
appear fully matured.
The proportions are also
standard.

3 to 4 months
The body and face now look more
mature and are closer to those of
an adult, but they still retain an
innocent, babyish air.

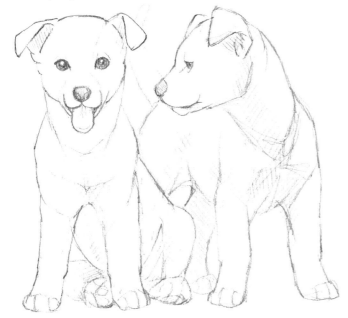

An unneutered male dog should be larger and
more muscular than a female.

Old Dogs
For dogs between 7 and 8 years
old and cats around 10 years
old, the skin begins to sag, and
the shoulders, back, and hips all
become emaciated with bones
sticking out.

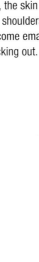

Portraying Texture: Sparkling Eyes and Fur Nap

1. Eyes

Dogs: Dog eyes typically have round pupils and dark irises.

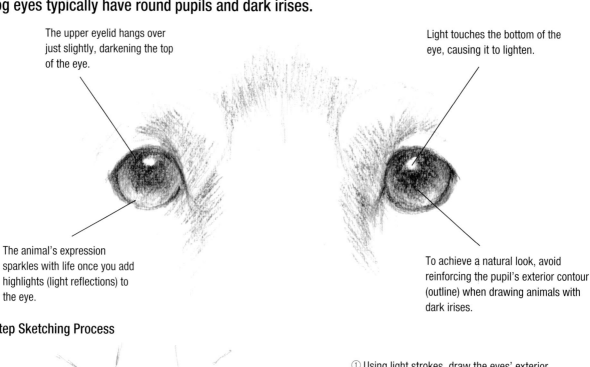

The upper eyelid hangs over just slightly, darkening the top of the eye.

Light touches the bottom of the eye, causing it to lighten.

The animal's expression sparkles with life once you add highlights (light reflections) to the eye.

To achieve a natural look, avoid reinforcing the pupil's exterior contour (outline) when drawing animals with dark irises.

Step-by-Step Sketching Process

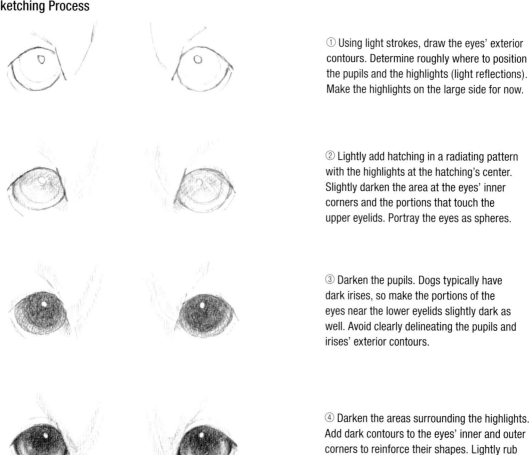

① Using light strokes, draw the eyes' exterior contours. Determine roughly where to position the pupils and the highlights (light reflections). Make the highlights on the large side for now.

② Lightly add hatching in a radiating pattern with the highlights at the hatching's center. Slightly darken the area at the eyes' inner corners and the portions that touch the upper eyelids. Portray the eyes as spheres.

③ Darken the pupils. Dogs typically have dark irises, so make the portions of the eyes near the lower eyelids slightly dark as well. Avoid clearly delineating the pupils and irises' exterior contours.

④ Darken the areas surrounding the highlights. Add dark contours to the eyes' inner and outer corners to reinforce their shapes. Lightly rub a kneaded eraser over the portion of the eyes close to the exterior corners. This makes the eyes look clear.

Dog Eyes

Doberman Pinscher
I raised the eyes' exterior corners more than they would actually be in order to give this dog a fiercer countenance.

Basset Hound
The droopy eyes create the Basset's distinctive expression.

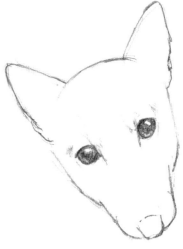

This shows typical dog eyes.

Chihuahua
Chihuahuas have distinctively bulging, round eyes.

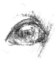

This shows the gentle eyes of a Labrador Retriever or other similar breed.

Eye seen from the side

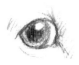

A sideways glance causes the white of the eye to come, making the dog look cute.

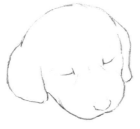

Sleeping eyes

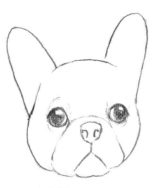

French Bulldog
Bulging eyes might face outward to the left and right.

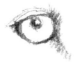

Siberian Husky
The Siberian Husky is unique in its light-colored irises.

Tip

Drawing only one eye at a time makes it extremely difficult to achieve visual balance. I highly recommend executing both sides at the same time.

Downcast eyes

Raised eyes

Cats: Cats have distinctive pupils that shift from round to narrow, vertical slits.

Drawing the highlight so that it overlaps slightly with the pupil makes the eye look clear.

Darkening the contours at the eye's inner and outer corners and using somewhat lighter contours for the rest of the eye enhances the notion that the eye is a sphere.

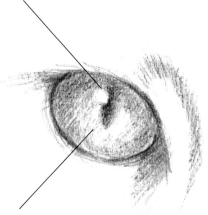

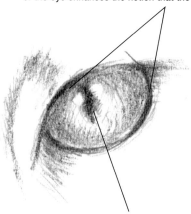

Brighten the eye's center when the pupil narrows.

To achieve a natural look, avoid clearly delineating the pupil's exterior contour.

Step-by-Step Sketching Process

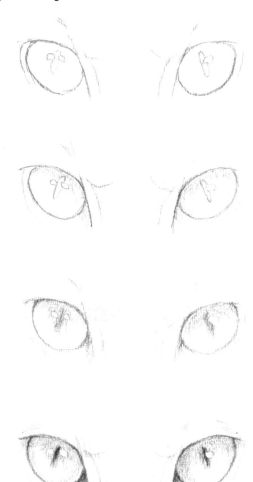

① Using light strokes, draw the eyes' exterior contours. Determine roughly where to position the pupils and the highlights (light reflections). Add one to two highlights, making them on the large side for now.

② Lightly add hatching in a radiating pattern with the highlights at the hatching's center. Cats' irises tend to be light in color, so apply light strokes when hatching. Slightly darken the area at the eyes' inner corners and the portions that touch the upper eyelids.

③ Darken the pupils. Cats' pupils are not purely vertical when viewed from the front. In fact, they subtly form an inverted "V". Avoid clearly delineating the pupils and irises' exterior contours. Apply dark lines to the pupils' centers and to the eyes' inner and outer corners.

④ Add slightly darkened contours to the eyes' inner and outer corners to indicate that the eyes have curved surfaces. Lightly rub a kneaded eraser near the eyes' outer corners to make the eyes appear clear.

Cat Eyes

Staring fixedly

Looking up

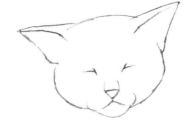

Sleeping

Glancing slightly to the side

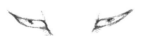

Squinting eyes

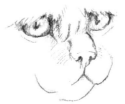

Persians and other cats with short noses have eyes like these.

Facing up

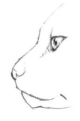

Eyes in profile

Surprised eyes

Changes in the Pupil

Pupils dilate and contract, adjusting the amount of light that reaches the retina. In dark places, when there is little light, the pupils dilate, and in bright places with plentiful light, the pupils contract. Dilated pupils look the same on just about any animal. However, when dogs' pupils contract, they retain their original round shape. When cats' eyes contract, they become vertical, narrow slits. When the pupils of horses, cows, goats contract, they become horizontal, narrow slits. Pupils will dilate when you are excited or surprised, and even when you are in a bright location.

Pupil's Size and Shape

Dog

Dark Light

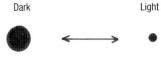

Cat

 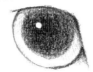

Horse, Sheep, Goat

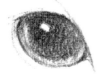

2. Fur

Use layers of hatching in pencil to portray an animal's body covered in fur. Practice using a pencil to make a variety of shades, and then apply these shades when to create hatched long and short fur.

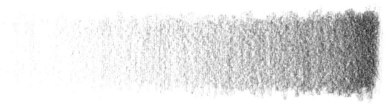

This was created by a pencil, held from above, and moved up and down to create vertically gradated shades.

Creating Different Shades

Working from left to right (or from right to left if you happen to be left-handed), use a pencil to made progressively darker shades. "Gradation" refers to shades or tones that shift from light to dark smoothly (without obvious transitions). You may use hatching or crosshatching to create gradated shades.

This figure shows diagonal strokes creating hatched gradation.

This shows crosshatched gradation. It would be difficult to create crosshatched gradation in one fell swoop. Instead, add layers of hatching while checking the figure's shades overall. Add darkened areas in between the crosshatching.

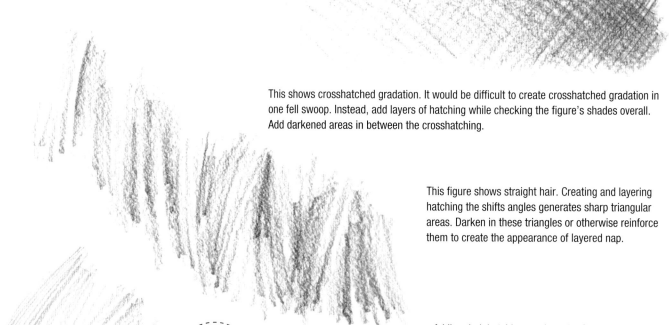

This figure shows straight hair. Creating and layering hatching the shifts angles generates sharp triangular areas. Darken in these triangles or otherwise reinforce them to create the appearance of layered nap.

Adding dark hatching to triangular forms like these creates the illusion that upper layers of hair are covering deeper layers, which in turn results in the impression of thick fur.

Fur Grows in a Fixed Direction

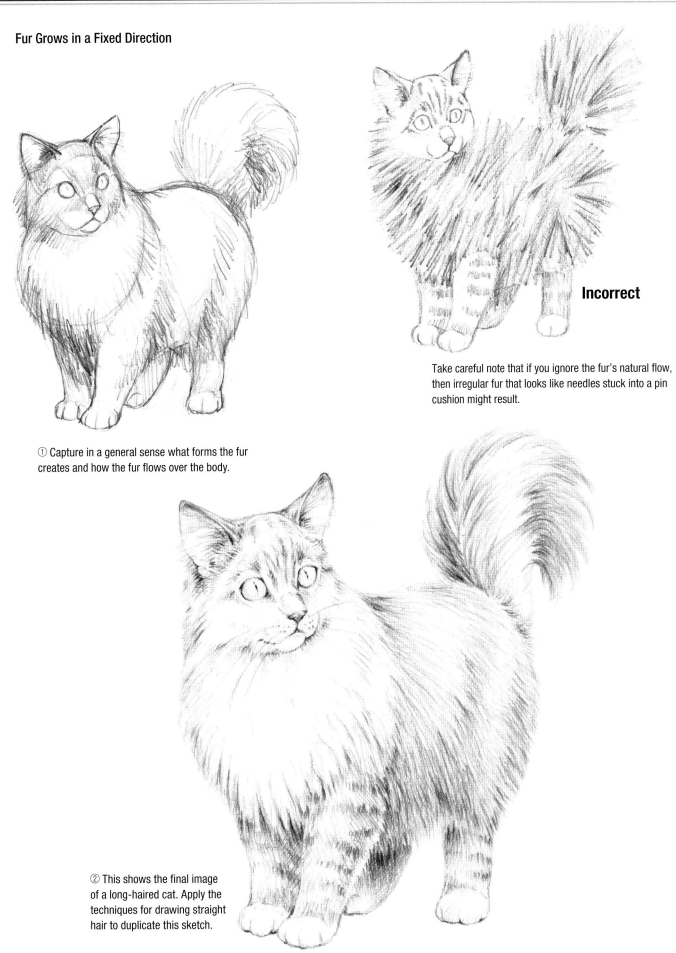

Incorrect

Take careful note that if you ignore the fur's natural flow, then irregular fur that looks like needles stuck into a pin cushion might result.

① Capture in a general sense what forms the fur creates and how the fur flows over the body.

② This shows the final image of a long-haired cat. Apply the techniques for drawing straight hair to duplicate this sketch.

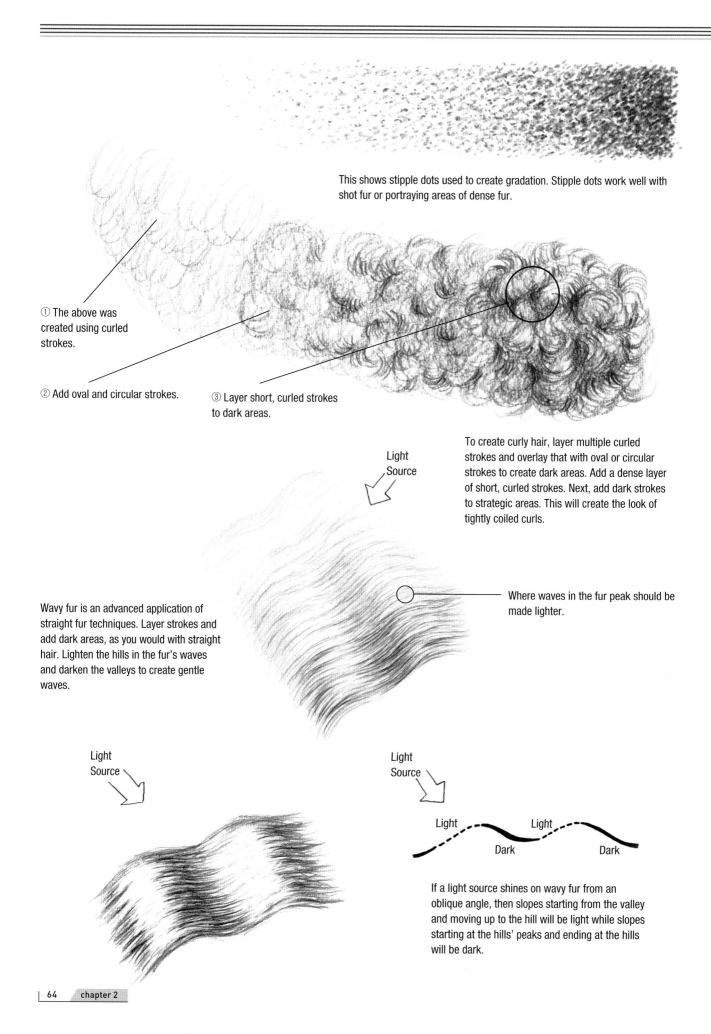

This shows stipple dots used to create gradation. Stipple dots work well with shot fur or portraying areas of dense fur.

① The above was created using curled strokes.

② Add oval and circular strokes.

③ Layer short, curled strokes to dark areas.

To create curly hair, layer multiple curled strokes and overlay that with oval or circular strokes to create dark areas. Add a dense layer of short, curled strokes. Next, add dark strokes to strategic areas. This will create the look of tightly coiled curls.

Light Source

Where waves in the fur peak should be made lighter.

Wavy fur is an advanced application of straight fur techniques. Layer strokes and add dark areas, as you would with straight hair. Lighten the hills in the fur's waves and darken the valleys to create gentle waves.

Light Source

Light Source

Light Light

Dark Dark

If a light source shines on wavy fur from an oblique angle, then slopes starting from the valley and moving up to the hill will be light while slopes starting at the hills' peaks and ending at the hills will be dark.

The techniques for creating wavy and curly fur may be used alone or may be combined with short hatching, stipple dots, or other such technique to create novel textures. Leaving parts of the paper uncolored is the most effective means of generating light areas in the fur. However, applying a kneaded eraser to darker shaded areas of layered hatching is another technique you can use.

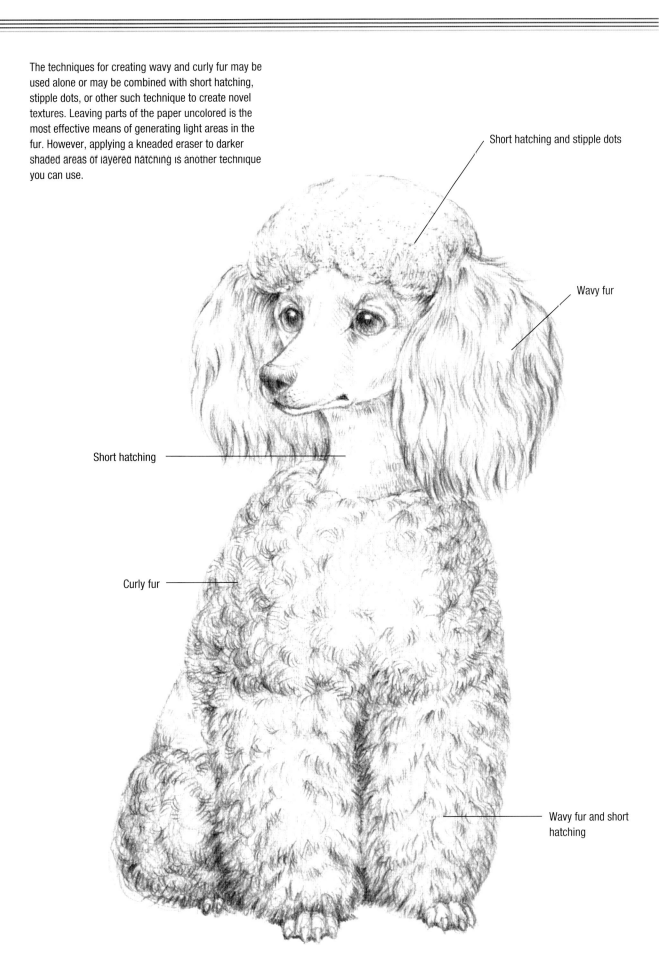

Short hatching and stipple dots

Wavy fur

Short hatching

Curly fur

Wavy fur and short hatching

Portraying White and Black Fur

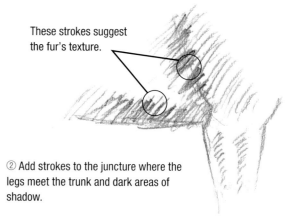

These strokes suggest the fur's texture.

② Add strokes to the juncture where the legs meet the trunk and dark areas of shadow.

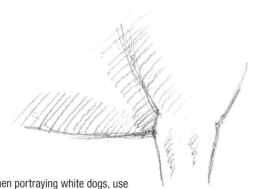

① When portraying white dogs, use light hatching to shade. To define bright areas, use the white of the paper.

These shadows seem unexpectedly dark, despite that this is a white dog. To achieve effective results, be bold and apply shadows in medium to dark shades.

③ Even in the case of a white dog, the majority of the dog's body will end up darker than the white of the drawing paper. Take note of the overall interplay between light and dark, and add dark shades bit by bit to define the figure's forms.

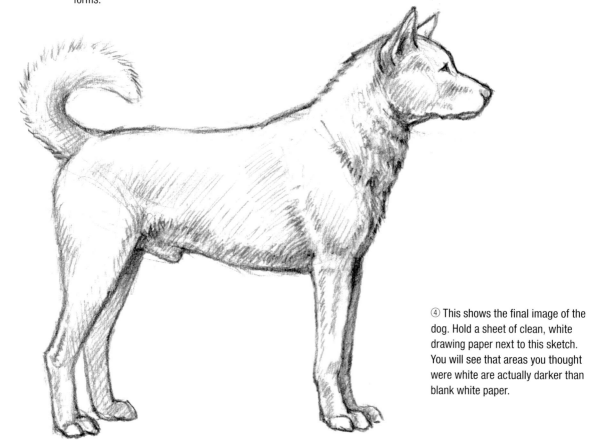

④ This shows the final image of the dog. Hold a sheet of clean, white drawing paper next to this sketch. You will see that areas you thought were white are actually darker than blank white paper.

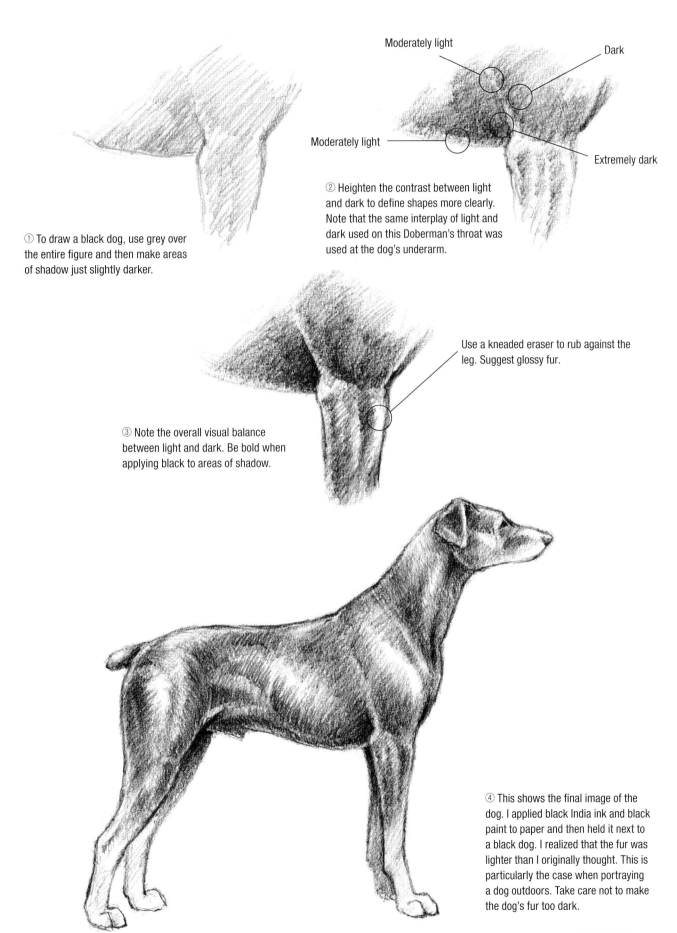

Moderately light

Dark

Moderately light

Extremely dark

① To draw a black dog, use grey over the entire figure and then make areas of shadow just slightly darker.

② Heighten the contrast between light and dark to define shapes more clearly. Note that the same interplay of light and dark used on this Doberman's throat was used at the dog's underarm.

Use a kneaded eraser to rub against the leg. Suggest glossy fur.

③ Note the overall visual balance between light and dark. Be bold when applying black to areas of shadow.

④ This shows the final image of the dog. I applied black India ink and black paint to paper and then held it next to a black dog. I realized that the fur was lighter than I originally thought. This is particularly the case when portraying a dog outdoors. Take care not to make the dog's fur too dark.

Let's Draw!

Use some form of reference image to sketch or use a real-live pet as a model.

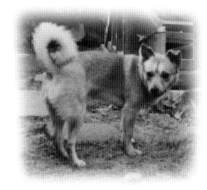

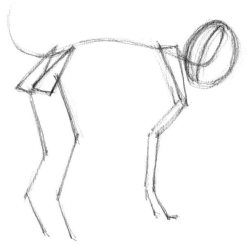

The standing dog in this photograph is our model. I used this snapshot to make a black-and-white photocopy on an A4 (21 x 29.9 cm or approx. $8\frac{5}{16}$" x $11\frac{3}{4}$")-sized sheet of paper.

① Lay a sheet of tracing paper over a photocopied picture or other reference image you plan to use. Mark the positions of the head, shoulders, elbows, knees, and other key body parts, and connect these with lines to create a skeletal structure mock-up. This will give you a general idea of the animal's overall form.

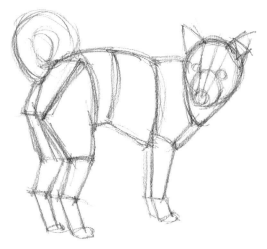

② Lay another sheet of paper over the skeletal structure mock-up, and using the figure visible from underneath as a guide, produce a fleshed-out sketch.

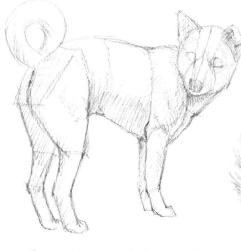

③ Add hatching to create shadows and suggest fur.

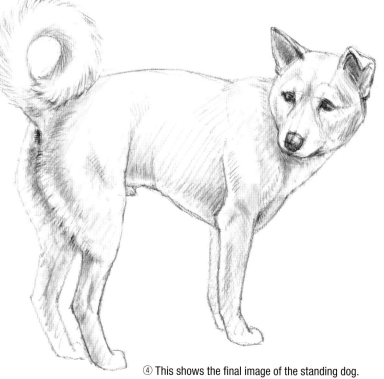

④ This shows the final image of the standing dog.

This is a reference photograph of a seated dog. Photographing an animal at a distance can yield surprisingly tiny results. So take one step forward before pushing the shutter. Fur photographs very nicely outdoors.

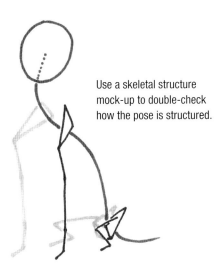

Use a skeletal structure mock-up to double-check how the pose is structured.

Sketch with Reinforced Exterior Contours

Produce a rough sketch and then add the eyes, nose, and other facial features using simple forms. While the goal is to produce a recognizable sketch of the dog, a rough sketch like this is sufficient at this stage.

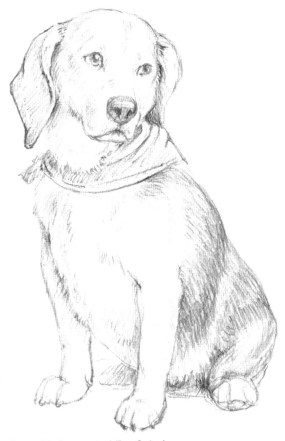

Photographing Animals

Unlike humans, animals will not pose for a camera. Typically, when a person tries to photograph their pet, the animal will bounce toward them, wanting to play, will be terrified of the shutter sound, or will look the other way and not at the camera. In such cases, ask a family member or a friend to help out. You can take a photograph from a good angle while someone dangles a piece of food or a toy to attract the animal's attention, When we photograph animals, we often do it from a standing position, which causes the animals to appear to have proportionally large heads compared to their bodies. Make an effort to lower the camera and snap the shot from somewhere around the animal's eye level. In photographs with depth, objects in the background tend to appear smaller than we picture them in our mind's eye. In photographs taken close-up and from a front view, the hind legs appear unexpectedly small. Consequently, when you draw the image, you will need to think about proportioning and adjust as needed.

Drawing with Suggested Fur Coloring

Use strong, straight strokes to define paws and other parts where the bones are close to the animal's skin. Use soft strokes for muscular body parts. Combining strong strokes with soft strokes gives visual balance to the composition. Add hatching to create Beagle's distinctive fur coloring.

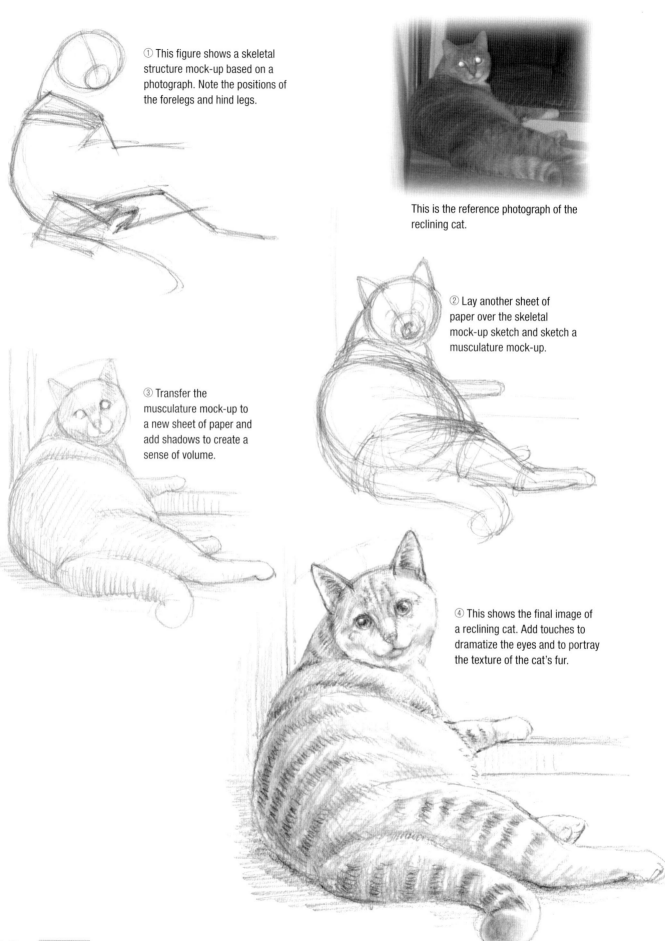

① This figure shows a skeletal structure mock-up based on a photograph. Note the positions of the forelegs and hind legs.

This is the reference photograph of the reclining cat.

② Lay another sheet of paper over the skeletal mock-up sketch and sketch a musculature mock-up.

③ Transfer the musculature mock-up to a new sheet of paper and add shadows to create a sense of volume.

④ This shows the final image of a reclining cat. Add touches to dramatize the eyes and to portray the texture of the cat's fur.

Spying a Sleeping Animal Is a Great Opportunity to Sketch

① Use a skeletal structure mock-up to capture the animal's form.

② Make the cat three-dimensional using a musculature mock-up.

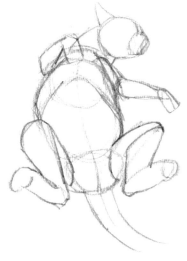

③ This sketch brings us close to a natural pose and one that is distinctive to cats.

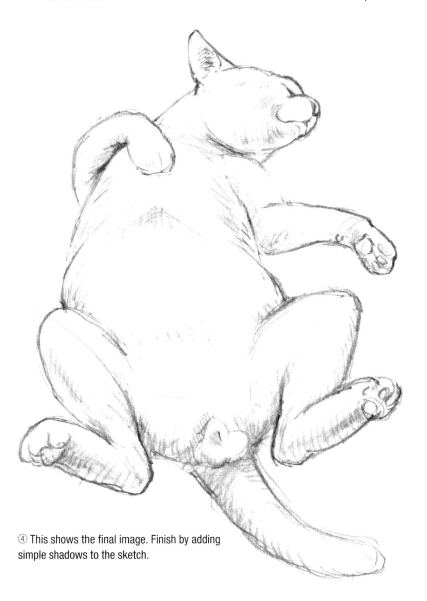

④ This shows the final image. Finish by adding simple shadows to the sketch.

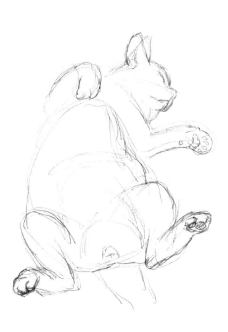

I sketched the above as I watched my cat sleep. While it is nothing more than a simple sketch, it still will make an excellent reference image in the future. Later, you may use a skeletal structure mock-up and a musculature mock-up to finish the drawing. If you take a photograph from the same angle that you sketched the sleeping animal, then later you can use it to add to those areas you were not able to complete while the animal was sleeping, color the fur, or add spots.

Capturing the Key Traits of a Seated Animal

When dogs sit, they hold themselves erect on their forelegs, and the hind legs are tucked underneath. We frequently see dogs and cats in this posture. While it is easy to draw animals sleeping, the stable pose we see dogs them in everyday is "sitting." The dog below looks as if he were commanded to sit. Examine and compare the various forms below and make sure you are familiar with any points you should know.

Dog

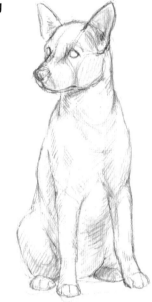 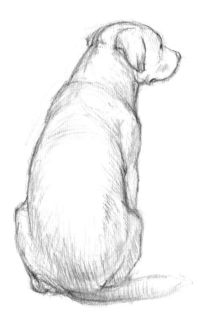 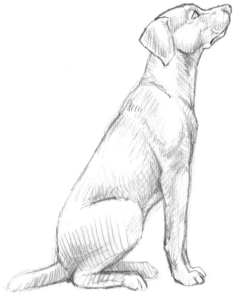

Front
The forelegs are spread apart about the same width as the trunk. The hind legs jut out to the right and left slightly wider than the forelegs.

Rear
The shoulders bulge and appear sturdy. The rump appears slightly wider than the trunk.

Profile
The back does not arch as much as a cat's.

Cat

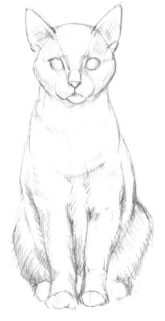 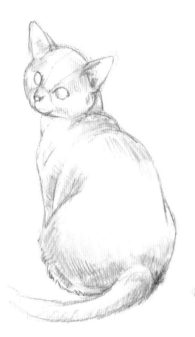 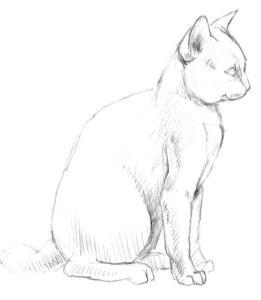

Front
The forelegs are held together, and both hind legs stick out to the cat's sides.

Rear
About midway down the back, the cat's back widens all the way down to the rump. Consequently, the cat's shoulders seem extraordinarily narrow to us, humans.

Profile
This shows a classic "cat back" look.

Chapter 3

All Types of Cat and Dog Expressions

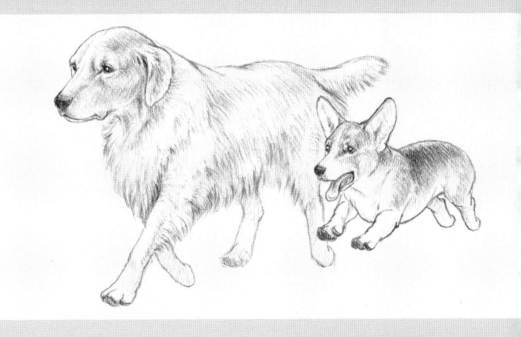

Twelve Faces of a Welsh Corgi

Dogs tend to have very expressive faces compared to other animals. In this section, I present dogs' facial expressions and have exaggerated their appearances.

- ## • Distinguishing Characteristics of a Corgi

 Welsh Corgis have large, erect ears and foxy faces.

- ## • Basic Facial Expressions

 The figures all show a male Corgi. Use strong, angular lines when reproducing these sketches.

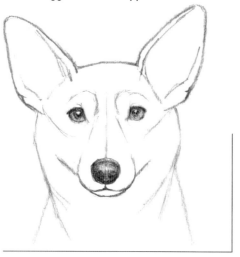

Cute face:
Showing the whites of the eyes makes the dog look endearing.

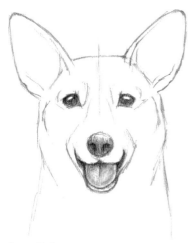

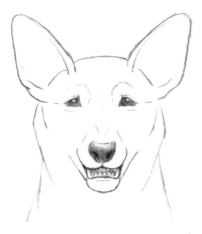

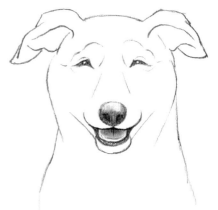

Energetic face:
Lower the eyes' outer corners and give the lower eyelids a bowlike shape to make the dog look like he is smiling. Show the mouth open and have the corners of the mouth curl upward to make the dog appear even more cheerful.

Pretend smile:
While such instances are rare, there are dogs that will grin and expose their teeth when meeting a human for the first time. Since these dogs show no hostilities in their eyes, it seems that the dogs are simply trying to smile.

Friendly face:
When dogs see their masters or close friends (including dog friends), they lay back their ears, slightly open their mouths, and assume gentle-looking eyes.

Tip

When drawing a female dog's face, use rounded, soft contours and make the eyes on the large side.

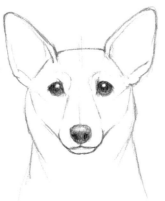

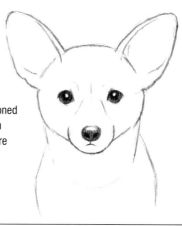

Puppies' eyes are positioned lower on their faces than adult dogs. Give the entire figure roundish forms to create an endearing expression.

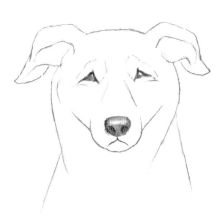

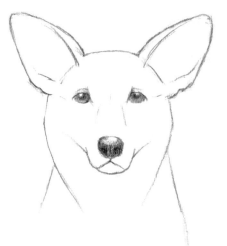

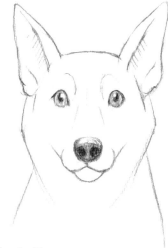

Sorry face:
This face suggests a distressed, worried dog. This is the face dogs tend to make when their masters scold them.

Depressed face:
Dogs certainly cannot make faces that are as depressed as humans can. However, you can achieve a "depressed" dog face if you extend a dog's ears out somewhat to the right and left, lower the outer corners of his upper eyelids and of his eyes, and make both corners of this mouth droop.

Surprised face:
To make a dog appear shocked, draw the pupils centered within the irises. Note that you should also flare the nose's nostrils, and puff out the dog's jowls on both sides.

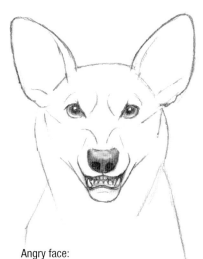

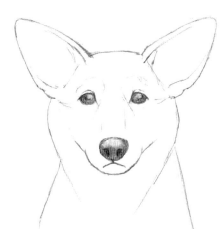

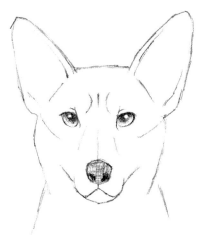

Angry face:
Show the ears held erect (when dogs attack, their ears lie back), the nostrils flared, wrinkles in the nose, the upper lip curled, and the teeth exposed for the enemy to see. Adding reinforced contours to the eyes' inner corners is also effective.

Sad face:
Show the ears extended out slightly to the right and left, and apply subdued highlights to the eyes. This will give the dog a profoundly dejected or perplexed expression. Lower the eyes' outer corners and make the mouth small.

Suspicious face:
Raise the eyes' outer corners, lighten the eyes' lower regions, and show white around three-quarters of the pupil to make a dog look suspicious. Add furrows at the brows and a firmly clenched mouth to suggest feelings of strong suspicion.

Tip
Enlarging the eyes and making the nose and mouth small is a common technique used to make an animal look endearing. In the case of animals with small eyes and large noses and mouths like the Golden Retriever, making the eyes squint and raising the corners of the mouth will give the dog a cheerful, loveable expression.

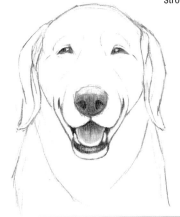

Canines and Facial Expressions

Experiment with drawing dogs and other canines in a variety of different poses. If you use mock-up sketches to capture the animal's movement, the animal's face will also come to life.

1. Various Dog Breeds and Fun Antics

Fox Terriers have fluffy fur, which tends to conceal their key body parts. Use mock-up sketches to capture the figure's basic forms.

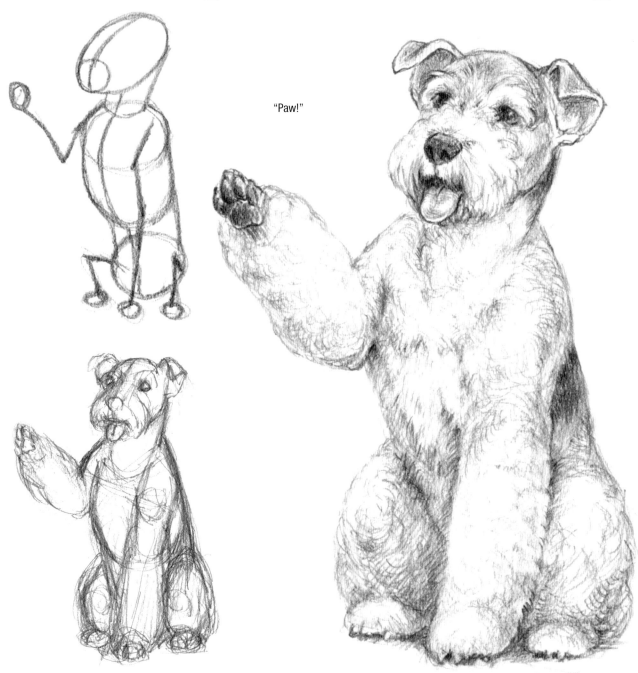

"Paw!"

Showing the right shoulder raised and the neck leaning slightly rearward creates the impression that the terrier is doing his best to raise his right forepaw.

Wire-haired Fox Terrier

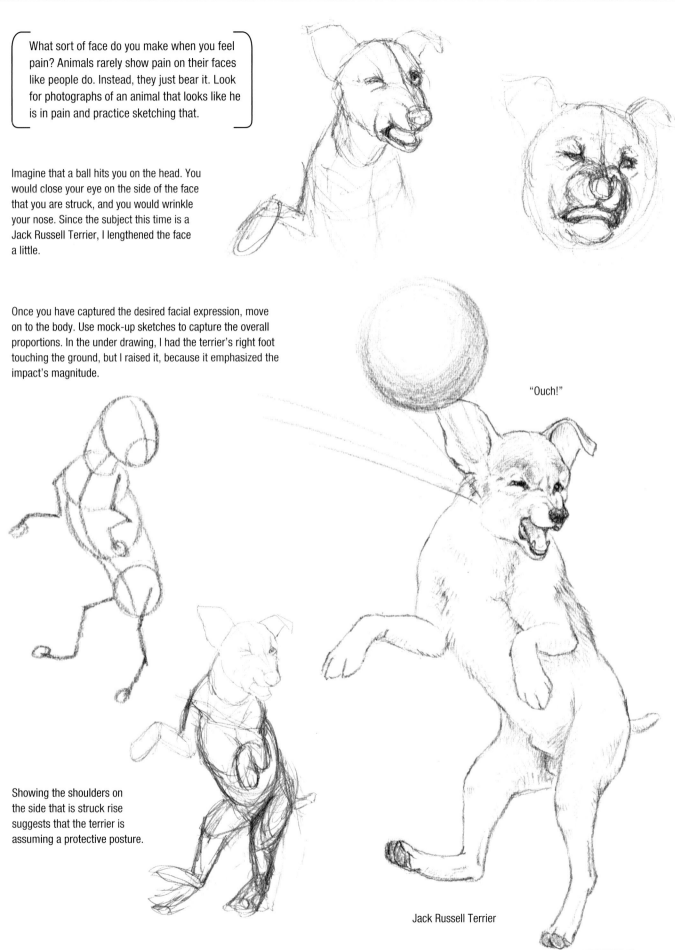

What sort of face do you make when you feel pain? Animals rarely show pain on their faces like people do. Instead, they just bear it. Look for photographs of an animal that looks like he is in pain and practice sketching that.

Imagine that a ball hits you on the head. You would close your eye on the side of the face that you are struck, and you would wrinkle your nose. Since the subject this time is a Jack Russell Terrier, I lengthened the face a little.

Once you have captured the desired facial expression, move on to the body. Use mock-up sketches to capture the overall proportions. In the under drawing, I had the terrier's right foot touching the ground, but I raised it, because it emphasized the impact's magnitude.

"Ouch!"

Showing the shoulders on the side that is struck rise suggests that the terrier is assuming a protective posture.

Jack Russell Terrier

Puppies have proportionally larger heads than adult dogs. In order to create a sense of depth, draw the rump, which lies closer to the picture plane, slightly larger

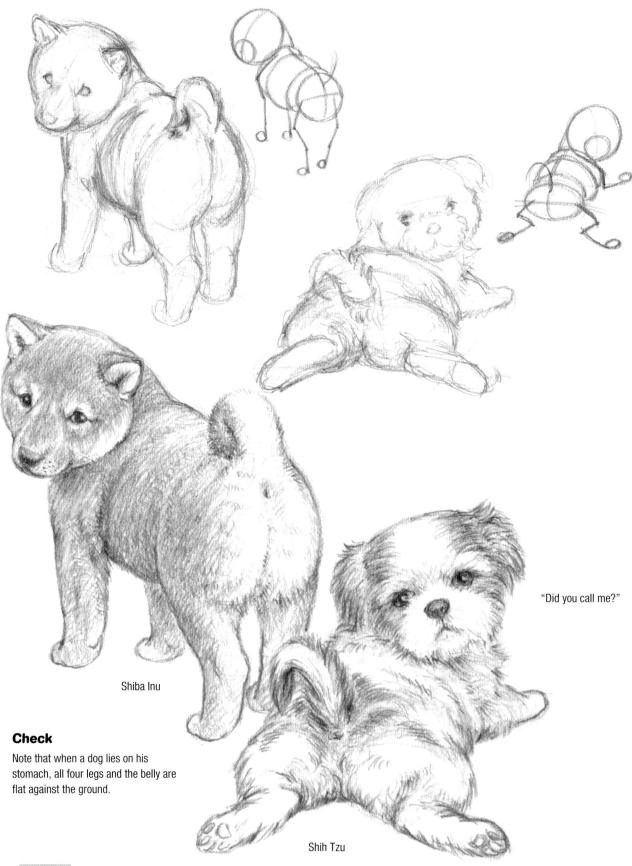

Shiba Inu

"Did you call me?"

Check

Note that when a dog lies on his stomach, all four legs and the belly are flat against the ground.

Shih Tzu

Make an effort to portray fur texture and coloring.

"Make us look cute, ok?"

Papillion

Yorkshire Terrier

Miniature Schnauzer

Check

Use areas of shadow to suggest fur texture when drawing a dog with white fur.

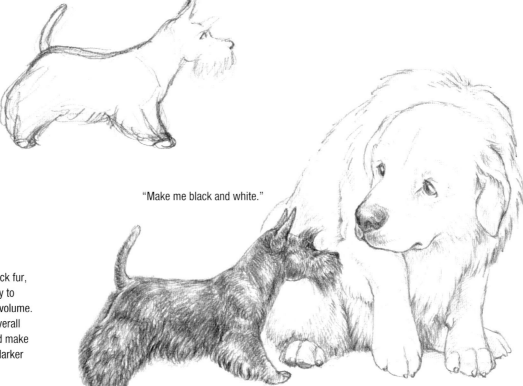

"Make me black and white."

Check

For a dog with black fur, use shades of grey to create a sense of volume. Think about the overall visual balance and make areas of shadow darker than the rest.

Scottish Terrier

Great Pyrenees

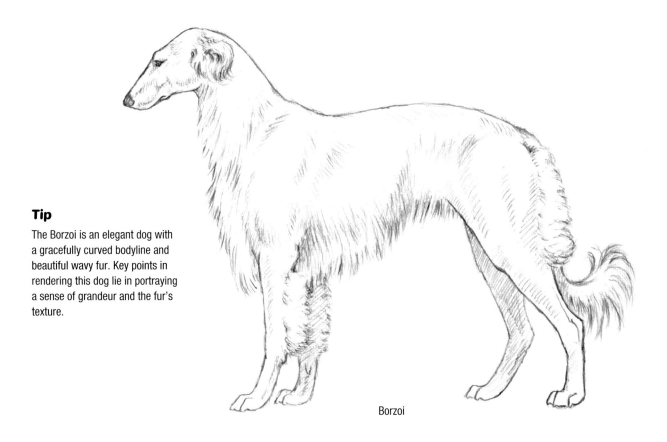

Tip

The Borzoi is an elegant dog with a gracefully curved bodyline and beautiful wavy fur. Key points in rendering this dog lie in portraying a sense of grandeur and the fur's texture.

Borzoi

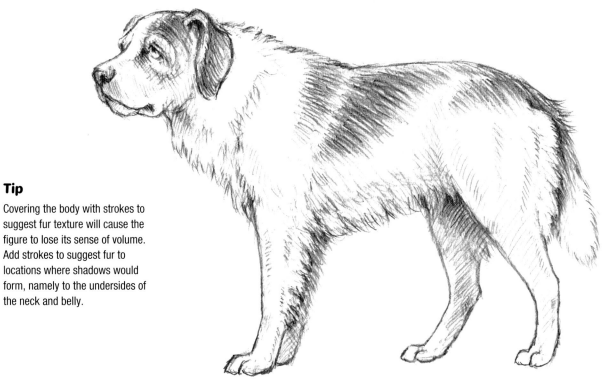

Tip

Covering the body with strokes to suggest fur texture will cause the figure to lose its sense of volume. Add strokes to suggest fur to locations where shadows would form, namely to the undersides of the neck and belly.

Saint Bernard

Try to suggest a dog with a quick gait (Golden Retriever) and a dog with a slow gait (Welsh Corgi).

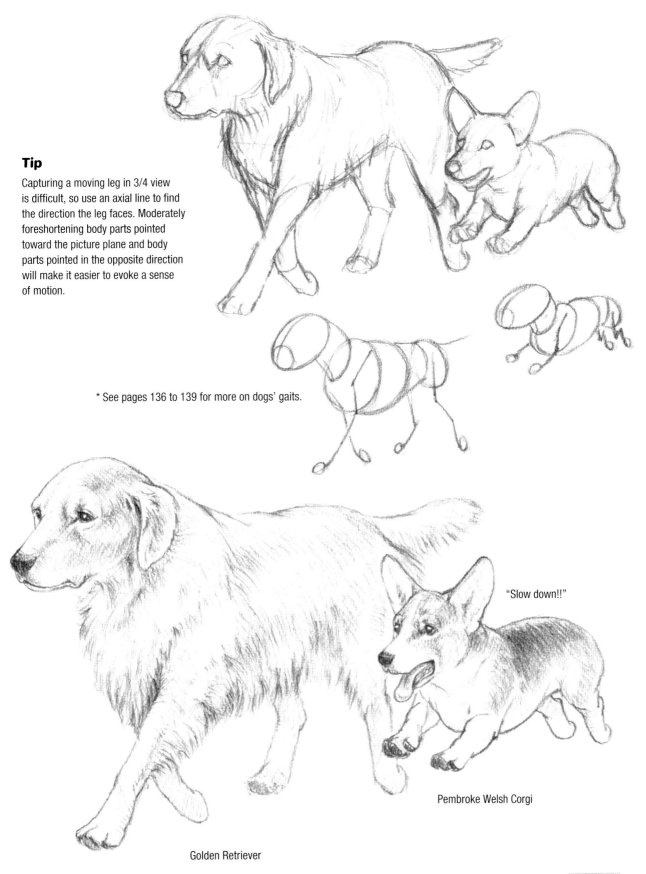

Tip

Capturing a moving leg in 3/4 view is difficult, so use an axial line to find the direction the leg faces. Moderately foreshortening body parts pointed toward the picture plane and body parts pointed in the opposite direction will make it easier to evoke a sense of motion.

* See pages 136 to 139 for more on dogs' gaits.

"Slow down!!"

Pembroke Welsh Corgi

Golden Retriever

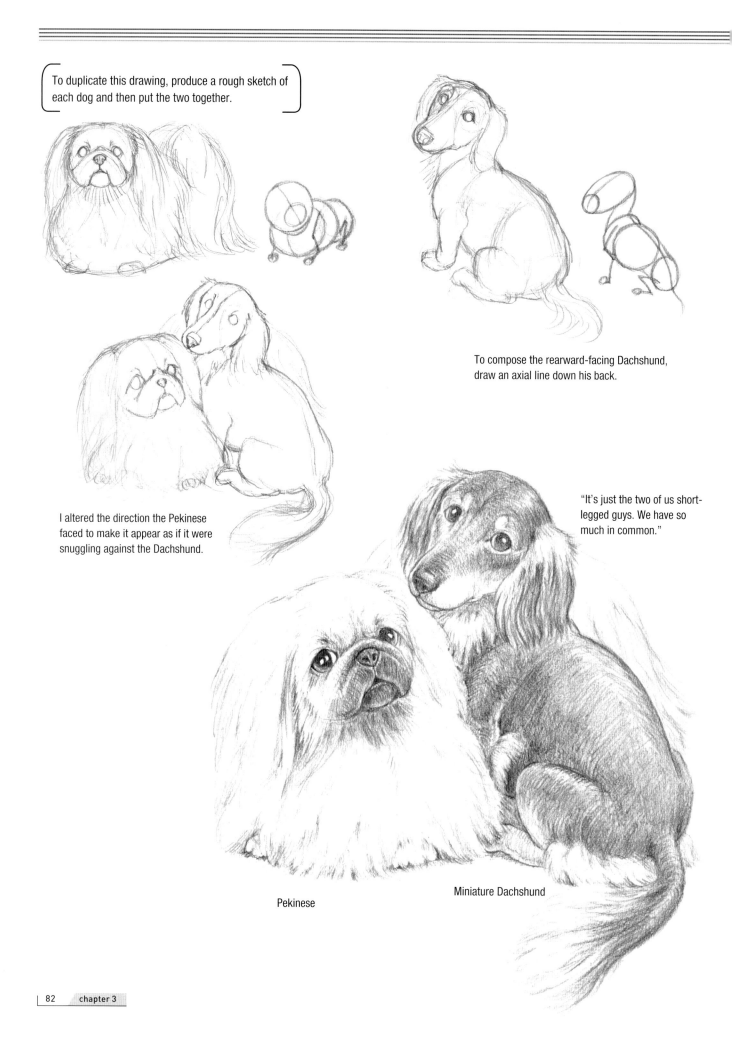

To duplicate this drawing, produce a rough sketch of each dog and then put the two together.

To compose the rearward-facing Dachshund, draw an axial line down his back.

I altered the direction the Pekinese faced to make it appear as if it were snuggling against the Dachshund.

"It's just the two of us short-legged guys. We have so much in common."

Pekinese

Miniature Dachshund

2. Expressing Emotion with the Entire Body

Show an animal running about to portray joyful playfulness.

Tip

Play around with the positions of the fore and hind legs, and use a little ingenuity to project the appearance of speed.

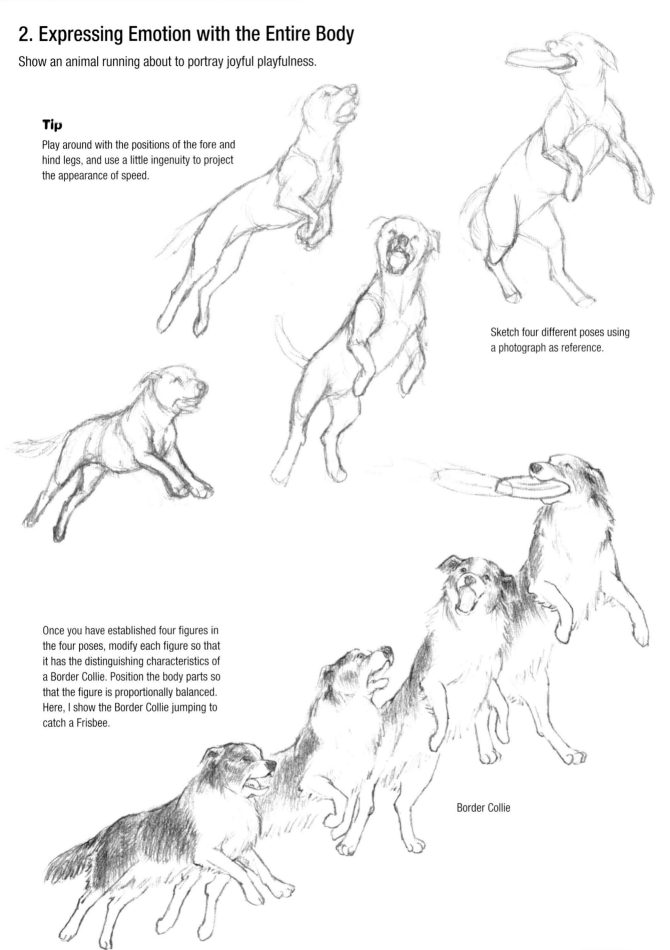

Sketch four different poses using a photograph as reference.

Once you have established four figures in the four poses, modify each figure so that it has the distinguishing characteristics of a Border Collie. Position the body parts so that the figure is proportionally balanced. Here, I show the Border Collie jumping to catch a Frisbee.

Border Collie

Similar But Different Breeds

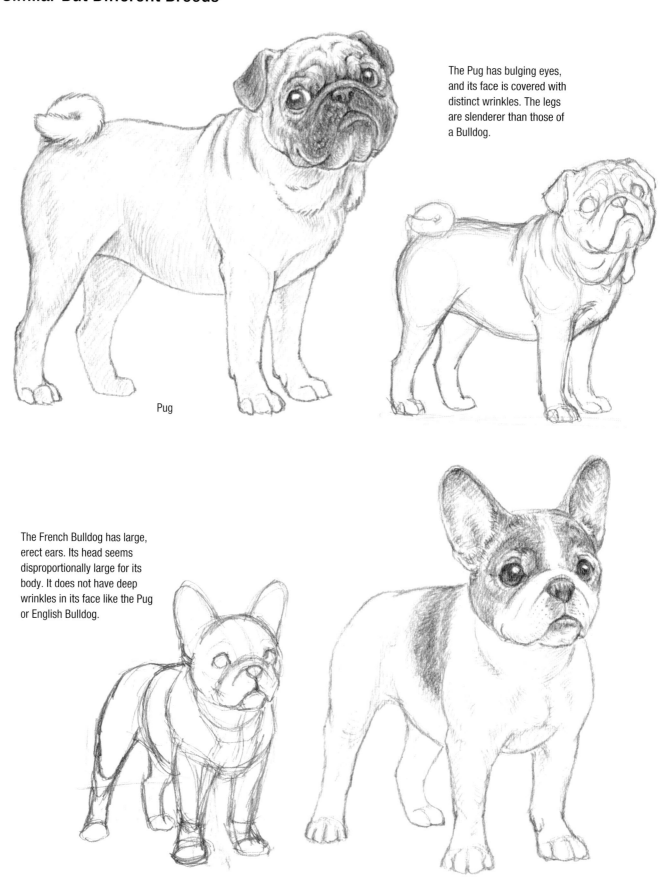

The Pug has bulging eyes, and its face is covered with distinct wrinkles. The legs are slenderer than those of a Bulldog.

Pug

The French Bulldog has large, erect ears. Its head seems disproportionally large for its body. It does not have deep wrinkles in its face like the Pug or English Bulldog.

French Bulldog

The Boxer's muzzle has somewhat of a longer snout than the other three breeds pictured. The Boxer has a muscular build and long legs. It used to be customary to crop the Boxer's ears. However, now, in consideration of the humane treatment of animals, the Boxer's ears are typically left in their natural state.

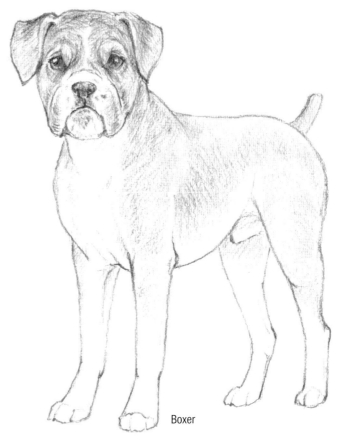

Boxer

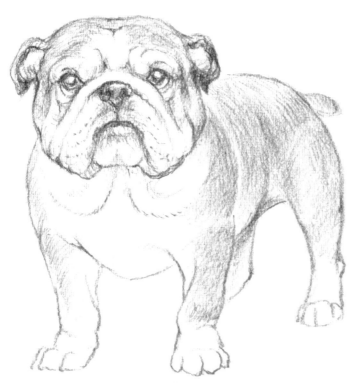

English Bulldog

The English Bulldog has a large head and strong, stocky build. It has short, bowed legs. Its ears are small. Its eyes do not bulge like those of the Pug or French Bulldog.

3. Dogs and Other Canines

This section compares the distinguishing features of faces and bodies
of dogs and other canines.

Dog (German Shepherd)

While eye shape does depend on the breed, in general dogs have eyes that appear rounder
than wolves, and the outer corners of dogs' eyes tend to drop.

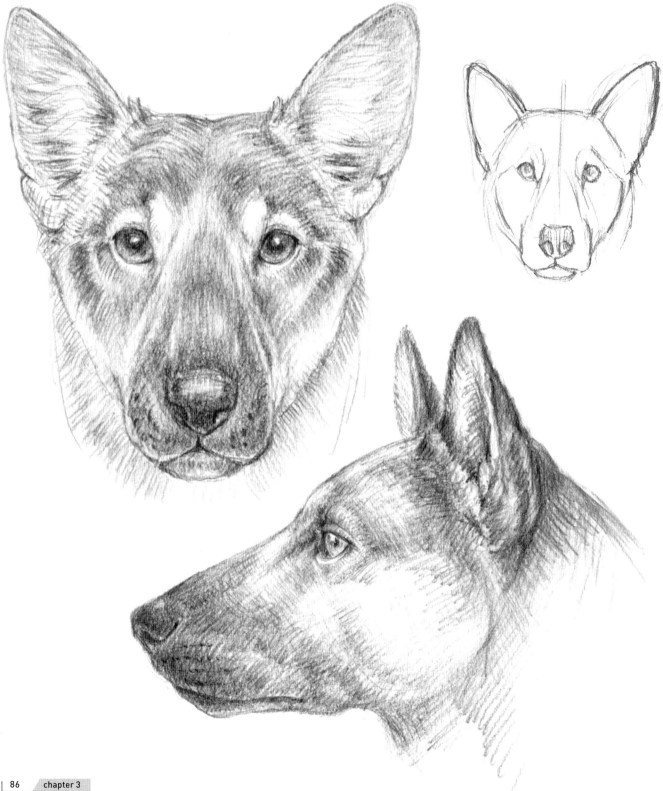

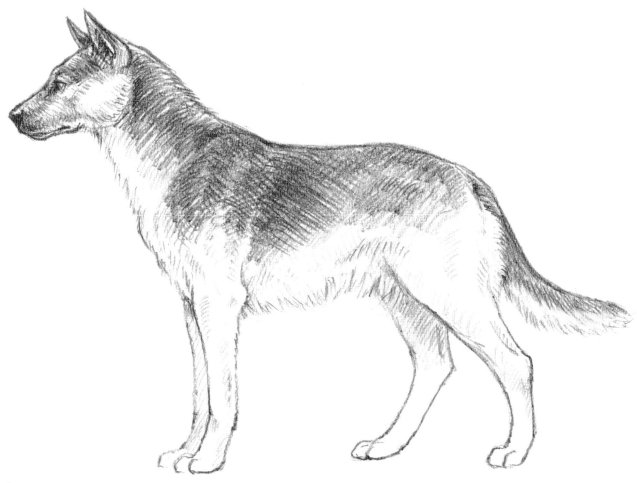

Note

Using the head's length as a unit of measurement, let's take a look at body proportions. The distance from the back of the head to the rump is typically three head-lengths for dogs and other canines and two head-lengths from the withers to the knee.

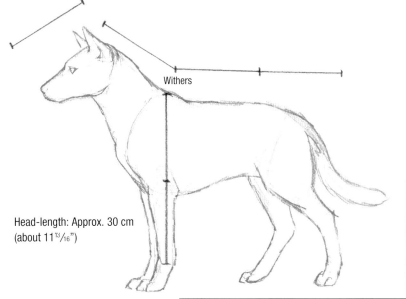

Withers

Head-length: Approx. 30 cm (about $11^{13}/_{16}$")

Wolf

The stop (depression on the snout marking where the forehead ends and the snout begins) on the wolf's face is shallower than that on a dog, giving the wolf a more powerful-looking snout.

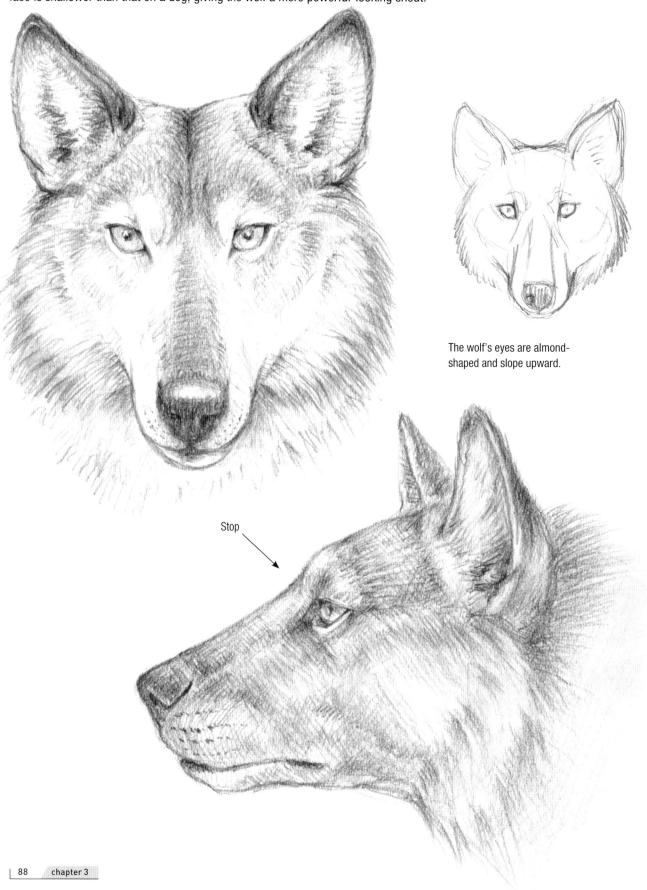

The wolf's eyes are almond-shaped and slope upward.

Stop

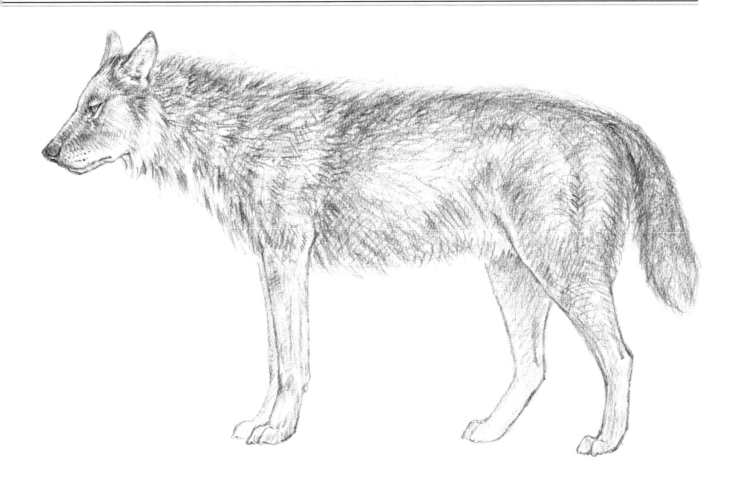

Note

The wolf has long legs and a muscular body.

Head-length: Approx. 30 to 40 cm (about $11^{13}/_{16}$" to $15^{11}/_{16}$")

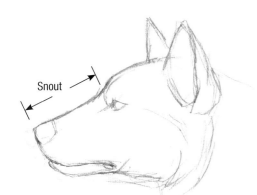

Snout

Jackal

The jackal has large ears and a slender snout. The eyes slant upward.

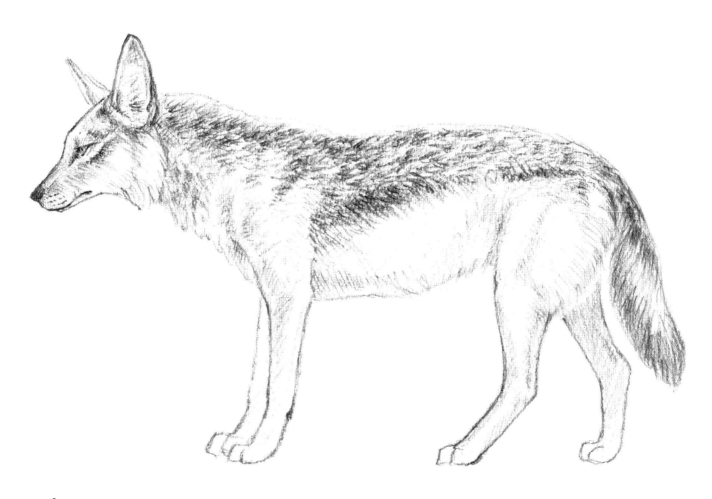

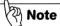 **Note**

The jackal's build is similar to that of a fox, but the tail is shorter.

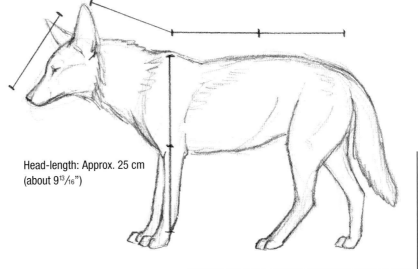

Head-length: Approx. 25 cm
(about $9^{13}/_{16}$")

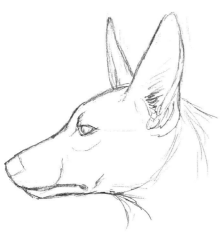

Coyote

The coyote looks similar to the wolf, but the coyote has larger ears and
a slenderer snout.

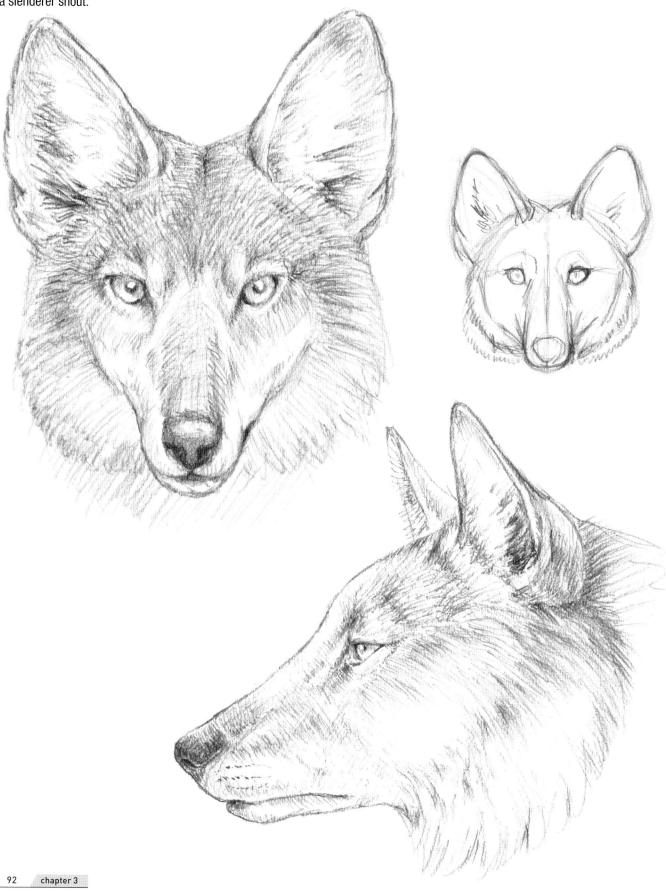

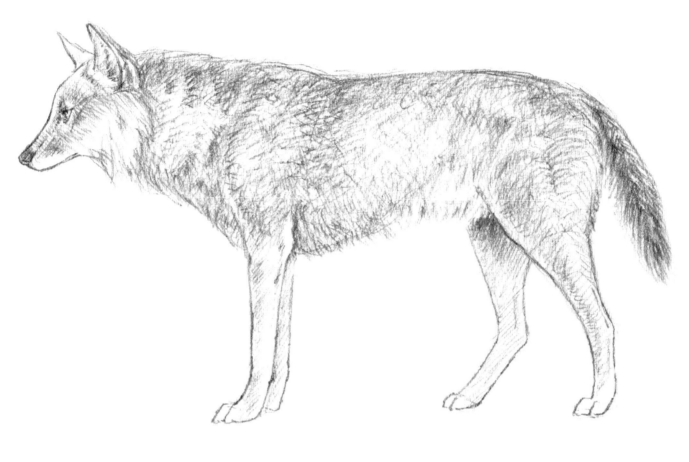

☝ Note

The coyote has a smaller body than does the wolf, and its legs are narrower, giving the coyote a slender appearance.

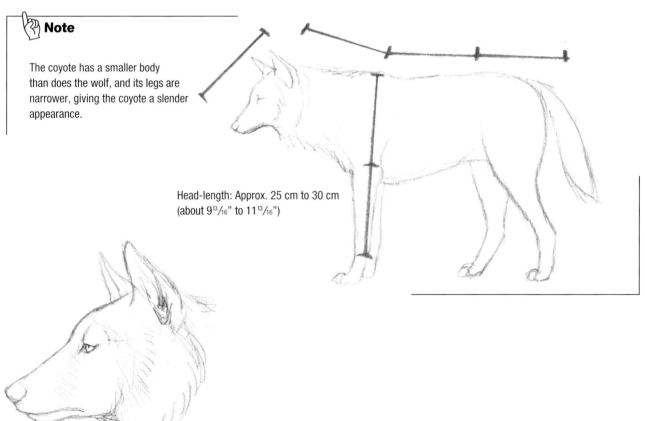

Head-length: Approx. 25 cm to 30 cm (about $9^{13}/_{16}$" to $11^{13}/_{16}$")

Felines and Facial Expressions

Housecats, lions, tigers, and all other felines have similar builds. If you are able to draw a common housecat, then you can apply your knowledge to the big cats as well. Cats have large differences in their faces, so pay close attention when you draw.

1. Cute Cat Antics

In this section, we will use skeletal structure mock-ups and musculature mock-ups to practice drawing cat rising up on their hind legs, sitting, and in other poses.

The body parts of long-haired animals can be difficult to distinguish, owing to the long hair covering their bodies. Make an effort to familiarize yourself with the flow of the entire figure from head to tail.

"Look what I found!"
Somalian kitten (Long-haired)

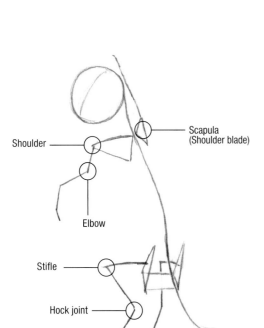

Shoulder

Scapula
(Shoulder blade)

Elbow

Stifle

Hock joint

Figure out how the forelegs move from the shoulder blades, shoulders, and elbows and how the hind legs move from the stifles (knees) and hocks.

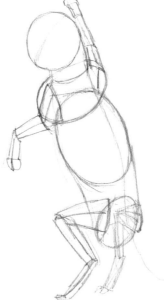

Flesh out the figure to create a musculature mock-up.

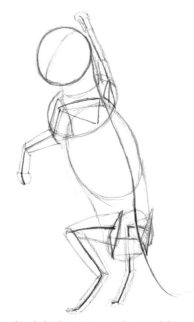

Lay the skeletal structure mock-up and the musculature mock-up one over the other. This allows you easily to check where the key body parts are located, which makes it easier to capture the cat's movements.

Curled up Like a Box

Cats have a distinctive way of sitting, where they curl up like a box. Again, it is vital that you capture the positions of the shoulders, elbows, stifle joints, hock joints, and spine when drawing.

Rough sketch stage

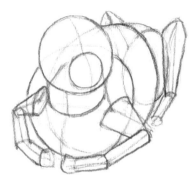

This shows a musculature mock-up. When drawing, sketch the forms of those areas that will be hidden in the final piece.

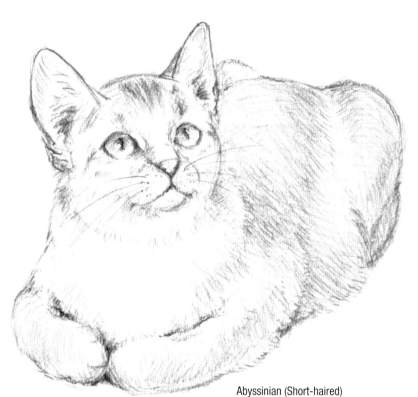

Abyssinian (Short-haired)

Skeletal structure mock-up

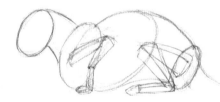

Musculature mock-up

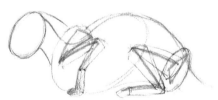

Figure showing the skeletal structure mock-up and the musculature mock-up overlapping

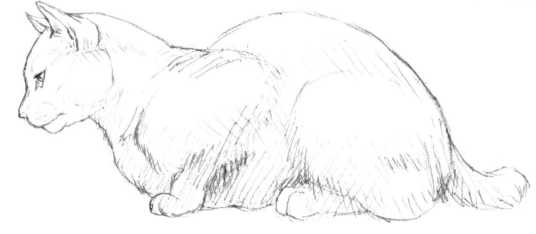

A hamster and a housecat (short-haired)

2. Cats and Other Felines

Compared to the big cat members of the Feline family, the housecat's face is rounder, and its eyes and nose lie closer together.

Housecat

Cats have short snouts and long eyes and ears.

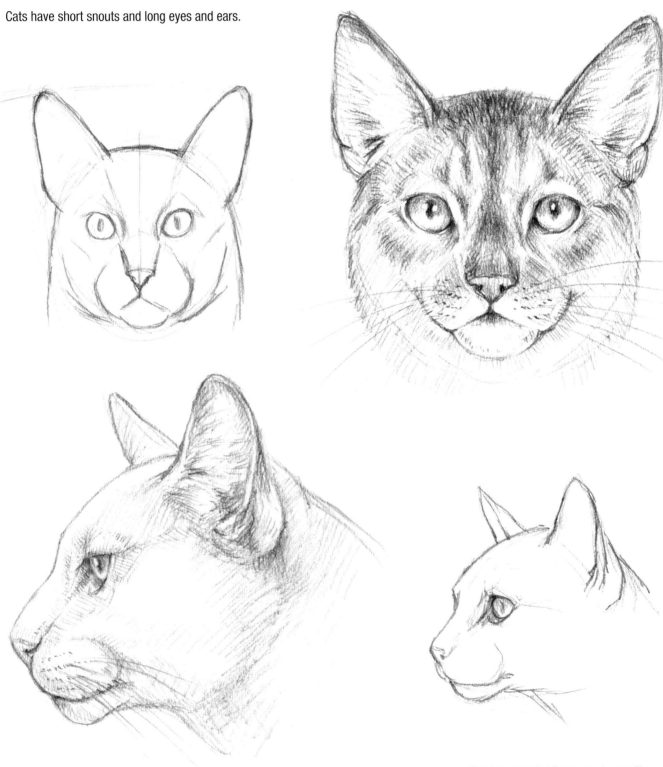

Cats have rounded faces even in a profile view. They have pointy ears and small mouths and noses.

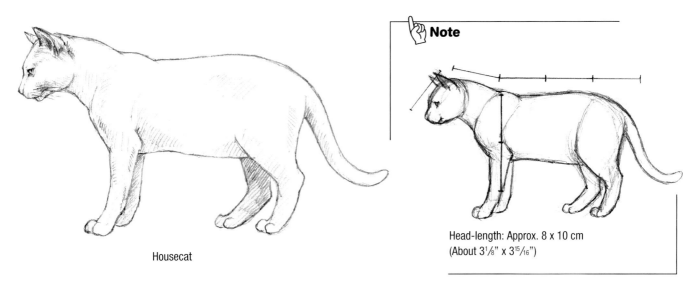

Housecat

☞ **Note**

Head-length: Approx. 8 x 10 cm
(About 3$\frac{1}{8}$" x 3$\frac{15}{16}$")

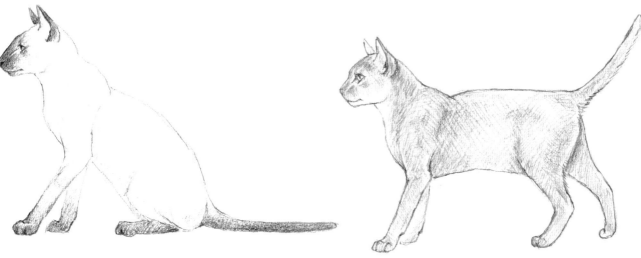

Siamese (Short-haired)
Siamese cats have dark faces, paws, and tails, while the remainder of their bodies is light in tone. Their faces are also somewhat long.

Abyssinian (Short-haired)
Be sure to express the Abyssinian's active, nimble nature when you draw it.

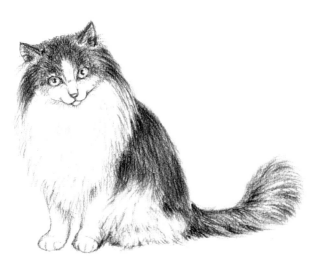

Norwegian Forest Cat (Long-haired)
The Norwegian Forest Cat has a relatively long face.

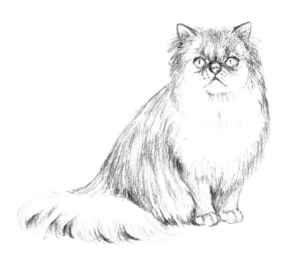

Persian (Long-haired)
Many Persians have squat noses. The eyes are far apart.

Tigers

The tiger has a round face and small ears. The tiger's nose is angular on both sides, and the upper lip puffs out to the right and left. The cheeks are also rounded and puff out. The eyes are proportionally small compared to the large head.

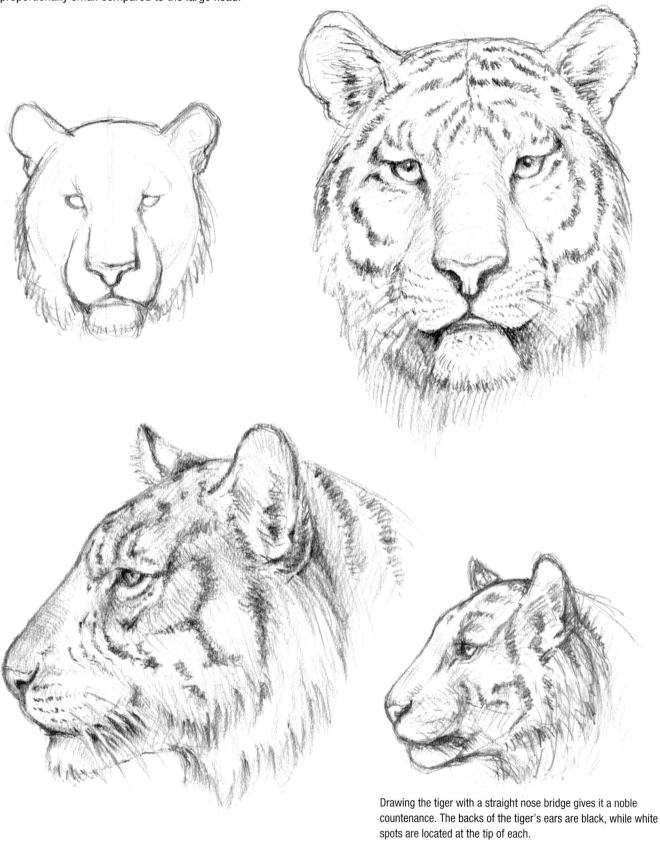

Drawing the tiger with a straight nose bridge gives it a noble countenance. The backs of the tiger's ears are black, while white spots are located at the tip of each.

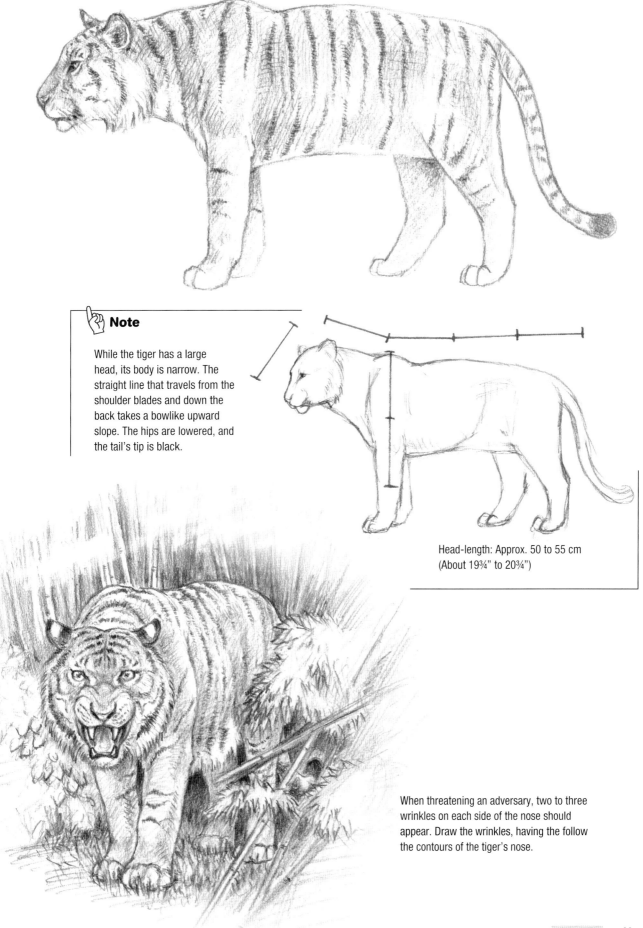

Note

While the tiger has a large head, its body is narrow. The straight line that travels from the shoulder blades and down the back takes a bowlike upward slope. The hips are lowered, and the tail's tip is black.

Head-length: Approx. 50 to 55 cm (About 19¾" to 20¾")

When threatening an adversary, two to three wrinkles on each side of the nose should appear. Draw the wrinkles, having the follow the contours of the tiger's nose.

Lion

The lion has hollow cheeks, causing the head to look like an isosceles triangle when viewed from the front. The lion has proportionally large ears compared to the face. The nose flares slightly to the right and left. The upper lip should be flat.

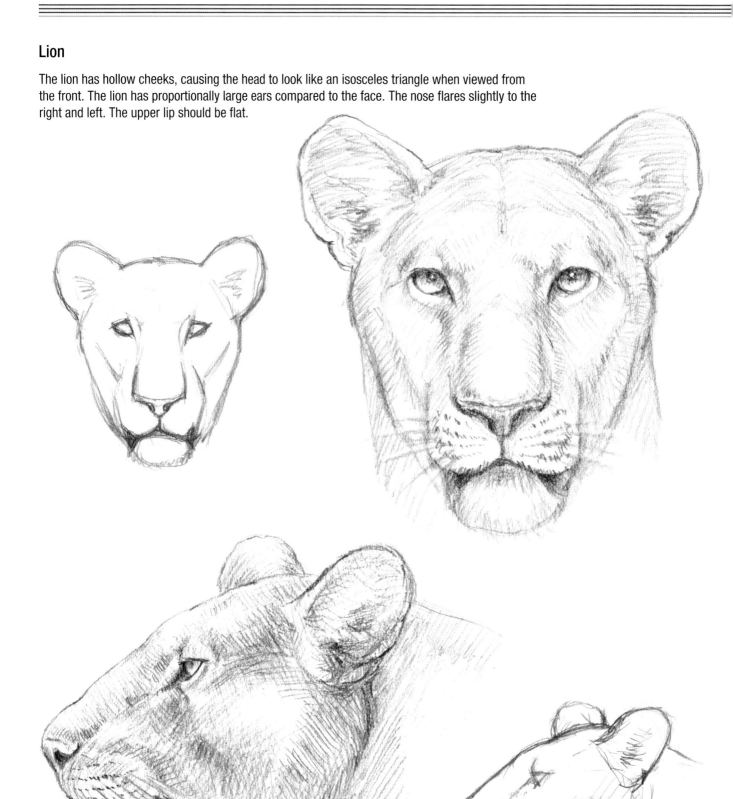

The snout is large and muscular. Show the black lower lip hangs limply from the mouth. Adding whiskers to the snout makes the lion appear more convincing.

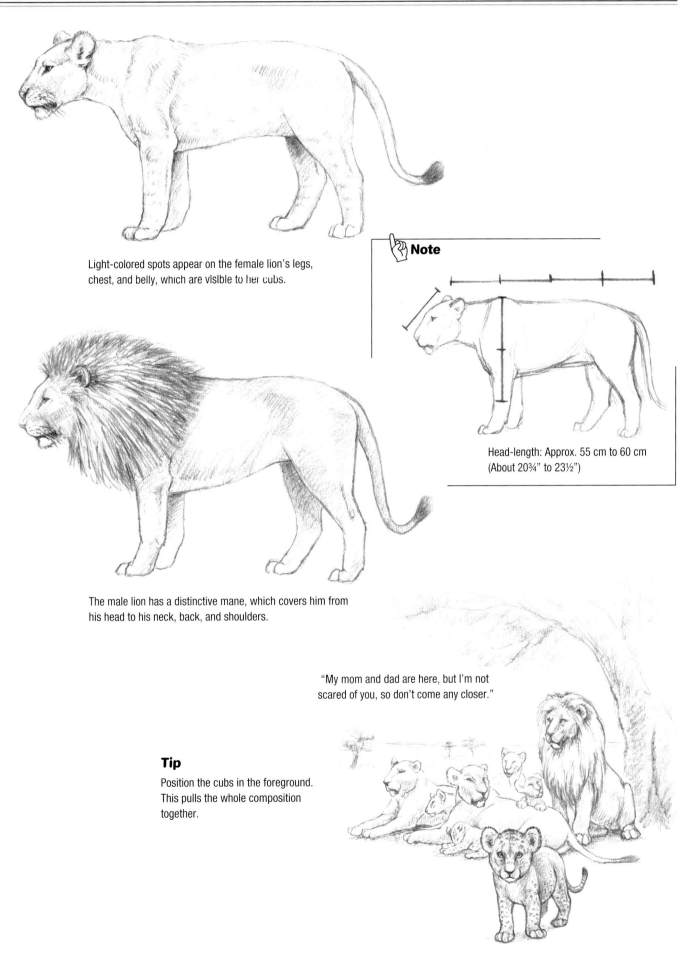

Light-colored spots appear on the female lion's legs, chest, and belly, which are visible to her cubs.

👆 **Note**

Head-length: Approx. 55 cm to 60 cm
(About 20¾" to 23½")

The male lion has a distinctive mane, which covers him from his head to his neck, back, and shoulders.

"My mom and dad are here, but I'm not scared of you, so don't come any closer."

Tip

Position the cubs in the foreground. This pulls the whole composition together.

Cheetah

The cheetah's head looks almost like an inverted triangle. Despite being a "big cat," the cheetah has a comparatively smallish snout.

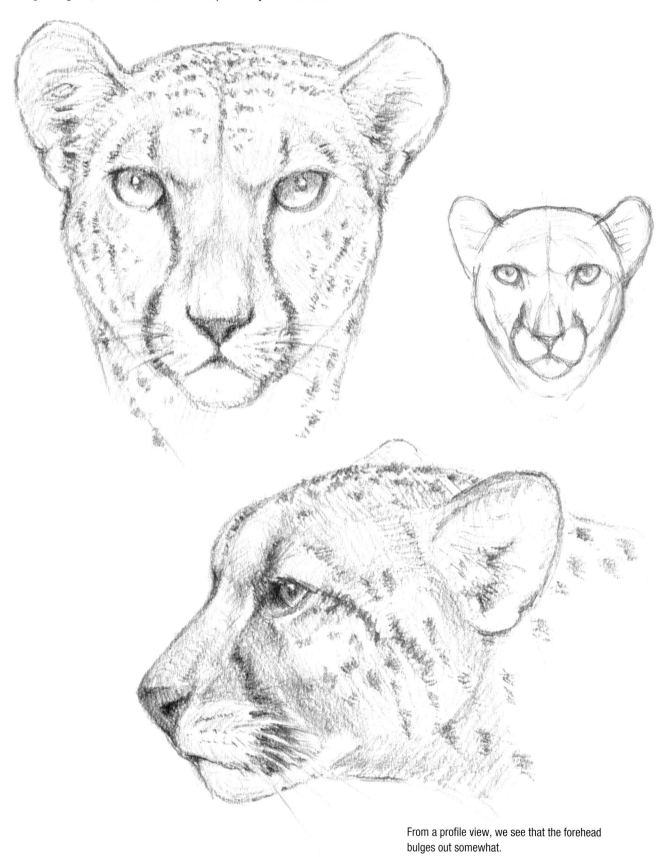

From a profile view, we see that the forehead bulges out somewhat.

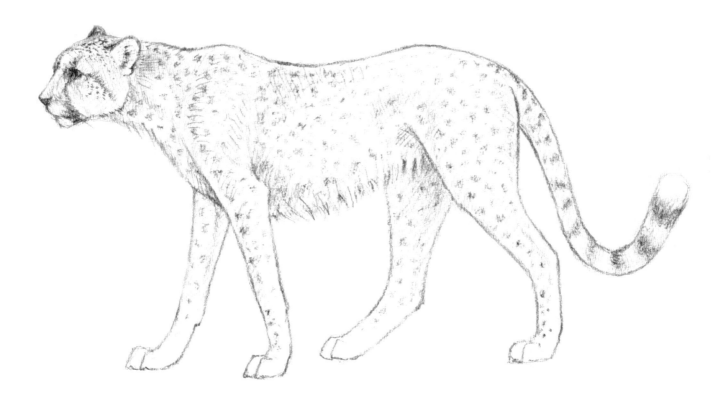

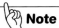 **Note**

The cheetah has a small head
and long forelegs and hind legs.
The chest is deep, while the
belly is waspish. The long tail is
white at the tip.

Head-length: Approx. 35 cm
(About $13^{13}/_{16}$")

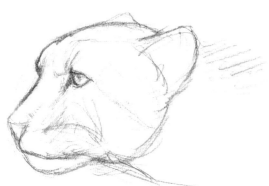

Cheetah Pursuing a Warthog

Draw a warthog fleeing for its life and a cheetah in hot pursuit.

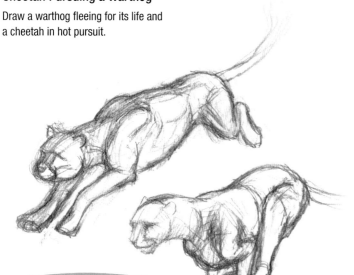

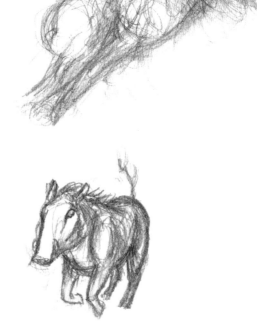

step 1

Use a photograph or other image as reference to produce multiple rough sketches of a cheetah running at top speed.

step 2

Sketch a warthog using a photograph as reference.

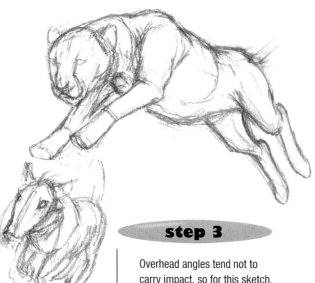

step 3

Overhead angles tend not to carry impact, so for this sketch, I shifted the composition's angle of perspective down slightly. However, I have not really achieved my desired effects: the sketch does not have the sense of a warthog running for its life and a cheetah in pursuit.

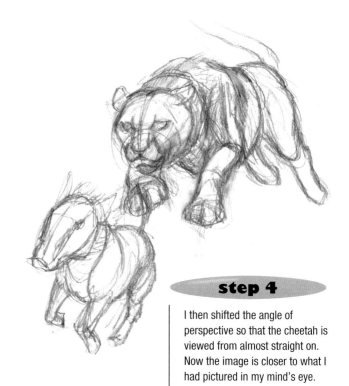

step 4

I then shifted the angle of perspective so that the cheetah is viewed from almost straight on. Now the image is closer to what I had pictured in my mind's eye.

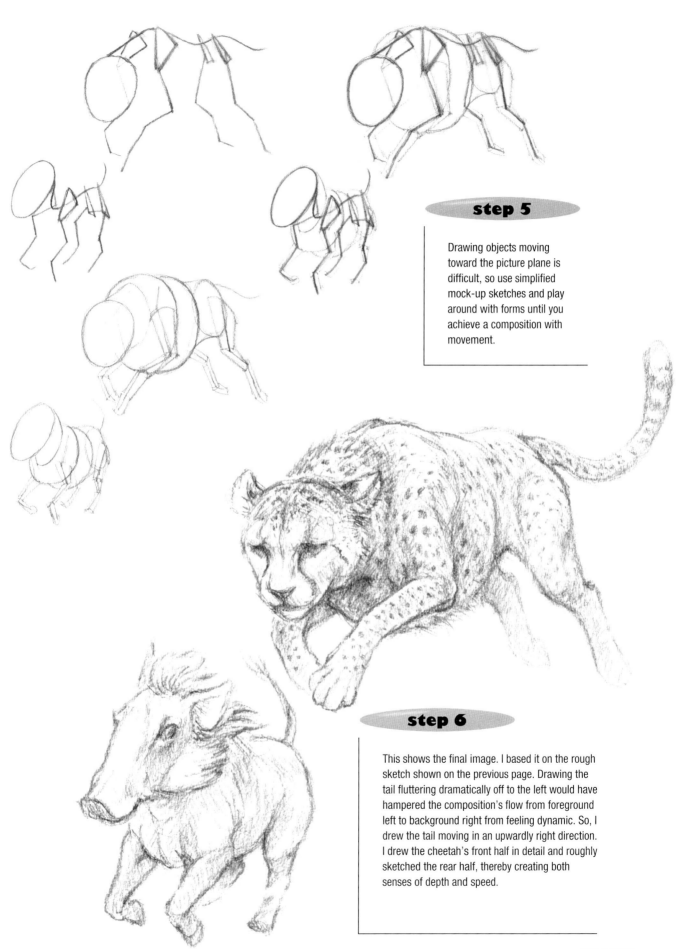

step 5

Drawing objects moving toward the picture plane is difficult, so use simplified mock-up sketches and play around with forms until you achieve a composition with movement.

step 6

This shows the final image. I based it on the rough sketch shown on the previous page. Drawing the tail fluttering dramatically off to the left would have hampered the composition's flow from foreground left to background right from feeling dynamic. So, I drew the tail moving in an upwardly right direction. I drew the cheetah's front half in detail and roughly sketched the rear half, thereby creating both senses of depth and speed.

Cougar

While the cougar (aka "puma" and "mountain lion") is considered a "big cat,"
it has a relatively short snout, and large eyes and ears.

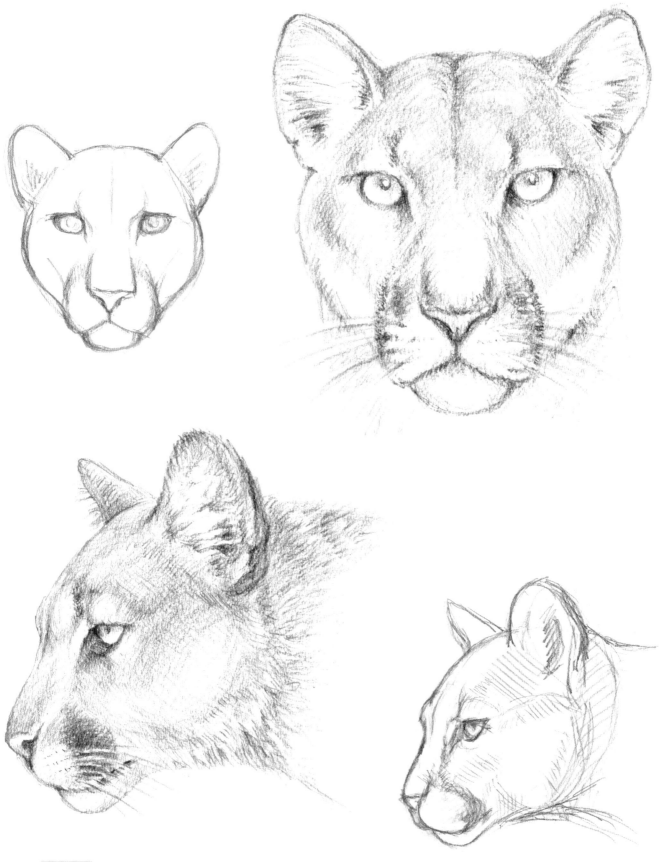

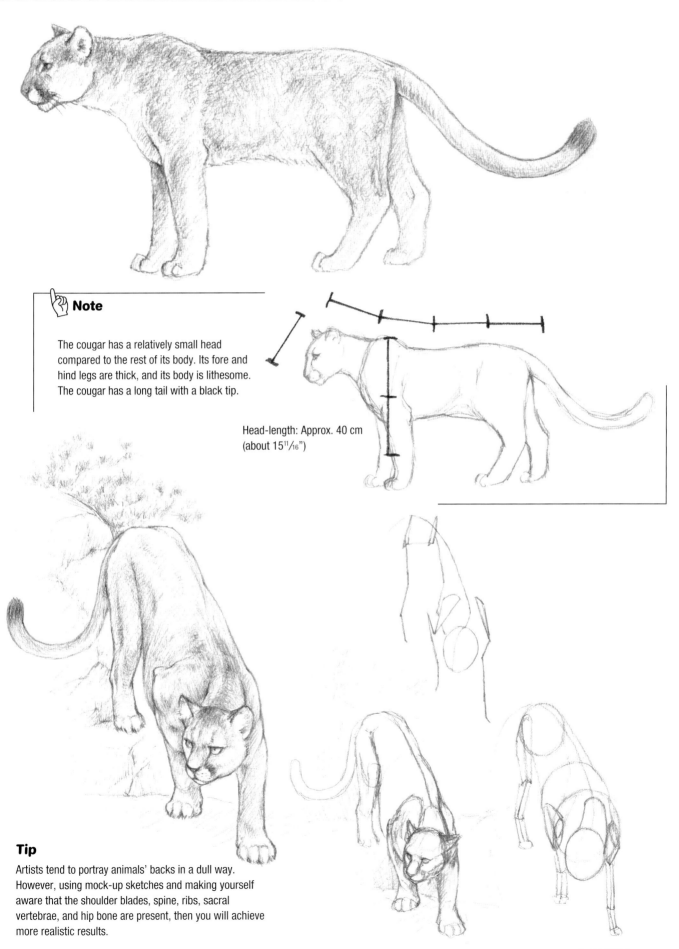

Note

The cougar has a relatively small head compared to the rest of its body. Its fore and hind legs are thick, and its body is lithesome. The cougar has a long tail with a black tip.

Head-length: Approx. 40 cm
(about 15$^{11}/_{16}$")

Tip

Artists tend to portray animals' backs in a dull way. However, using mock-up sketches and making yourself aware that the shoulder blades, spine, ribs, sacral vertebrae, and hip bone are present, then you will achieve more realistic results.

Leopard

The leopard has a round head, and its cheeks are moderately taut.has a relatively short snout, and large eyes and ears.

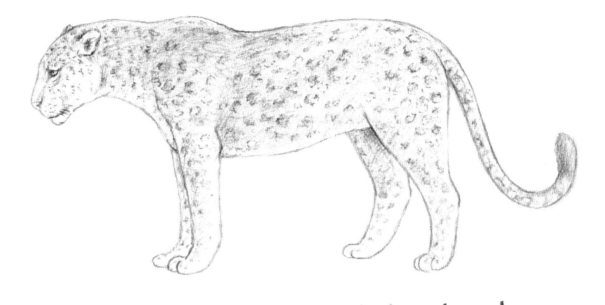

Note

The leopard has an overall rounded, nimble body and a long tail with a black tip. The leopard sports distinctive plumb-shaped and square spots. Black panthers are leopards with black fur, but close observation reveals that they do have spots.

Head-length: Approx. 35 cm to 40 cm (About $13^{13}/_{16}$" to $15^{11}/_{16}$")

This leopard is using all its strength to drag its prey up a tree. Draw bulging muscles to portray the leopard's strength.

Leopard Carrying Prey up a Tree

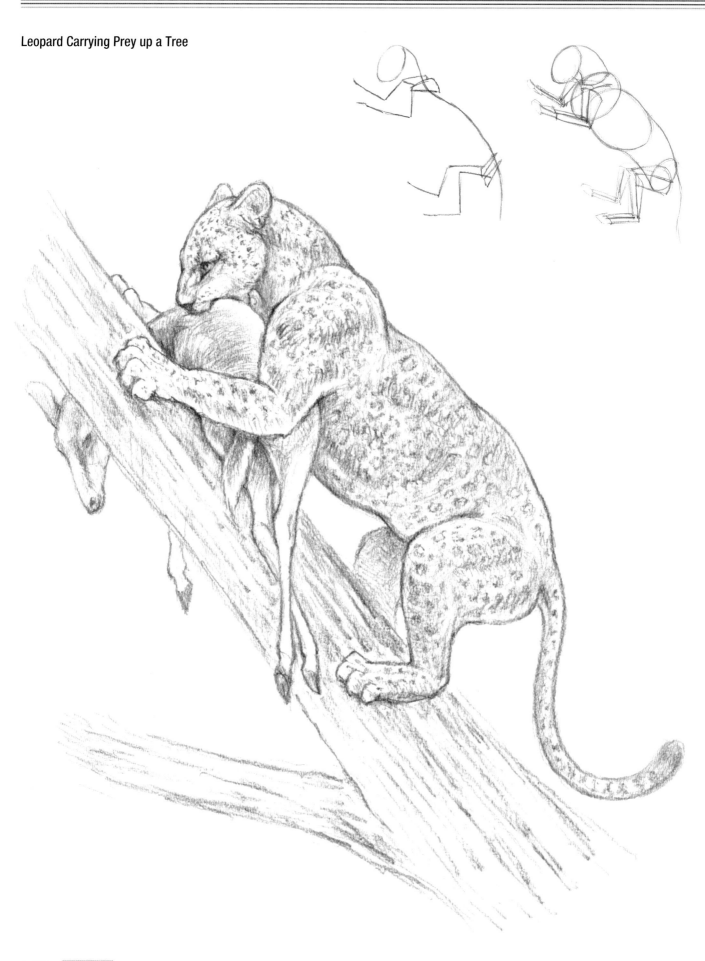

Chapter 4
Assorted Animals

Fun Tidbits about Drawing Animals' Bodies and Capturing Distinguishing Traits

Animals may be roughly divided into herbivores, which eat plants, and carnivores, which hunt and eat other animals. Their bodies reflect differences in their diets and living conditions.

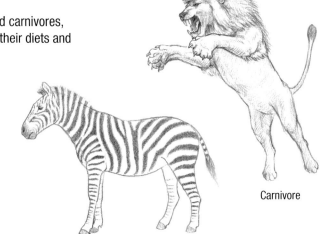

Carnivore

Contrasting Herbivores and Carnivores

Herbivores consume plants, which are difficult to digest, in large volume, so they rely on microscopic organisms to help them digest and absorb nutrients. Herbivores have an extremely long digestive tract and swollen bellies. Carnivores rely on flesh, which is easy to digest and absorb, as their energy source. Consequently, they have short digestive tracts and narrow bellies. Differences are evident in their spines as well. Herbivores' backs are virtually straight from the thoracic vertebrae to the sacral vertebrae, while carnivores' backs display slight arcs, which makes them lither than herbivores. Differences in diets become evident upon looking at herbivore and carnivore skulls.

Herbivore

Herbivore figure mock-up sketch

The back is virtually straight.

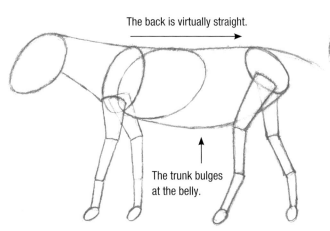

The trunk bulges at the belly.

Carnivore figure mock-up sketch

The back curves slightly.

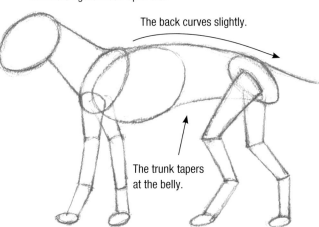

The trunk tapers at the belly.

Herbivore skull (Horse)

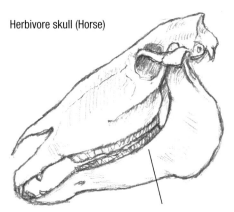

Herbivores eat plants, which contain an abundance of fiber, so their skulls contain a long line of molars, and the mouth extends expansively forward.

Carnivore skull (Lion)

Carnivores eat prey, so their lower jaws move expansively up and down.

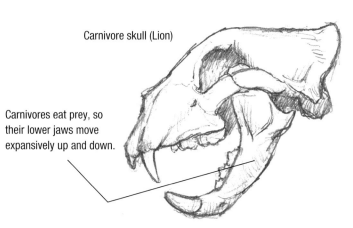

Carnivores have proportionally large brains compared to their skulls. They require large brains to allow them to engage in complicated actions that allow them to catch prey.

Animals That Fatten, Thin, and Use Fat Skillfully

Animals that hibernate consume large quantities of food in the fall to store fat, and become physically rotund. During hibernation, their metabolism drops, and they consume their fat stores little by little as their nutrition sources. When they wake up from hibernation, their fast reserves are spent, and they become emaciated.

When camels are in a strong nutritional state, their humps are full of fat and stand erect. In severe circumstances, such as walking for days in the desert without food or water, camels' humps thin and collapse to the side.

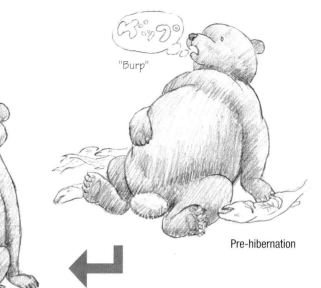

"Burp"

Pre-hibernation

Post-hibernation
(Spring)

Rule: Animals That Live in Cold Places Have Larger Bodies

Animals that live farther north tend to be larger than their cousins who live farther south. Let's compare the sizes of different bears. The polar bear, who lives in the Arctic, is significantly larger than the Asiatic black bear, whose habitat spans from Japan to the Korean Peninsula and China. This is because surface area does not increase at the same rate as body size, The larger an animal's body becomes, the smaller the ratio of surface size to body area becomes. Consequently, larger body sizes are better able to prevent heat loss.

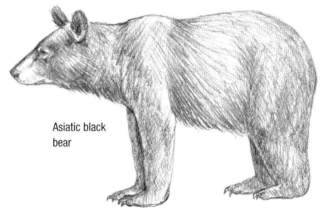

Asiatic black bear

Brown bear

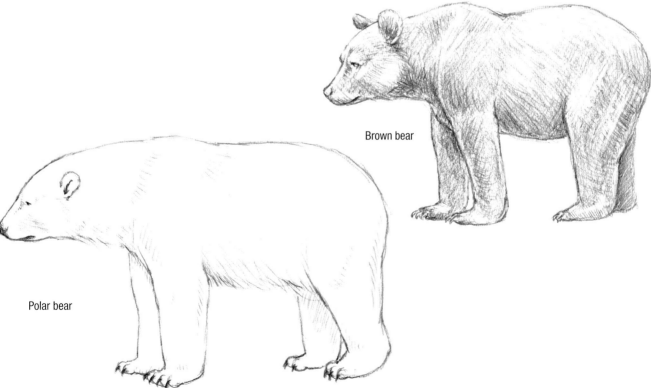

Polar bear

Comparing Different Body Parts

Each facial feature displays tremendous differences for each animal. Capturing the distinguishing features is key when drawing. The shapes of tails, forelegs, and hind legs play a vital role, when you intend to portray natural movement. Try using different animal parts when you plan to create a new character. It might enable you to produce unique forms of expression.

1. Mouths

Mouths indicate more about an animal's eating habits than other pats. Carnivore teeth and herbivore teeth differ in form. Consequently, we can infer by looking at a single tooth fossil what that animal ate and what lifestyle that animal led.

Carnivore Mouths

Carnivores have sturdy jaws that allow them to open their mouths wide to catch their prey and then hold onto their prey.

Check

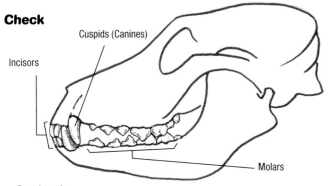

Dogs' teeth:
Dogs' have developed cuspids (aka "canines"), while their molars are shaped to allow them to tear and chew flesh. Dogs' teeth are typical of carnivores.

Long snout

Muscles of the Mouth (Dog)

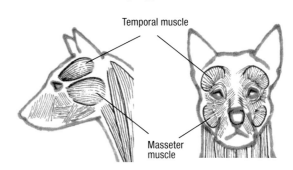

Because carnivores have developed masseter muscles, their faces are rounder from the front than those of herbivores.

Typical dog snout

Some dogs have been bred to have short snouts with sturdy lower jaws to allow them to bite and hold onto a target, while other dogs with short snouts have been bred as pets. Dog snouts come in a wide range of forms.

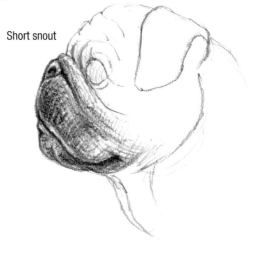

Short snout

Dog and Cat Mouths

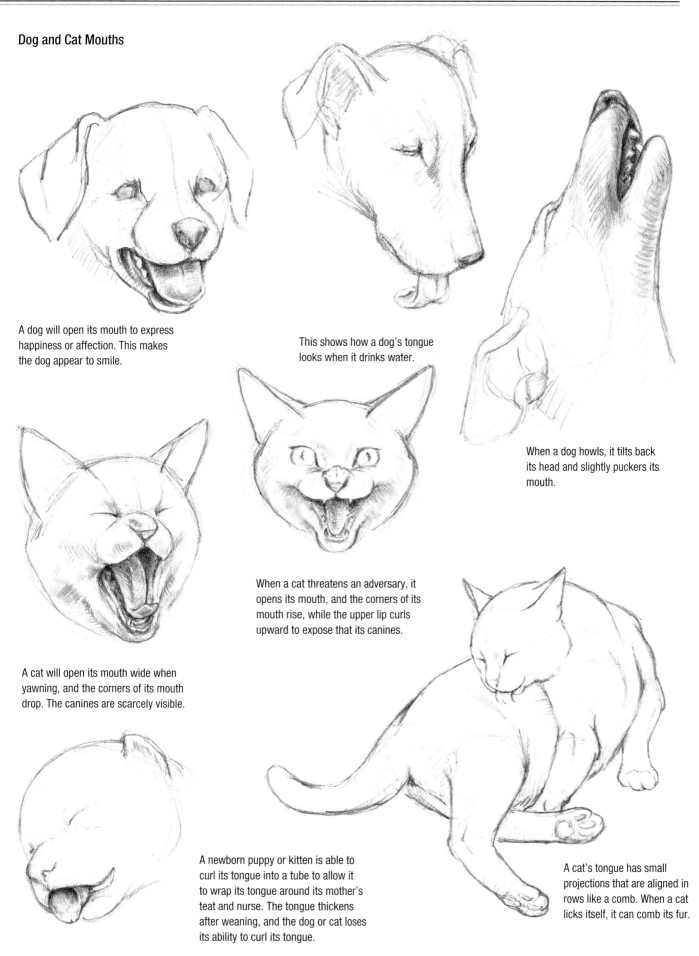

A dog will open its mouth to express happiness or affection. This makes the dog appear to smile.

This shows how a dog's tongue looks when it drinks water.

When a dog howls, it tilts back its head and slightly puckers its mouth.

When a cat threatens an adversary, it opens its mouth, and the corners of its mouth rise, while the upper lip curls upward to expose that its canines.

A cat will open its mouth wide when yawning, and the corners of its mouth drop. The canines are scarcely visible.

A newborn puppy or kitten is able to curl its tongue into a tube to allow it to wrap its tongue around its mother's teat and nurse. The tongue thickens after weaning, and the dog or cat loses its ability to curl its tongue.

A cat's tongue has small projections that are aligned in rows like a comb. When a cat licks itself, it can comb its fur.

Herbivore Mouths

The male horse has canines, but the female does not. Cattle and other ruminants do not have incisors in their upper jaws. Instead, they have a hard dental pad in the upper jaw. On the bottom jaw, cattle have canines that have taken the shape of incisors.

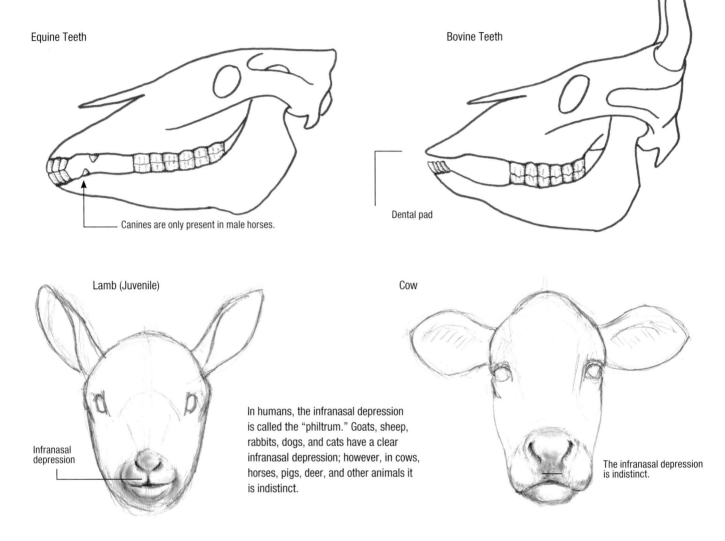

Equine Teeth

Canines are only present in male horses.

Bovine Teeth

Dental pad

Lamb (Juvenile)

Infranasal depression

In humans, the infranasal depression is called the "philtrum." Goats, sheep, rabbits, dogs, and cats have a clear infranasal depression; however, in cows, horses, pigs, deer, and other animals it is indistinct.

Cow

The infranasal depression is indistinct.

Note

When a ruminant eats grass, its wraps its long tongue around the grass, pulls it into its mouth, and bites. At this point, the lower jaw moves in an up and down motion. When a ruminant chews its cud, its lower jaw drops, shifts dramatically to the side, and then returns to its original position. This action is repeated over and over again.

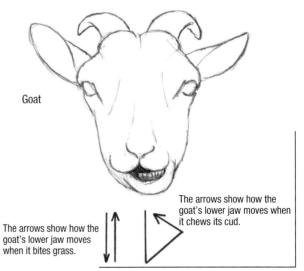

Goat

The arrows show how the goat's lower jaw moves when it bites grass.

The arrows show how the goat's lower jaw moves when it chews its cud.

Teeth, Noses, Tongues, and Whiskers That Stick Out

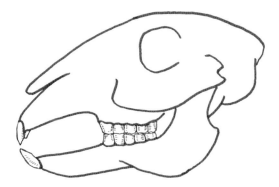

Rabbit Teeth
Rodents have incisors that continuously grow. To ensure that their upper and lower teeth fit against each other properly, rodents must constantly gnaw on hard objects to wear down the excess growth.

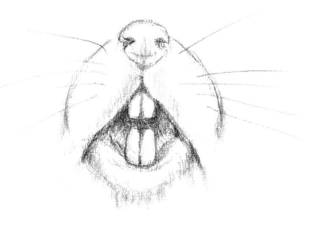

Rodent Mouth

Elephant Mouth
The upper lip and nose have fused.

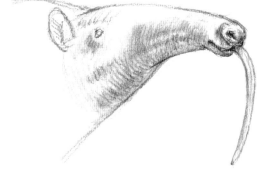

Giant Anteater Mouth
The giant anteater's long tongue and small mouth reflect its ant-based diet.

☞ Note

Animal Whiskers Grow in Straight Lines

Dogs, cats and other carnivores as well as rabbits, rats, and other rodents have tactile that grow around their mouths, on their cheeks, and on what would constitute the eyebrows of a human. This tactile hair appears especially in abundance around the mouth. On cats and rodents, tactile hair, which we call "whiskers," grows particularly long. Whiskers grow in four to five rows, following a regular pattern.

Correct

Incorrect

Animal whiskers do not appear as random dots like the hair stubble on a human face.

2. All about Eyes

Pupils, which change their shape to adjust the amount of light that enters the eye, are distinctive to different animals.

Right Eye of a Goat

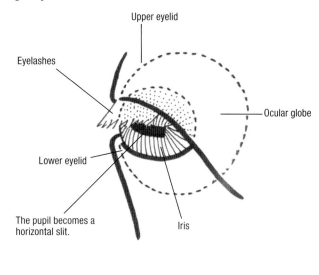

- Upper eyelid
- Eyelashes
- Ocular globe
- Lower eyelid
- The pupil becomes a horizontal slit.
- Iris

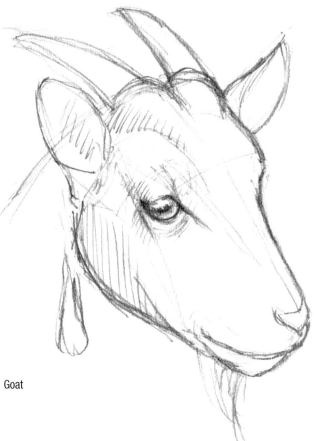

Goat

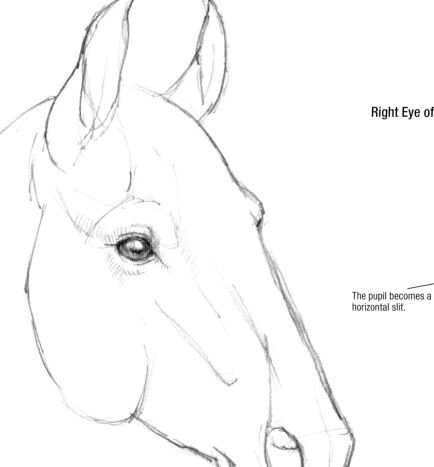

Horse

Right Eye of a Horse

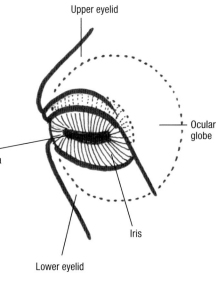

- Upper eyelid
- Ocular globe
- The pupil becomes a horizontal slit.
- Iris
- Lower eyelid

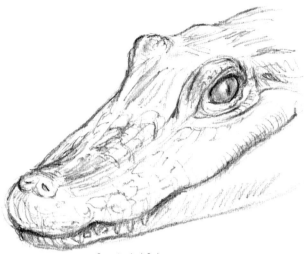

Spectacled Caiman
This caiman is making a cameo appearance as the only reptile in this book. Like the cat, alligators, crocodiles, and caiman have pupils that become vertical slits.

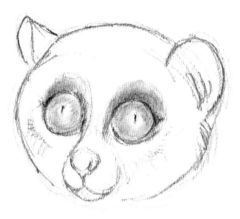

Slow Loris
This relative of monkeys has distinctive large, round eyes. The pupil becomes a vertical slit.

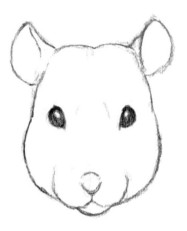

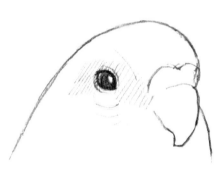

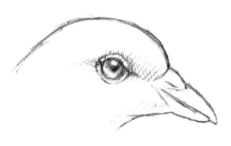

Dove
In bright places, the dove's pupil becomes small.

Hamster
Hamsters have round pupils like humans and dogs.

Parakeet
In dark places, the parakeets round pupil enlarges.

Right Eye of a Bird

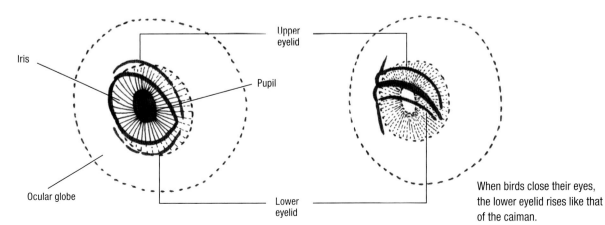

Iris

Ocular globe

Upper eyelid

Pupil

Lower eyelid

When birds close their eyes, the lower eyelid rises like that of the caiman.

3. Noses

The hairless tip of the nose is called the "nose pad," and it is developed on dogs, cows, pigs, deer, and other animals.

Dog Nose

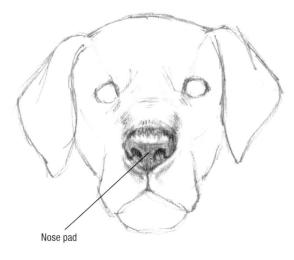

Nose pad

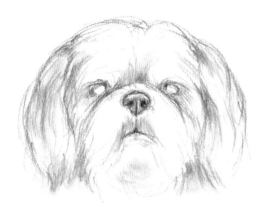

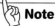

Cat Nose

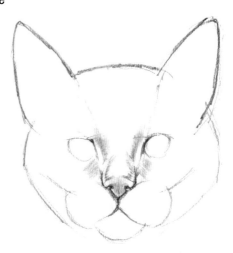

The nostrils turn upward on dogs and cats that have jutting jaws.

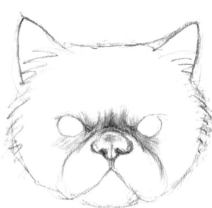

✋ **Note**

Camels have nostrils that open and close. Scientists believe this prevents sand from entering into the camels' noses while they are in the desert. Seals close their nostrils when they dive under water.

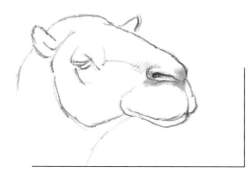

Assorted Noses

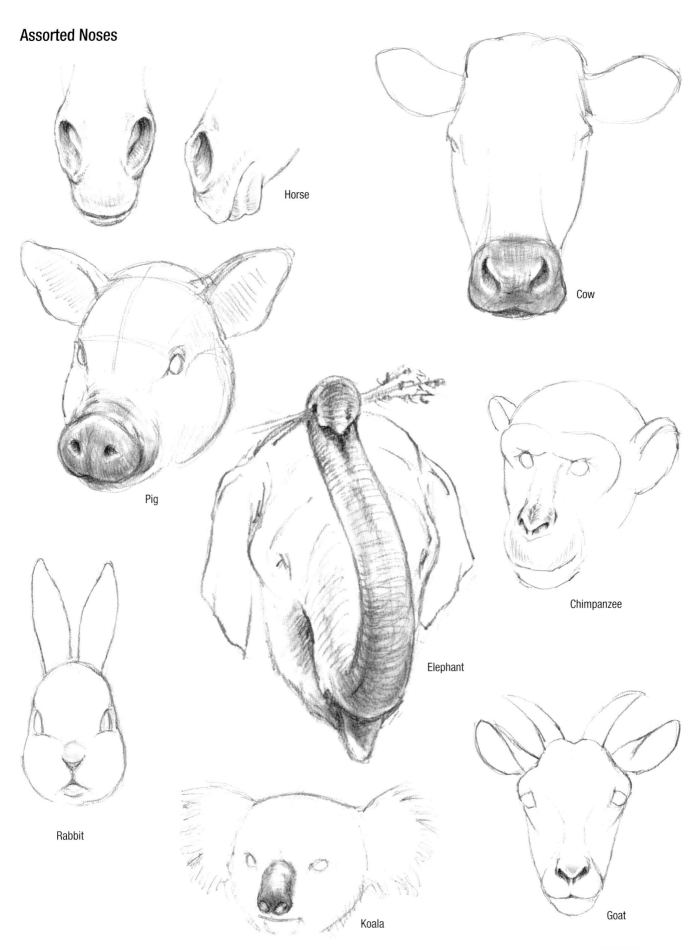

Horse

Cow

Pig

Elephant

Chimpanzee

Rabbit

Koala

Goat

4. Ears

Dogs, cats, pigs, rabbits and other animals that we keep as pets are occasionally born with ears that display interesting forms that arise through mutations. People prize these new forms, and they become set genetically. As a result, these animals have an assortment of ear shapes.

In addition to hearing sounds, animals' ears are able to shift positions, allowing them to display emotional states.

Assorted Dog Ears

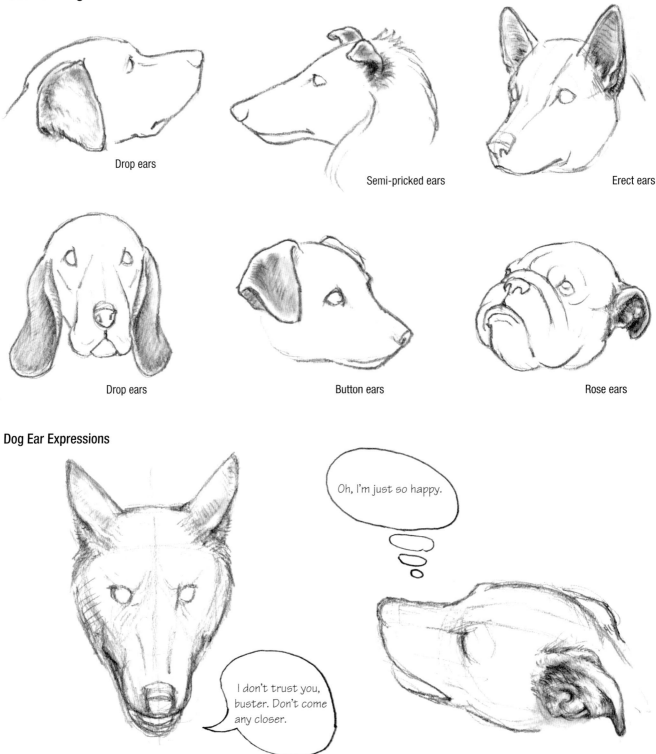

Drop ears

Semi-pricked ears

Erect ears

Drop ears

Button ears

Rose ears

Dog Ear Expressions

Oh, I'm just so happy.

I don't trust you, buster. Don't come any closer.

Ear Positions

At first glance, animals' ears appear to be positioned atop their heads. However, like humans, the ear holes of animals are located slightly lower than eye level.

Tip

If you intend to draw an animal so that it appears realistic, then avoid attaching the ears to the top of the animals head like a bow.

Animals have large ears that expand above their heads.

Human ear holes are approximately 4 to 5 cm (about $1^5/_8$" to 2").

Ear hole

Tympanic cavity

The ear hole is actually located where the ear swells at its base.

Assorted Cat Ears

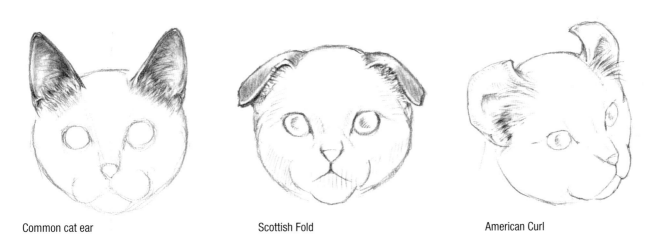

Common cat ear

Scottish Fold

American Curl

Cat Ear Expressions

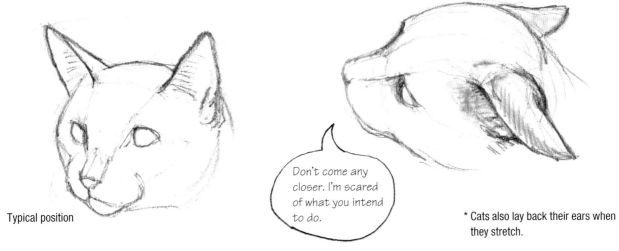

Typical position

Don't come any closer. I'm scared of what you intend to do.

* Cats also lay back their ears when they stretch.

Horse Ears

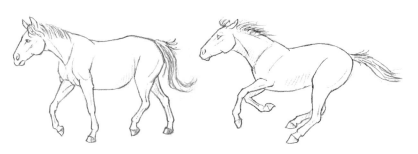

When a horse is walking, it faces its ears forward. When a horse is galloping at top speed, it lays back both ears.

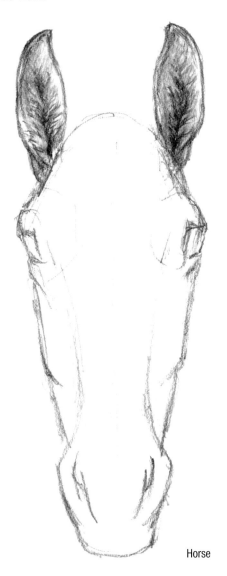

Horse

Grevy's zebra

Horse Ear Expressions

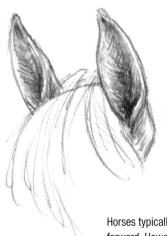

Horses typically face their ears forward. However, when they hear a noise that concerns them, they turn one ear toward that sound.

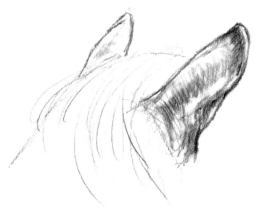

When a horse feels alarmed or when it intends to attack, it lays back or twitches its ears.

Assorted Animal Ears

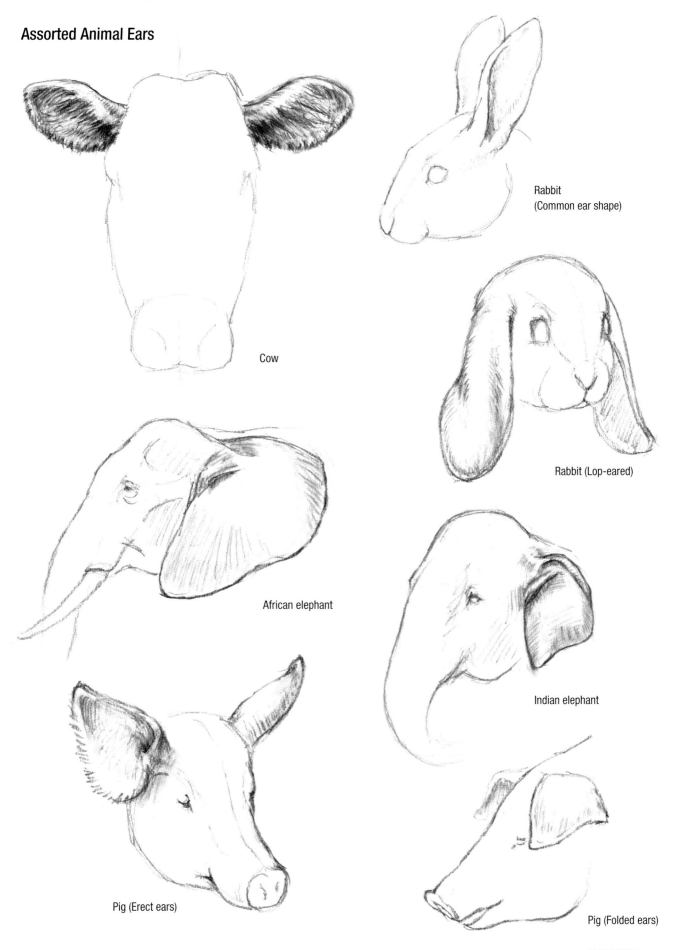

Rabbit
(Common ear shape)

Cow

Rabbit (Lop-eared)

African elephant

Indian elephant

Pig (Erect ears)

Pig (Folded ears)

5. Tusks, Horns, and Antlers

With the exception of the Reeve's muntjac (which has short antlers and developed canines), a Cervidae, the vast majority of herbivores have horns, antlers, or tusks. Warthogs and elephants use their tusks to dig in the dirt and find food. Horns and antlers may also be used to ward off enemies. However, the majority of the time, males use horns and antlers to display strength and fight other males of the same species.

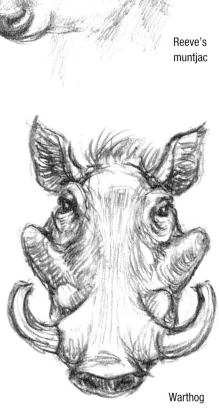

Reeve's muntjac

Tusks

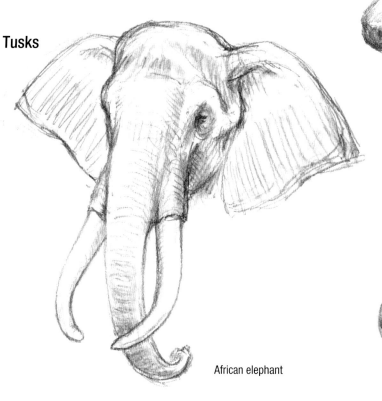

African elephant

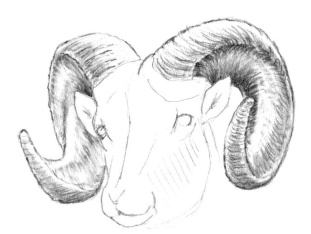

Warthog

Assorted Animals with Horns and Antlers

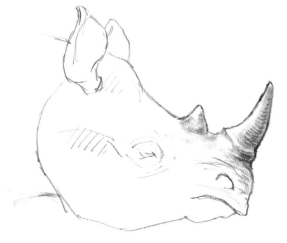

Black rhinoceros

Bighorn sheep

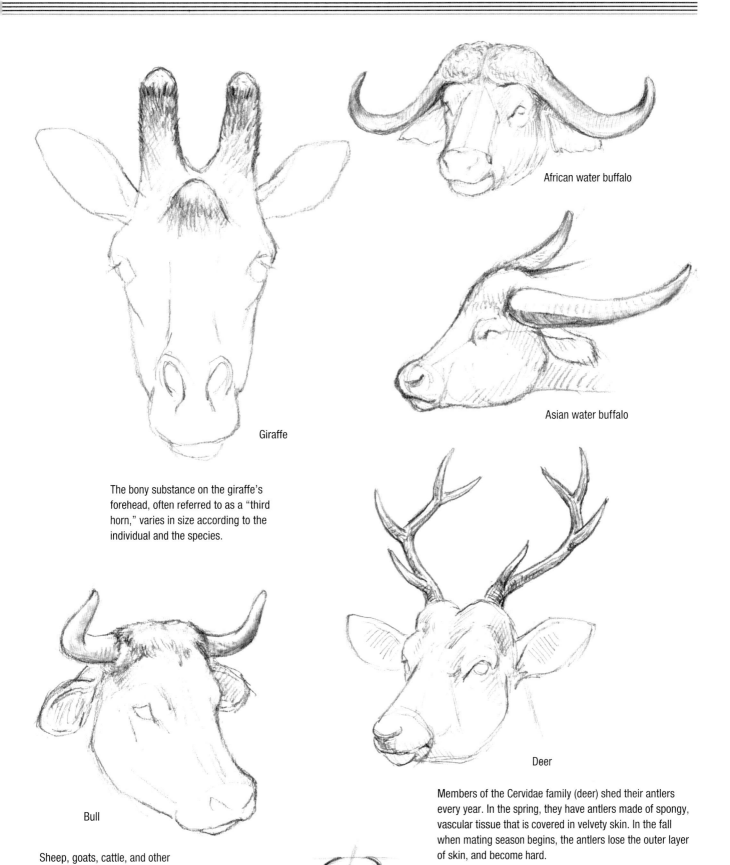

African water buffalo

Asian water buffalo

Giraffe

The bony substance on the giraffe's forehead, often referred to as a "third horn," varies in size according to the individual and the species.

Deer

Members of the Cervidae family (deer) shed their antlers every year. In the spring, they have antlers made of spongy, vascular tissue that is covered in velvety skin. In the fall when mating season begins, the antlers lose the outer layer of skin, and become hard.

Bull

Sheep, goats, cattle, and other members of the Bovine family do not shed their horns.

Note that the right and left antlers form the same curve.

6. Tails

A tail typically helps to balance an animal when it runs or helps it to communicate. Amongst monkeys, a tail might help the animal grasp onto a branch as it moves through the treetops. Horses and cattle use their tails to swat gadflies and other flies. Humans have modified dogs' tails. They originally looked the same as that of a wolf tail (see page 89). However, now dogs have tails that stand erect or that curl. There are even some tailless dogs. Cats with stubby tails typically suffered a bent joint soon after birth, or their tails became covered with fur as they grew and took on the appearance of a bobtail.

All about Dog Tails

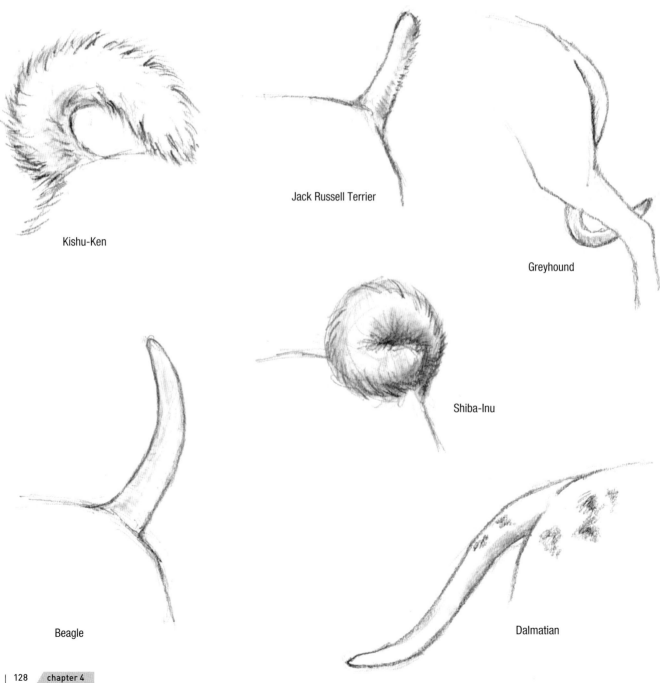

Kishu-Ken

Jack Russell Terrier

Greyhound

Shiba-Inu

Beagle

Dalmatian

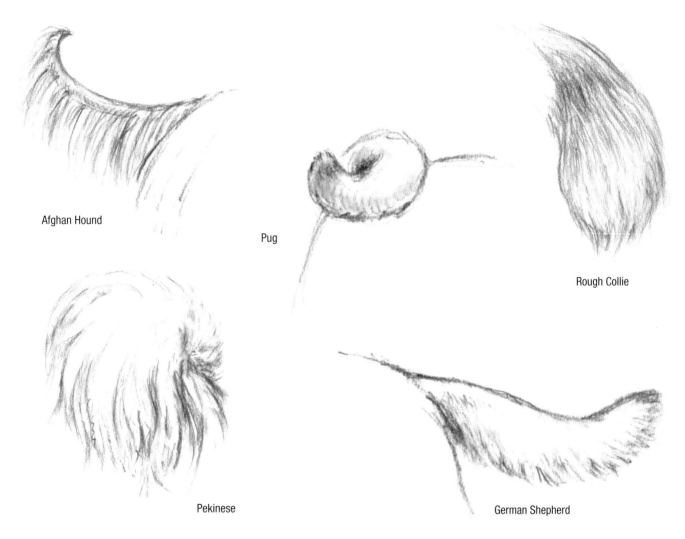

Afghan Hound

Pug

Rough Collie

Pekinese

German Shepherd

Dog Tail Expressions of Emotions

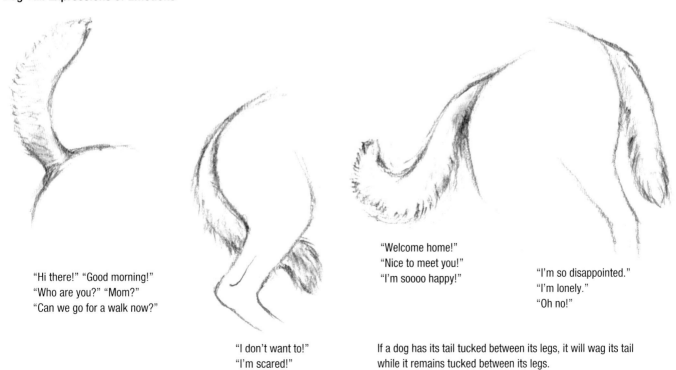

"Hi there!" "Good morning!"
"Who are you?" "Mom?"
"Can we go for a walk now?"

"I don't want to!"
"I'm scared!"
"Cut it out!"

"Welcome home!"
"Nice to meet you!"
"I'm soooo happy!"

"I'm so disappointed."
"I'm lonely."
"Oh no!"

If a dog has its tail tucked between its legs, it will wag its tail while it remains tucked between its legs.

All about Cat Tails

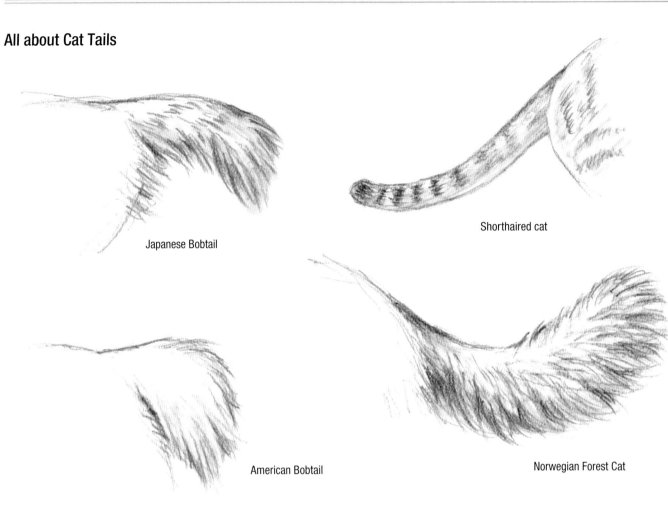

Japanese Bobtail

Shorthaired cat

American Bobtail

Norwegian Forest Cat

Cat Tail Expressions of Emotions

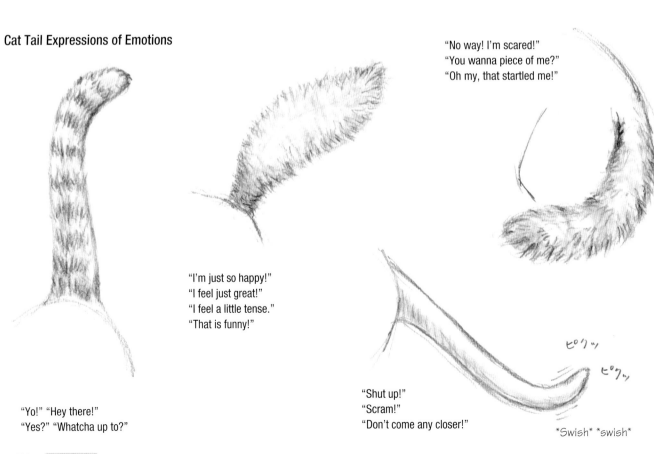

"No way! I'm scared!"
"You wanna piece of me?"
"Oh my, that startled me!"

"I'm just so happy!"
"I feel just great!"
"I feel a little tense."
"That is funny!"

"Yo!" "Hey there!"
"Yes?" "Whatcha up to?"

"Shut up!"
"Scram!"
"Don't come any closer!"

ピクッ
ピクッ

Swish *swish*

Assorted Animal Tails

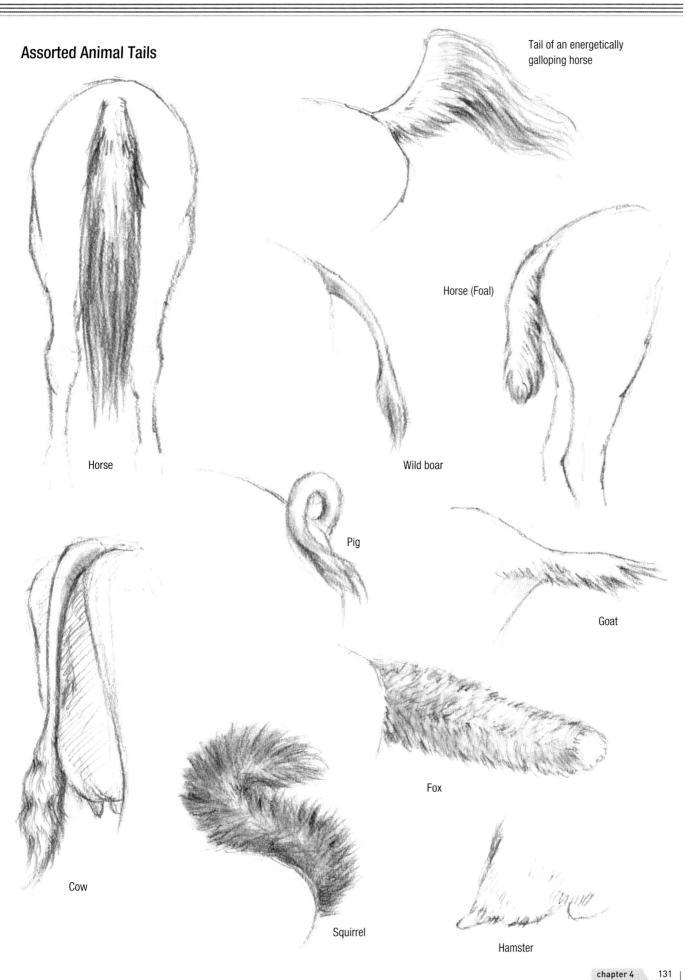

Tail of an energetically galloping horse

Horse (Foal)

Horse

Wild boar

Pig

Goat

Cow

Squirrel

Fox

Hamster

7. Feet

This section takes a look at the distinguishing characteristics of the tips of animals' feet.

Size and Shape Differences

The forepaws are typically moderately larger than the hind paws of animals that walk on four legs. Scientists believe this is because the forepaws support more weight. Looking at the legs from the side reveals that the pastern lies at a more horizontal angle on the hind leg than the foreleg.

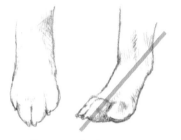

Forepaws of a dog

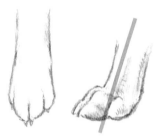

Hind paws of a dog

The paws of digigrade animals (animals that walk on their toes) tend to narrow when it rises off the ground and widen when it comes back into contact with the ground.

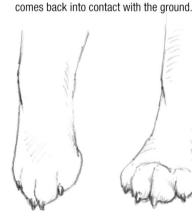

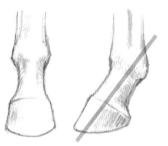

Front hooves of a horse

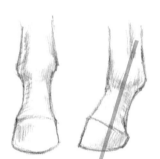

Hind hooves of a horse

Paw held off the ground Paw touching the ground

Pad Shapes

The undersides of the paws of digigrade animals and the undersides of the paws of bears have pads that serve as cushions when they walk on the ground.

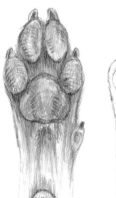
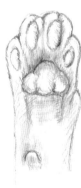

Dog Cat

Feline Claws

Felines are typically able to retract their claws. When a cat holds down its prey or gets excited, the extensor muscles contract, exposing the animal's claws. Although, the cheetah is a feline, it is unable to retract its claws.

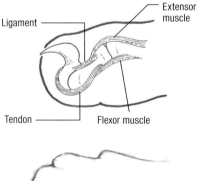

Ligament — Extensor muscle
Ligament
Tendon — Flexor muscle

Ligament — Extensor muscle
Ligament
Tendon — Flexor muscle

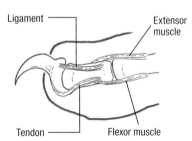

Sections of the Foot That Touch the Ground

Animals' feet have evolved into a range of forms suited to that animal's living conditions. We can divide animals' feet into three categories based on which parts of their feet touch the ground when they walk.

Animals Who Walk on the Flat of Their Feet

Plantigrade: The entire sole of the foot touches the ground when these animals walk.

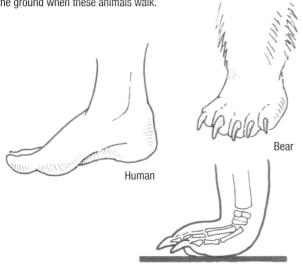

Human

Bear

☝ **Note**

There are animals that have hooves but walk with the soles of their feet touching the ground.

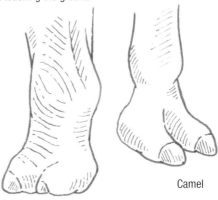

Elephant

Camel

Elephants, camels, rhinoceroses, and hippopotamuses have hooves, but the part of their feet that touches the ground is either the sole or their toes. Consequently, they possibly might be considered closer to digigrade than horses and cows.

Animals That Walk on Their Toes

Digigrade: When these animals walk, the parts that touch the ground are the toes.

Cats and other large felines

Dogs, wolves, foxes

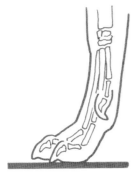

Animals That Walk on Hooves

Animals that walk on hooves are called "unguligrade."

Donkey

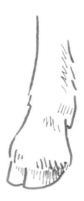

Goat

Cow

Pig

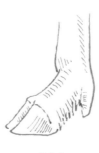

Reindeer

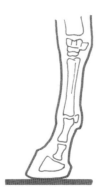

Comparison of the Digits of the Hands and Feet

Since herbivores run faster in order to escape carnivores, they have fewer toes. Having fewer toes reduced the area of their four feet that touches the ground as well as enabled them to develop hooves. The quintessential hoofed animal is the horse. The only set of phalanges that the horse has retained is that of row III in a developed state. The rest have fully degenerated. Pigs and cattle have retained rows III and IV in developed states. The rest have fully or partially degenerated. The forepaws of dogs and cats have rows I through IV; however, row I has degenerated in the hind paws. There are rare cases in dogs and some canine species where row I is present in the hind paws, and their owners may remove the extra digit if it poses aesthetic issues.

Name

1. Wrist	6. Front hoof	11. Hind pastern	16. Cannon bone	21. Cannon bone
2. Knee	7. Heel	12. Hind hoof	17. Phalanx of the front hoof	22. Phalanx of the hind hoof
3. Front cannon	8. Hock	13. Radius	18. Tibia	
4. Front Fetlock	9. Hind cannon	14. Ulna	19. Fibula	
5. Front pastern	10. Hind fetlock	15. Splint bone	20. Hock	

* The figures of animals' feet show the right fore and hind feet and the skeletal structure of each.

I through V refer to the phalanges of the hand and fore and hind feet.

Human

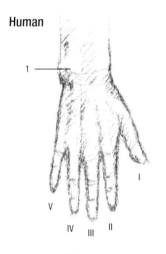

Right hand

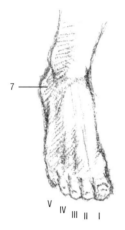

Right foot

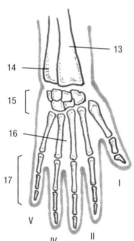

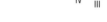

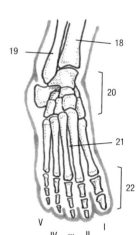

Horse

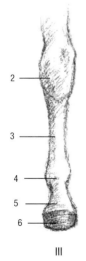

III

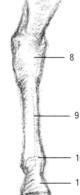

III

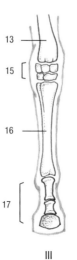

III

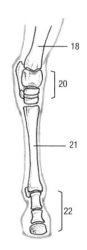

III

Dog

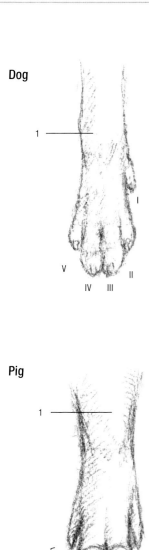
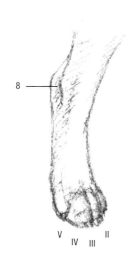
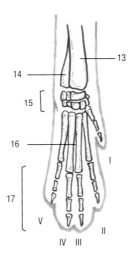
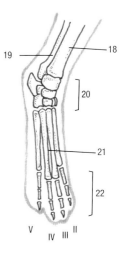

1

8

13
14
15
16
17

I
II
III
IV
V

18
19
20
21
22

Pig

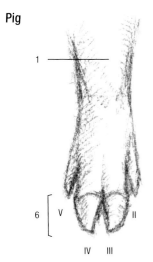
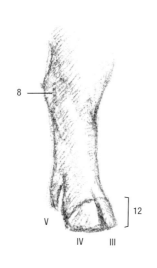
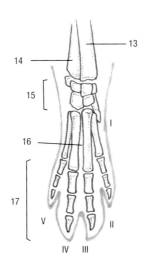
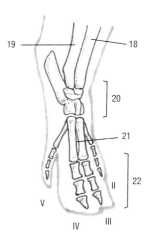

1

8

6
12

13
14
15
16
17

18
19
20
21
22

Cow

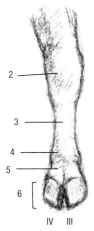
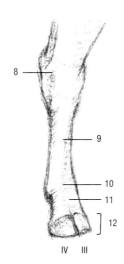
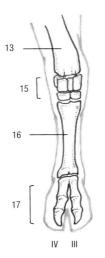
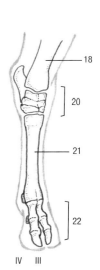

2
3
4
5
6

8
9
10
11
12

13
15
16
17

18
20
21
22

Walking and Running

When humans walk and run, they repeatedly move their left feet forward and then their right. The difference between walking and running lies solely in the speed of each repetition and the gait distances. The way we move our legs remains the same. In the case of four-legged animals, we have to factor in the flexible nature of their trunks. Consequently, four-legged animals move their fore and hind legs differently for each of "walking," "trotting," and "running."

1. Walking

Using skeletal structure mock-ups helps clarify how the feet are positioned. Horses and dogs move in the same manner when they walk.

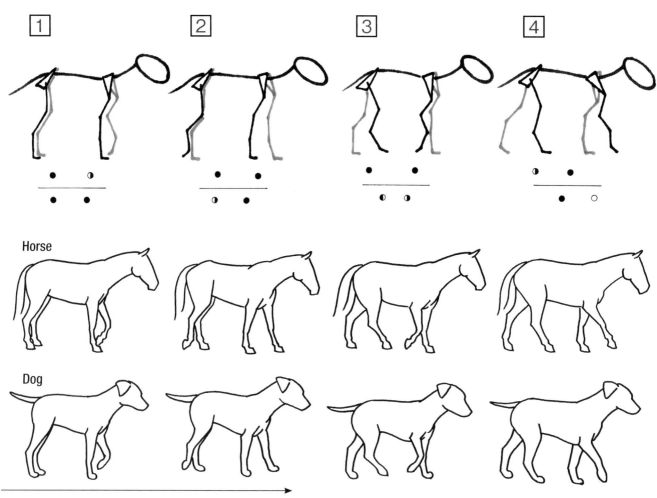

Horse

Dog

This shows the animals beginning to walk from a resting position.

Steps [1] and [2] show the animal preparing to walk from a resting position. Once the animal is actually in motion, it shifts from step [8] back to step [3], skipping steps [1] and [2].

Footstep Legend

● Foot touching the ground (Foot supporting weight)
◗ Foot rising off the ground
○ Foot completely not touching the ground
◐ Foot lowering to touch the ground

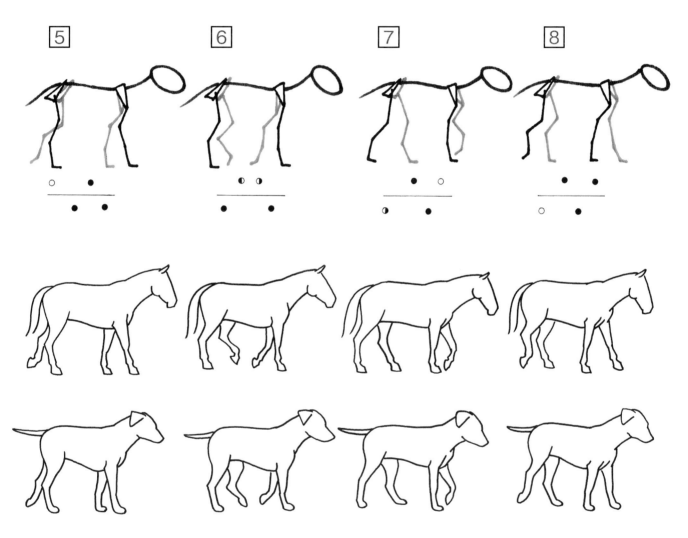

Return to step [3].

Three Gaits

• Walking [Walking]: This is the gait used when walking at a standard pace.

• Trotting [Trotting]: This is the gait used when the animal is moving at a pace somewhere between slightly faster than walking and slightly slower than running or galloping.

• Running [Cantering to Galloping]: This is the gait used from when the animal is running at a slow pace to when the animal is running at full throttle.

Words in brackets [] refer to equestrian terminology. Because this discussion includes the gaits of a dog, description of gaits also includes vernacular expressions.

2. Trotting

The figures below illustrate animals moving from a regular walking pace to a somewhat faster pace.

Steps [1] and [2] show the animal preparing to transition from a walk to a trot.

When an animal is walking, two to three legs are always touching the ground. However, when an animal is trotting, the right foreleg and the left hind leg move together, and the left foreleg and the right hind leg move together. There is also a moment when all four legs are not touching the ground.

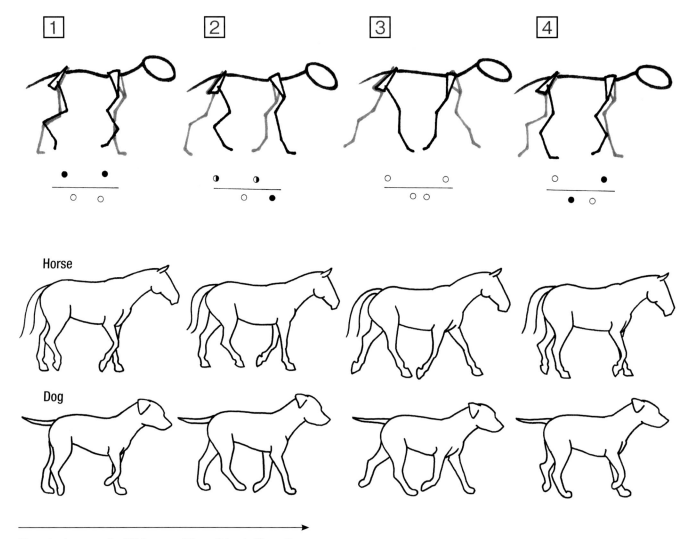

Horse

Dog

The animal prepares to shift from a walking gait to a trotting gait.

Check
If you draw the picture in your mind's eye, you will make a mistake!
Herbivores and carnivores use different gaits when "running." Using your imagination to draw one of these animals running will result in you making a mistake, so please use the illustrations provided as reference.

The figures below show an incorrectly drawn horse running. See pages 140 and 141 for the correct appearance of a running horse.

Incorrect

Footstep Legend

● Foot touching the ground (Foot supporting weight)
◑ Foot rising off the ground
○ Foot completely not touching the ground
◐ Foot lowering to touch the ground

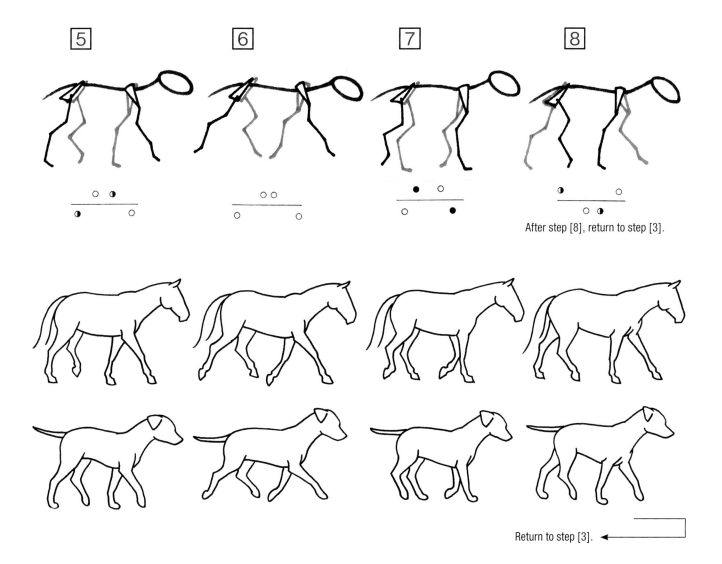

After step [8], return to step [3].

Return to step [3]. ◄

3. Running

While horses and dogs share similar gaits when "walking" and "trotting," they differ when "running."

Horse

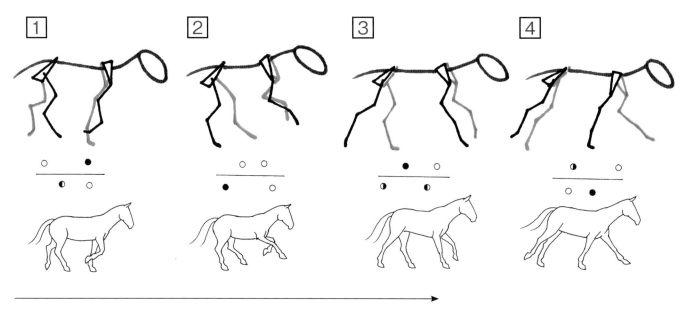

These steps show a horse preparing to transition from a trot to a gallop.

Compare how the horse and the dog's gaits differ in steps [3] through [8]. The horse's feet that touch the ground follow the pattern, left hind foot → right forefoot → left forefoot → all four feet rise off the ground → right hind foot → left hind foot. In contrast, the dog's feet follow the pattern, right hind foot → right forefoot → left forefoot → all four feet rise off the ground → left hind foot → right hind foot.

Dog

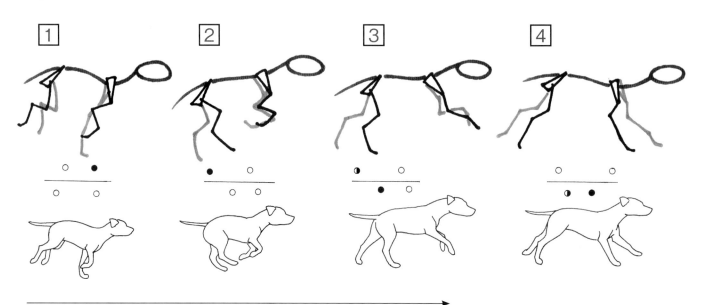

These steps show the dog preparing to transition from a trot to a run.

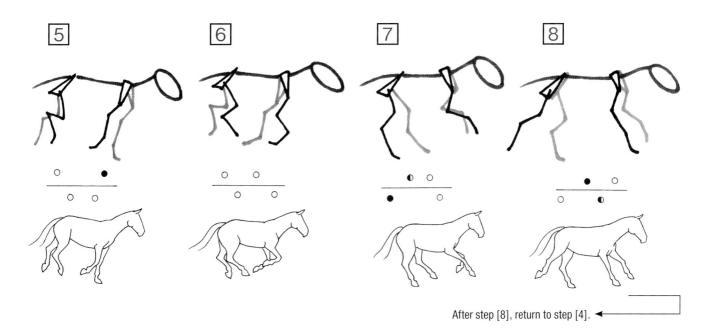

After step [8], return to step [4].

Scientists believe that differences in flexibilities in the spines caused these different gaits. The dog has a much more flexible spine than does the horse. Consequently, when the dog is running, its back arcs dramatically. The cat, the lion, the cheetah and other carnivores run using the same gait as the dog. Flexible spines enable these animals to breathe while running, which causes their bodies to move up and down dramatically. As a result, the dramatic up-and-down motion has no detrimental effect on their ability to move, and they are able to hold their head at a fixed height and focus on their prey, while running.

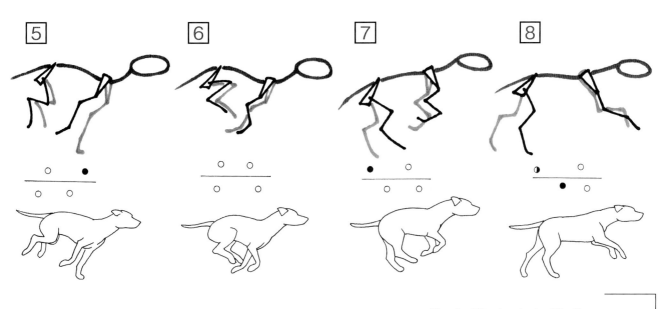

After step [8], return to step [4].

4. Jumping

When walking and running, both a horse and a dog will have either the right or left hind leg touch the ground (bearing the animal's weight). However, when jumping, the animal will bring their left and right hind legs together and have them touch the ground at the same time in front of the obstacle and bend them to make the jump. In the following instant, the two bent hind legs will extend dramatically and kick off the ground, causing the body to leap.

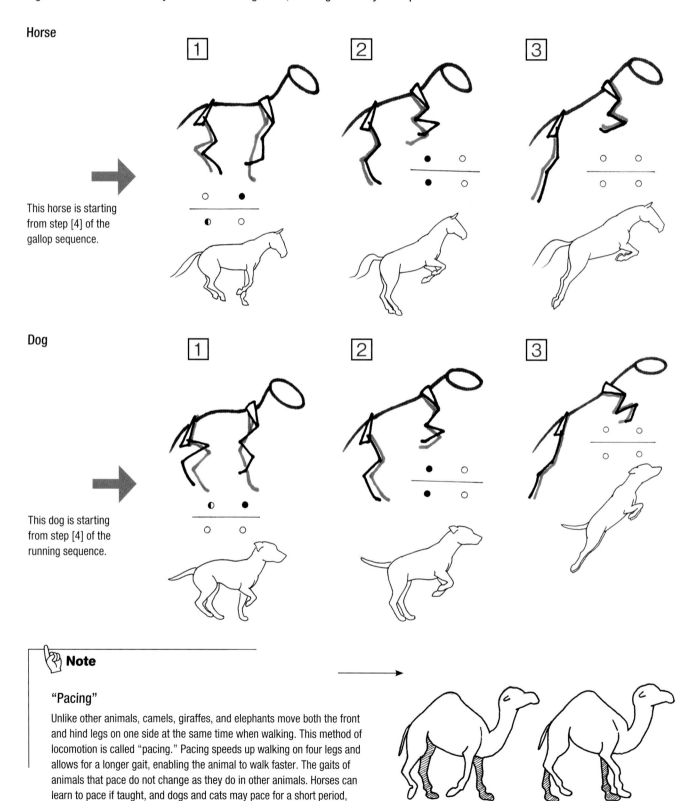

Horse

This horse is starting from step [4] of the gallop sequence.

Dog

This dog is starting from step [4] of the running sequence.

☞ **Note**

"Pacing"

Unlike other animals, camels, giraffes, and elephants move both the front and hind legs on one side at the same time when walking. This method of locomotion is called "pacing." Pacing speeds up walking on four legs and allows for a longer gait, enabling the animal to walk faster. The gaits of animals that pace do not change as they do in other animals. Horses can learn to pace if taught, and dogs and cats may pace for a short period, depending on the circumstances.

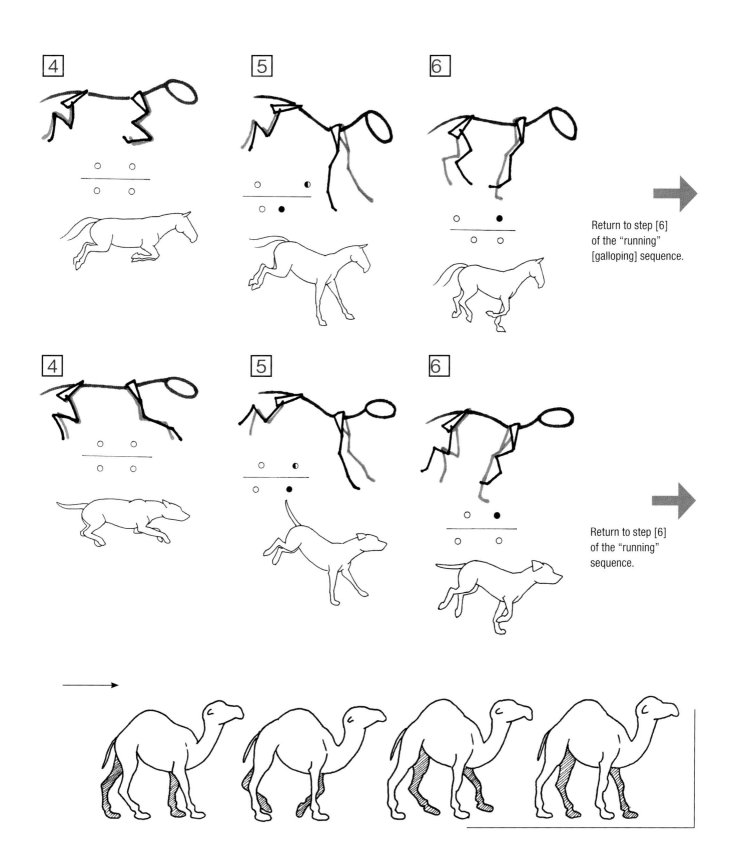

Return to step [6] of the "running" [galloping] sequence.

Return to step [6] of the "running" sequence.

Animals Other Than Dogs and Cats

Use skeletal structure and musculature mock-ups to practice drawing a host of other animals.

1. Elephants

The African elephant is larger than the Indian elephant, and their builds differ tremendously.

Picturing the African elephant's head in rough terms, it can be regarded as an oval lying with its long axis at a tilt.

These figures show a skeletal structure mock-up and a musculature mock-up of the African elephant.

African Elephant

The scapulae and the hips form hills on the back.

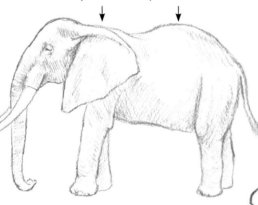

The top of the African elephant's head is flat.

The African elephant's ears are large and cover the shoulders.

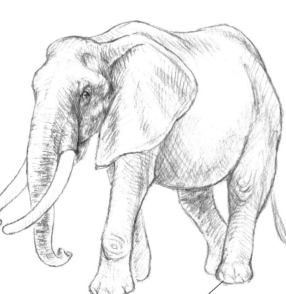

Each forefoot has approximately four to five toenails.

Each hind foot has approximately three to four toenails.

Both males and females have long tusks. (The male's tusks are longer.)

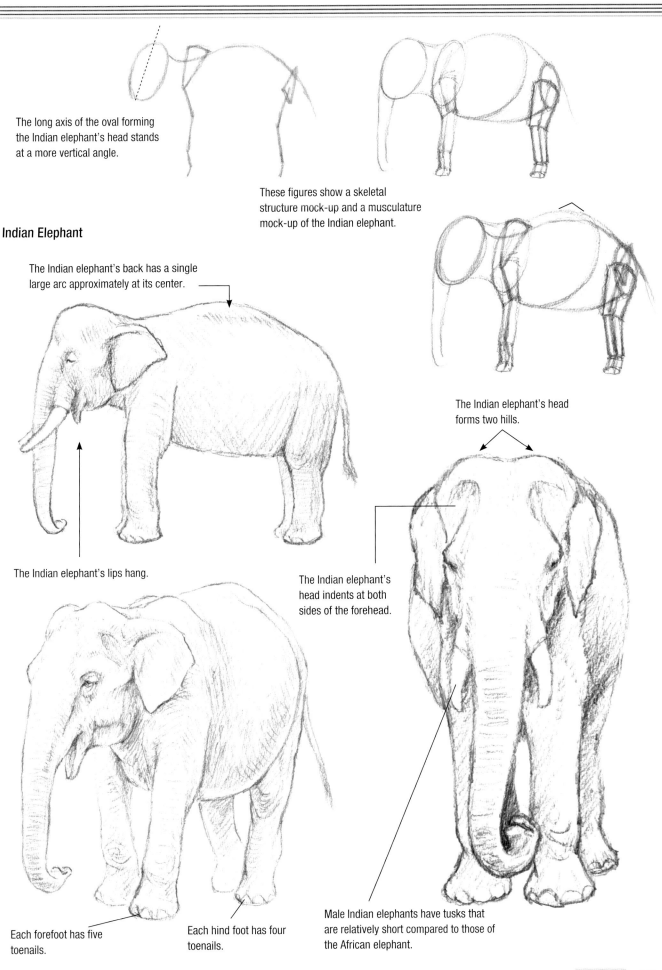

The long axis of the oval forming the Indian elephant's head stands at a more vertical angle.

These figures show a skeletal structure mock-up and a musculature mock-up of the Indian elephant.

Indian Elephant

The Indian elephant's back has a single large arc approximately at its center.

The Indian elephant's head forms two hills.

The Indian elephant's lips hang.

The Indian elephant's head indents at both sides of the forehead.

Each forefoot has five toenails.

Each hind foot has four toenails.

Male Indian elephants have tusks that are relatively short compared to those of the African elephant.

3. Camels

Bactrian camels are smaller and stockier than dromedaries. Start by drawing mock-up sketches.

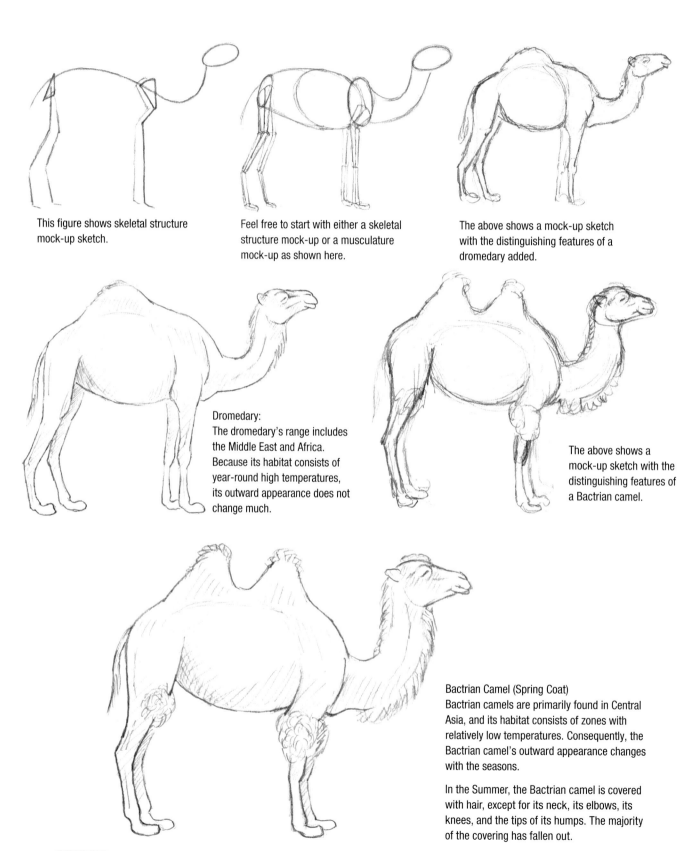

This figure shows skeletal structure mock-up sketch.

Feel free to start with either a skeletal structure mock-up or a musculature mock-up as shown here.

The above shows a mock-up sketch with the distinguishing features of a dromedary added.

Dromedary:
The dromedary's range includes the Middle East and Africa. Because its habitat consists of year-round high temperatures, its outward appearance does not change much.

The above shows a mock-up sketch with the distinguishing features of a Bactrian camel.

Bactrian Camel (Spring Coat)
Bactrian camels are primarily found in Central Asia, and its habitat consists of zones with relatively low temperatures. Consequently, the Bactrian camel's outward appearance changes with the seasons.

In the Summer, the Bactrian camel is covered with hair, except for its neck, its elbows, its knees, and the tips of its humps. The majority of the covering has fallen out.

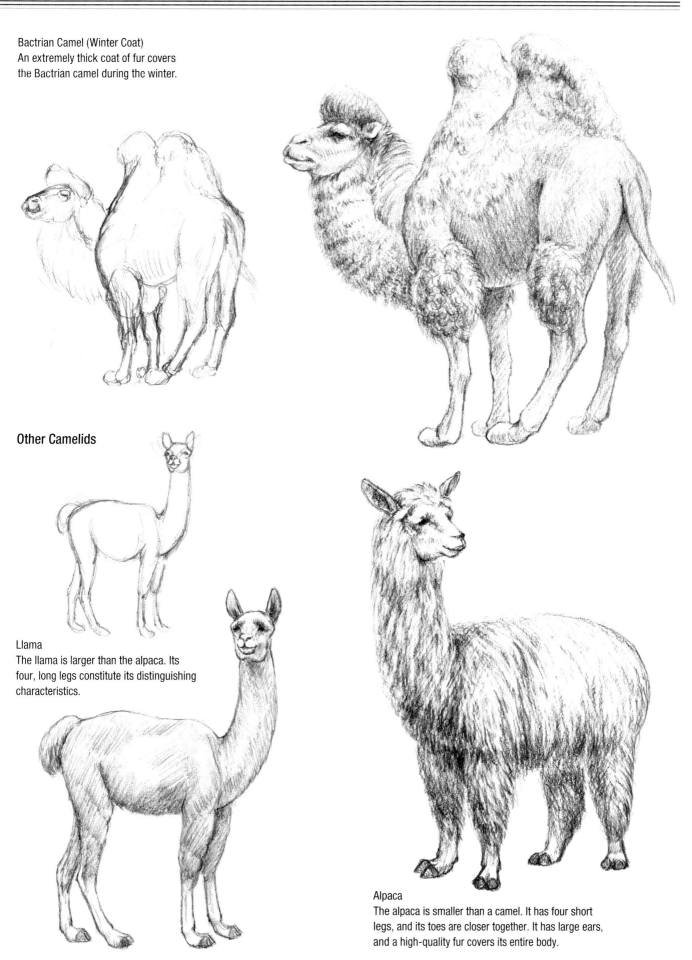

Bactrian Camel (Winter Coat)
An extremely thick coat of fur covers
the Bactrian camel during the winter.

Other Camelids

Llama
The llama is larger than the alpaca. Its
four, long legs constitute its distinguishing
characteristics.

Alpaca
The alpaca is smaller than a camel. It has four short
legs, and its toes are closer together. It has large ears,
and a high-quality fur covers its entire body.

3. Hippopotamuses

The hippopotamus has tiny ears and eyes compared to its large head.
The snout is huge.

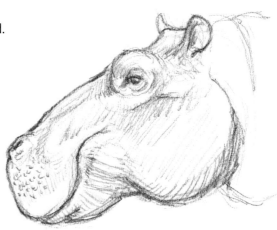

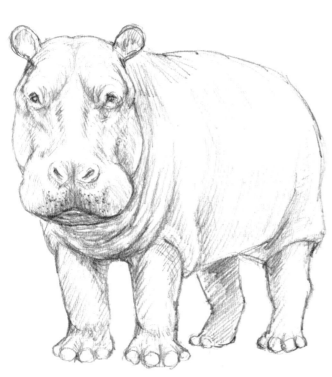

Looking at the hippopotamus's profile, we see that the corners of its mouth rise unexpectedly high.

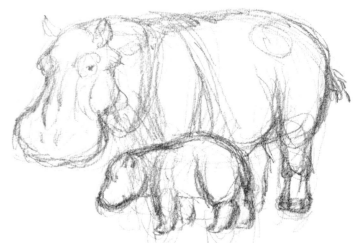

The hippopotamus has four toes on each of its four feet.

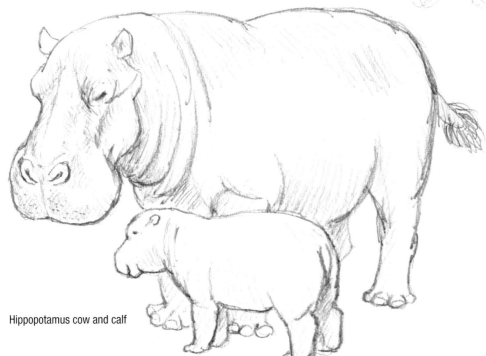

Hippopotamus cow and calf

4. Rhinoceroses

The primary difference between the White rhinoceros and the Black rhinoceros is that the space between the right and left nostrils is flat and wide on the White rhinoceros and narrow and pointed on the Black rhinoceros. The White rhinoceros's head is big and long, while the Black rhinoceros's head is round and smallish.

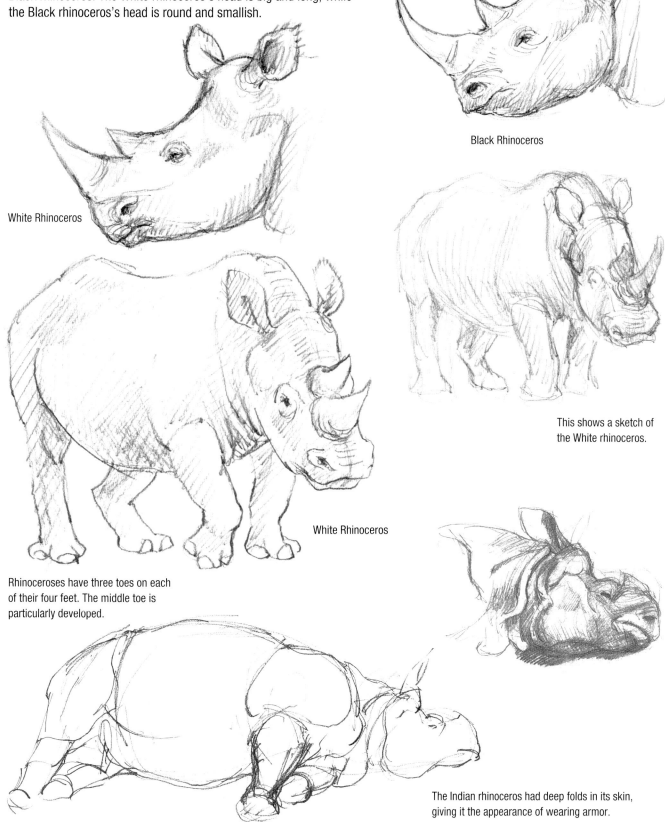

Black Rhinoceros

White Rhinoceros

This shows a sketch of the White rhinoceros.

White Rhinoceros

Rhinoceroses have three toes on each of their four feet. The middle toe is particularly developed.

The Indian rhinoceros had deep folds in its skin, giving it the appearance of wearing armor.

5. Horses

These pages examine the changes that the horse's body undergoes as it ages from foal to nag. Comparing differences in the figure of an active race horse versus a retired race horse reveals large differences in the belly.

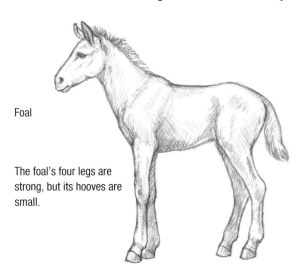

Foal

The foal's four legs are strong, but its hooves are small.

The foal has disproportionately long legs compared to its body and long, thick joints.

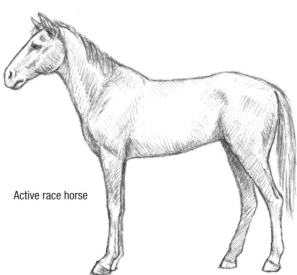

Active race horse

The age of active race horses may be equated to the teen years in humans. Race horses undergo training and have no excess fat. Their entire bodies are mounts of muscle.

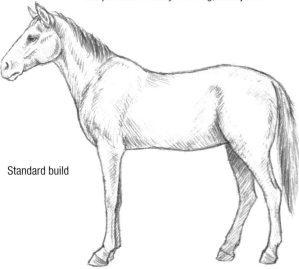

Standard build

After retiring, ex-race horses lead slow-paced lives in horse pastures, so their bellies begin to bulge and grow thick.

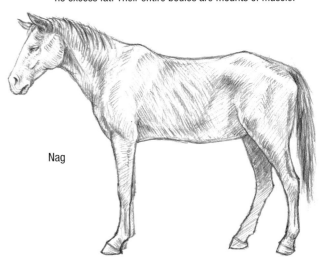

Nag

The flesh at the shoulders and hips sag, and the spine bows, causing the withers and the hip bones to project in a pronounced manner.

——————— Standard build (Post-retirement)

- - - - - - - Active race horse

·············· Nag

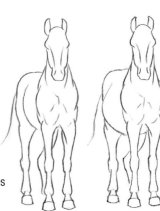

These sketches show horses depicted from the front.

Galloping Horse

This pose is the equivalent of step [7] on page 141. While both images show the legs in similar positions, this example features the hind legs stepping dramatically further inward than on step [7], and the head is slightly raised. The main and the tail are flowing, indicating that the horse is galloping at top speed.

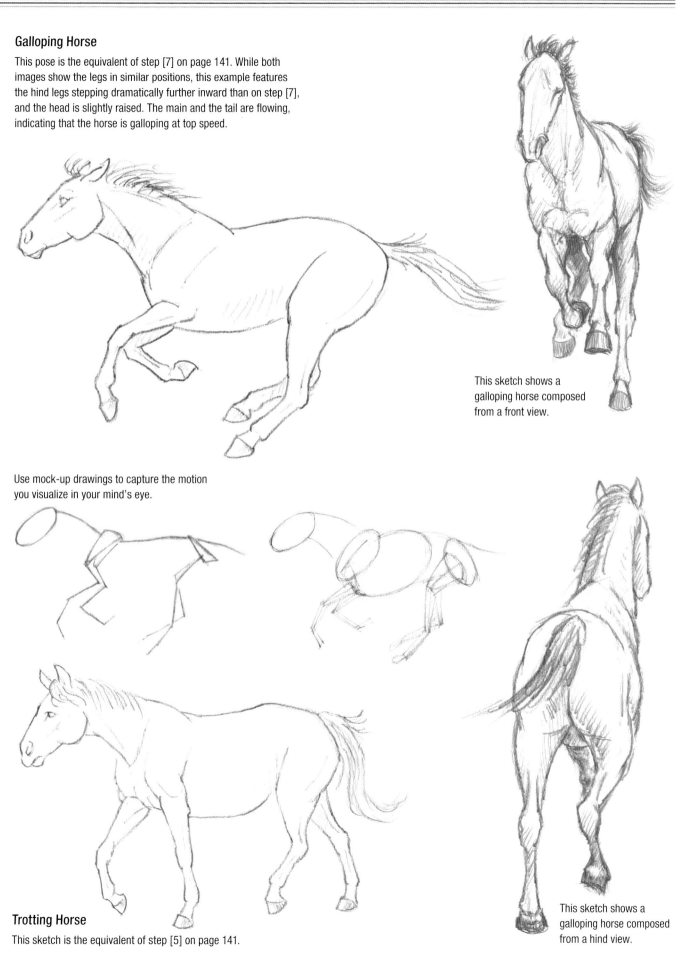

This sketch shows a galloping horse composed from a front view.

Use mock-up drawings to capture the motion you visualize in your mind's eye.

Trotting Horse

This sketch is the equivalent of step [5] on page 141.

This sketch shows a galloping horse composed from a hind view.

Horse Falling

These pages explore drawing a horse falling dramatically and then standing back up and walking away. I use mock-up sketches to create the compositions.

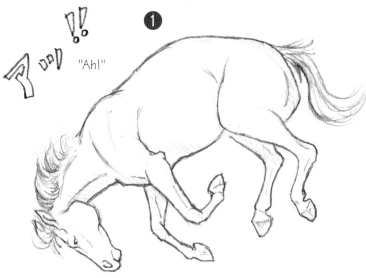

"Ah!"

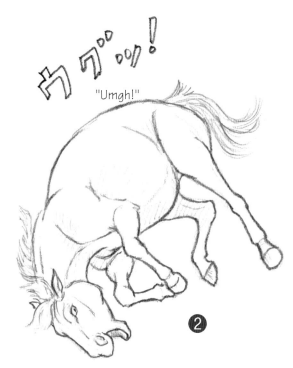

"Umgh!"

This figure shows the horse losing its balance and falling on its head, while the rear half of its body rises up.

The horse's head and the front half of its body hit the ground first. The rear half follows a little later.

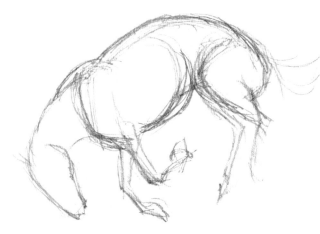

The entire body appears to curl up.

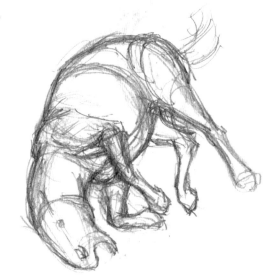

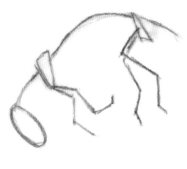

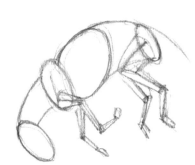

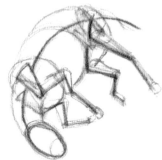

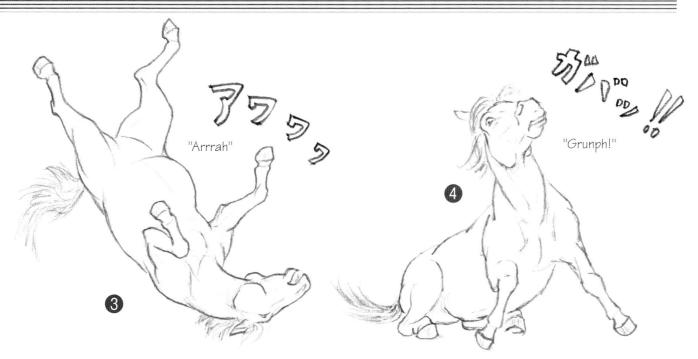

"Arrrah"

❸

"Grunph!"

❹

This shows the horse on its back facing upward. While its four legs were bent in the previous step in the sequence, draw the legs extended in this step. The forms shown here are difficult to capture, so turn the paper upside down to make it easier to draw.

The horse pushes against the ground with its forelegs, raising the front half of its body.

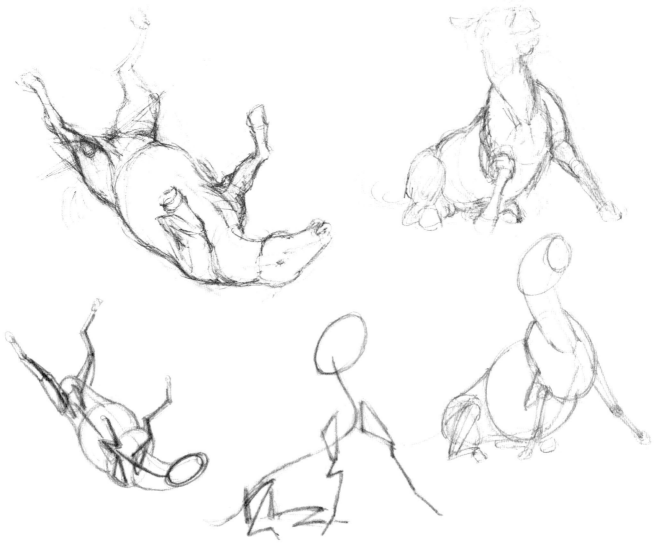

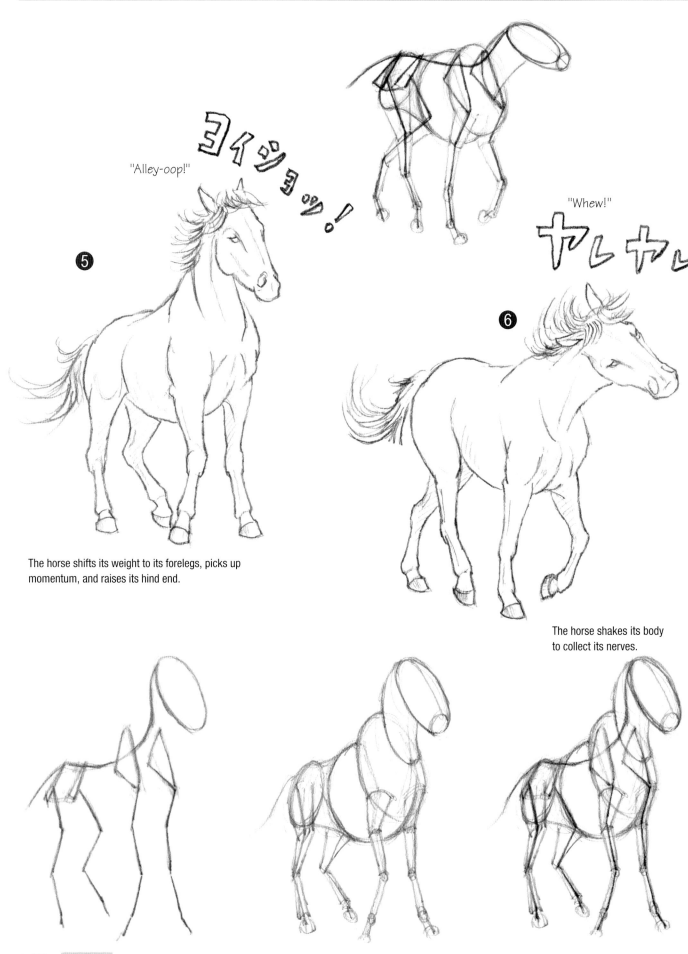

"Alley-oop!"

ヨイショッ！

❺

The horse shifts its weight to its forelegs, picks up momentum, and raises its hind end.

"Whew!"

ヤレヤレ

❻

The horse shakes its body to collect its nerves.

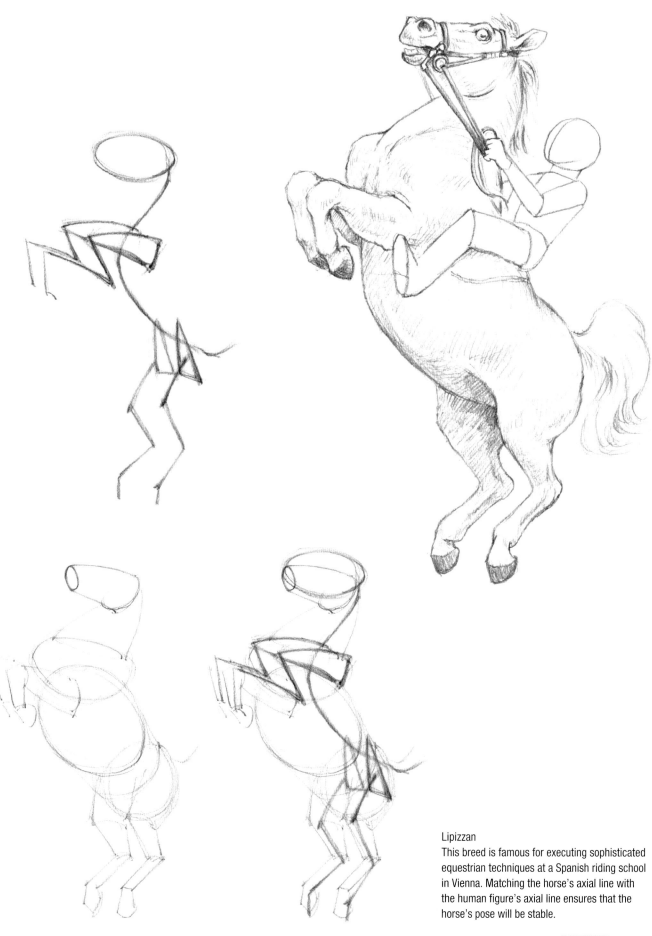

Lipizzan
This breed is famous for executing sophisticated equestrian techniques at a Spanish riding school in Vienna. Matching the horse's axial line with the human figure's axial line ensures that the horse's pose will be stable.

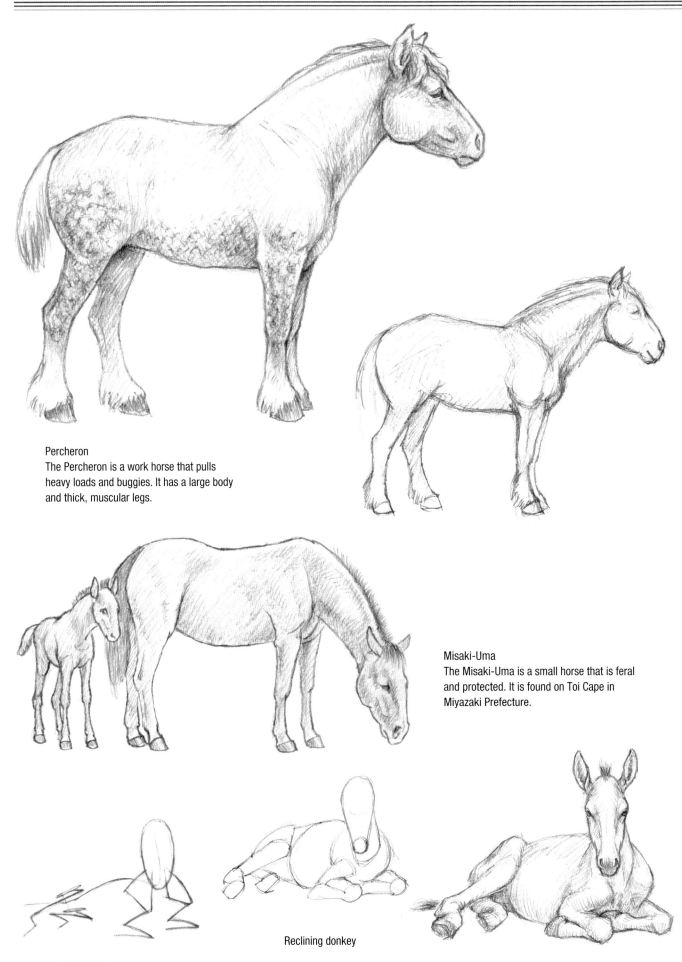

Percheron
The Percheron is a work horse that pulls heavy loads and buggies. It has a large body and thick, muscular legs.

Misaki-Uma
The Misaki-Uma is a small horse that is feral and protected. It is found on Toi Cape in Miyazaki Prefecture.

Reclining donkey

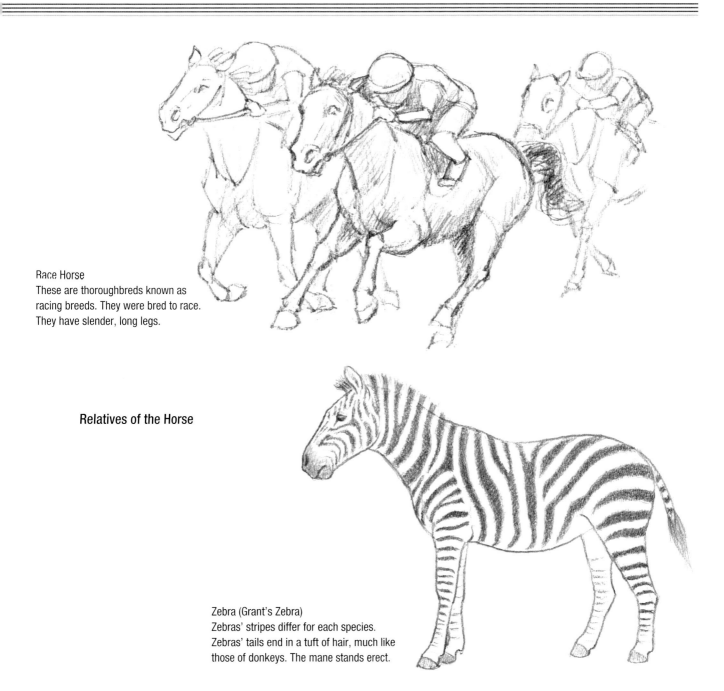

Race Horse
These are thoroughbreds known as
racing breeds. They were bred to race.
They have slender, long legs.

Relatives of the Horse

Zebra (Grant's Zebra)
Zebras' stripes differ for each species.
Zebras' tails end in a tuft of hair, much like
those of donkeys. The mane stands erect.

Donkey
The donkey has large, long ears compared
to other equines. The mane stands erect
like that found on zebras. The donkey has
a distended belly and proportionally large
head compared to its body.

6. Bears

Bears' habitat spans a wide range, from Eurasia to North America and various other regions. There are many species of bears, and they vary in size from the tiny Malaysian bear to the large polar bear. This section compares the most well-known bears, the brown bear, the Asiatic black bear, and the polar bear.

Foreleg Hind leg

While bears' head shapes differ according to the species, their bodies are stocky, and their rumps are plump. Their heads appear round from the front; however, in profile their heads are longer from back to front than tall.

Bears have thick legs, and they are slightly bow-legged and walk on the flats of their feet. (See page 133 for more on plantigrade animals.)

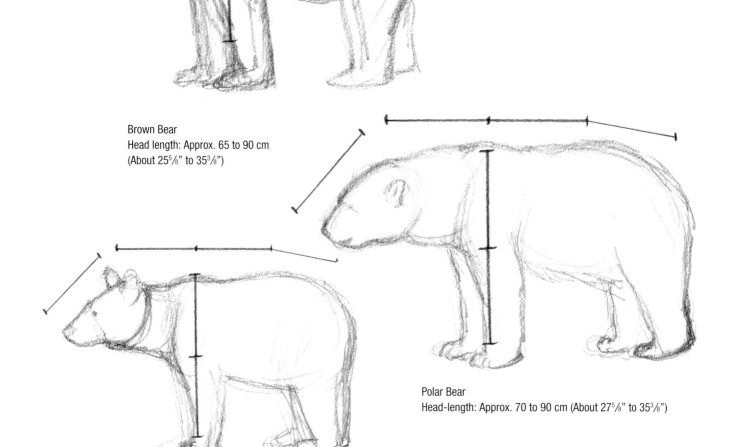

Brown Bear
Head length: Approx. 65 to 90 cm
(About 25⅝" to 35⅜")

Polar Bear
Head-length: Approx. 70 to 90 cm (About 27⅝" to 35⅜")

Asiatic Black Bear
Head-length: Approx. 65 to 70 cm (About 25⅝" to 27⅝")

Brown Bear

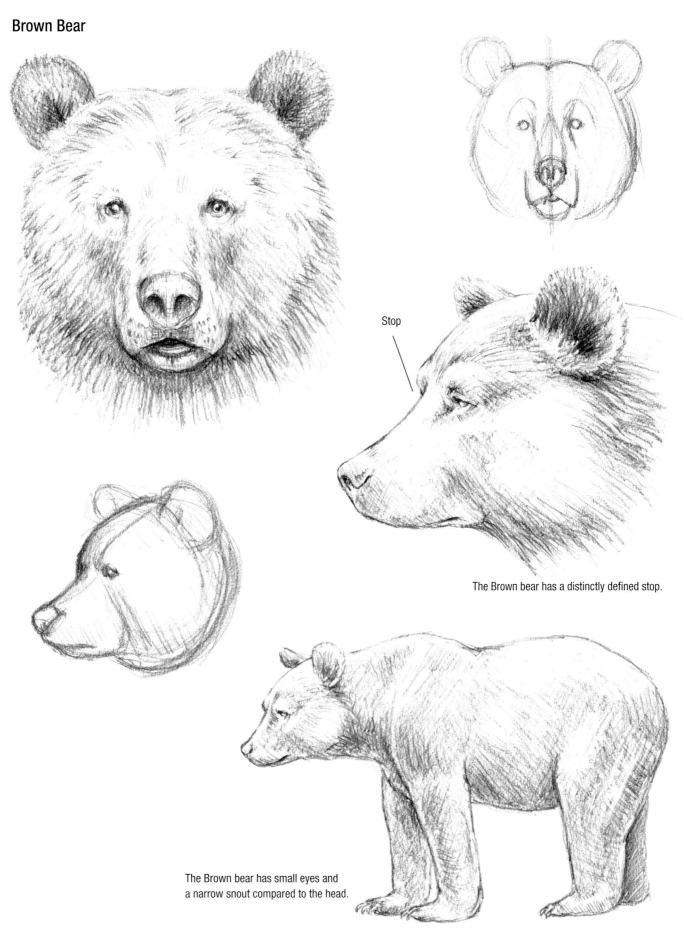

Stop

The Brown bear has a distinctly defined stop.

The Brown bear has small eyes and a narrow snout compared to the head.

Asiatic Black Bear

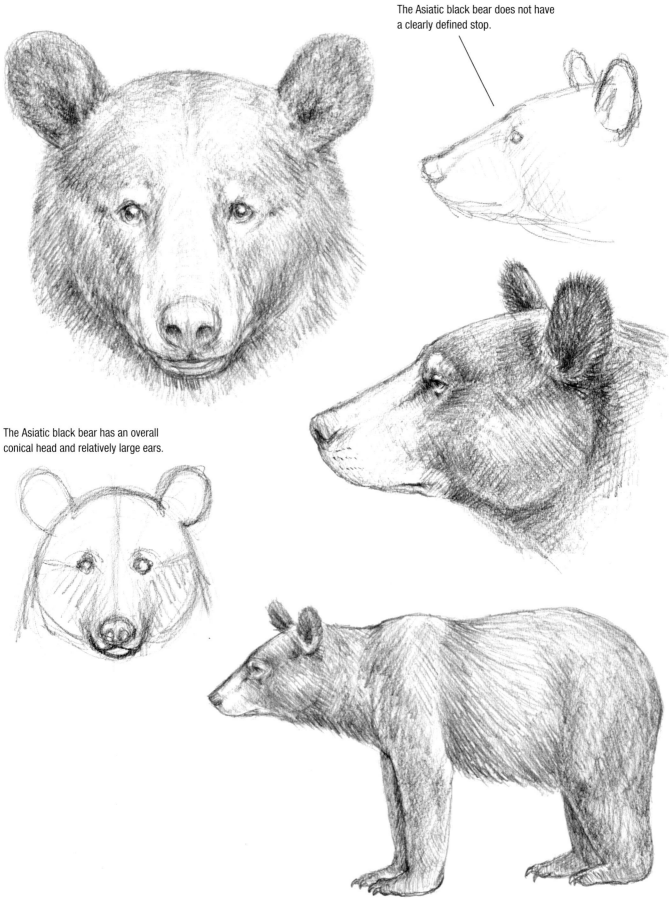

The Asiatic black bear does not have a clearly defined stop.

The Asiatic black bear has an overall conical head and relatively large ears.

Polar Bear

The polar bear's ears are smaller than those of other bears to enable it to withstand the extremely cold climate in which it lives.

The polar bear does not have a clearly defined stop.

The polar bear has a narrow snout compared with its head.

Bear Scenes and Sketches

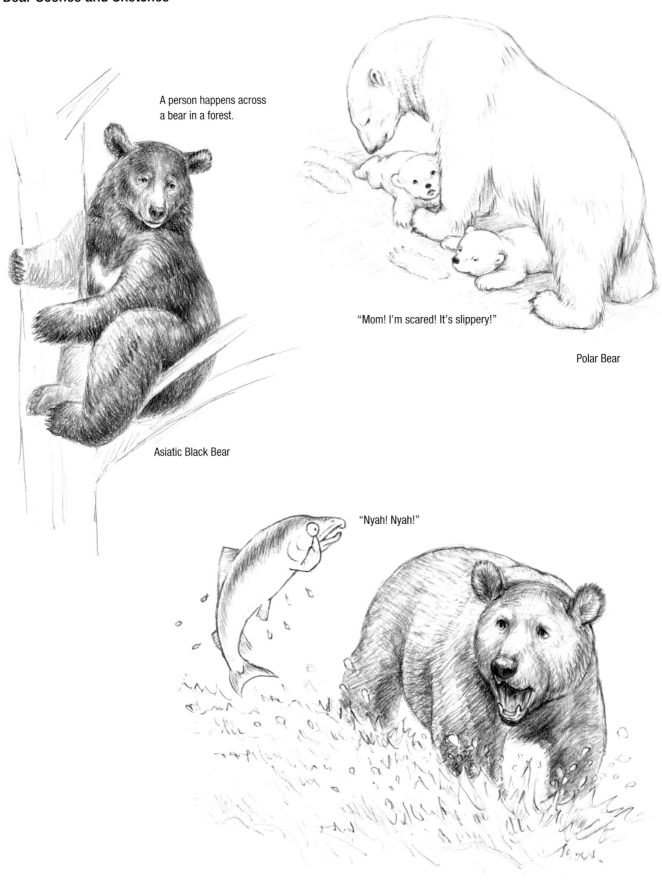

A person happens across a bear in a forest.

Asiatic Black Bear

"Mom! I'm scared! It's slippery!"

Polar Bear

"Nyah! Nyah!"

Brown Bear

7. Cuddly Critters

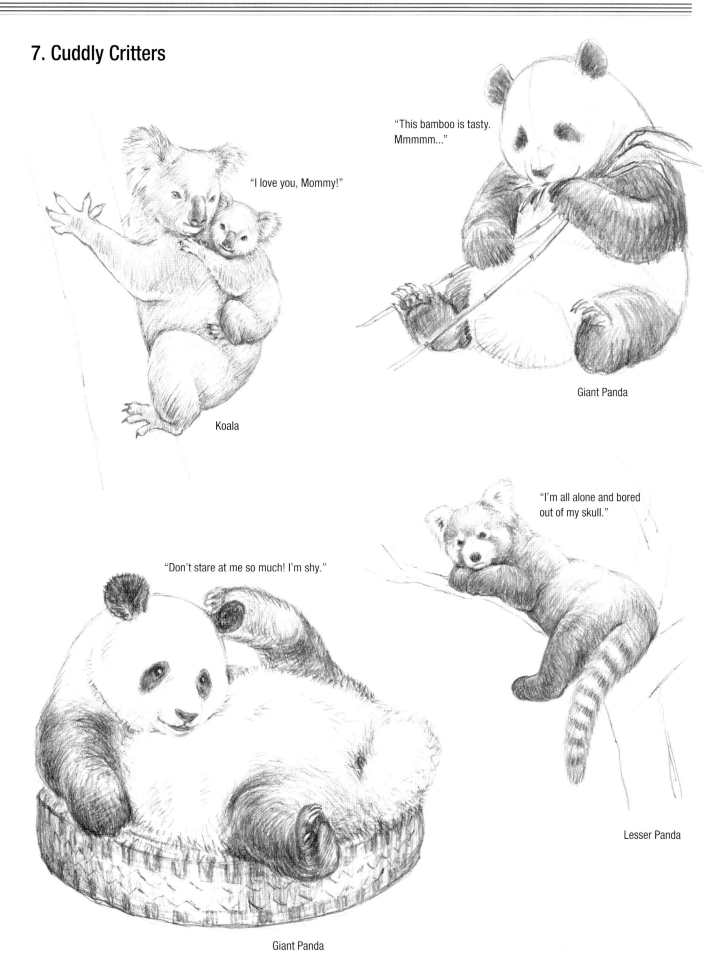

"I love you, Mommy!"

Koala

"This bamboo is tasty. Mmmmm..."

Giant Panda

"Don't stare at me so much! I'm shy."

"I'm all alone and bored out of my skull."

Lesser Panda

Giant Panda

8. Man's Closest Relatives

You may use sketch mock-ups for great apes that are similar to a human in form; however, apes have longer arms, while their legs are shorter. Great apes' necks are scarcely visible, giving them squared shoulders. Draw them without visually distinguishable wrists and give them longer fingers than you would a human. The big toe of a great ape attaches very differently to the foot from the big toe on a human foot.

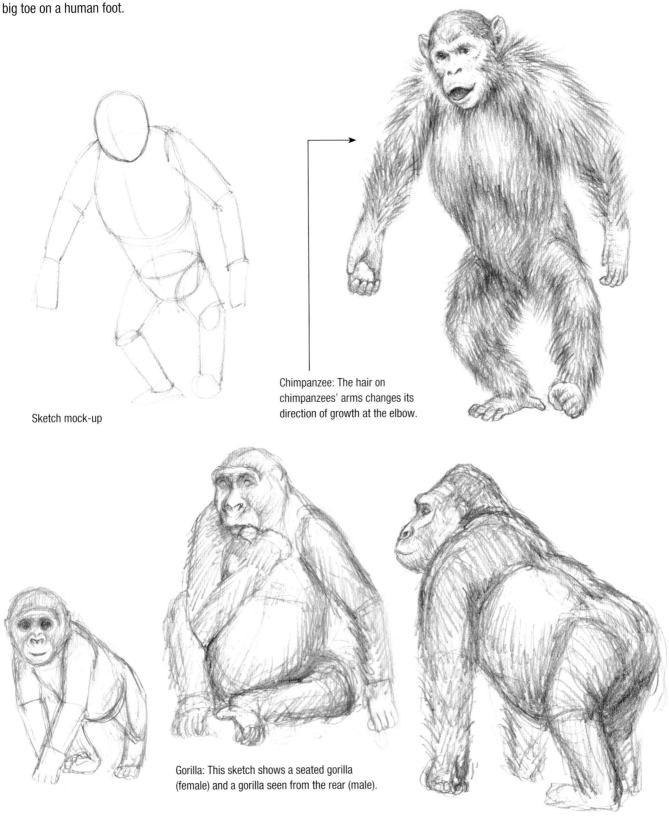

Sketch mock-up

Chimpanzee: The hair on chimpanzees' arms changes its direction of growth at the elbow.

Gorilla: This sketch shows a seated gorilla (female) and a gorilla seen from the rear (male).

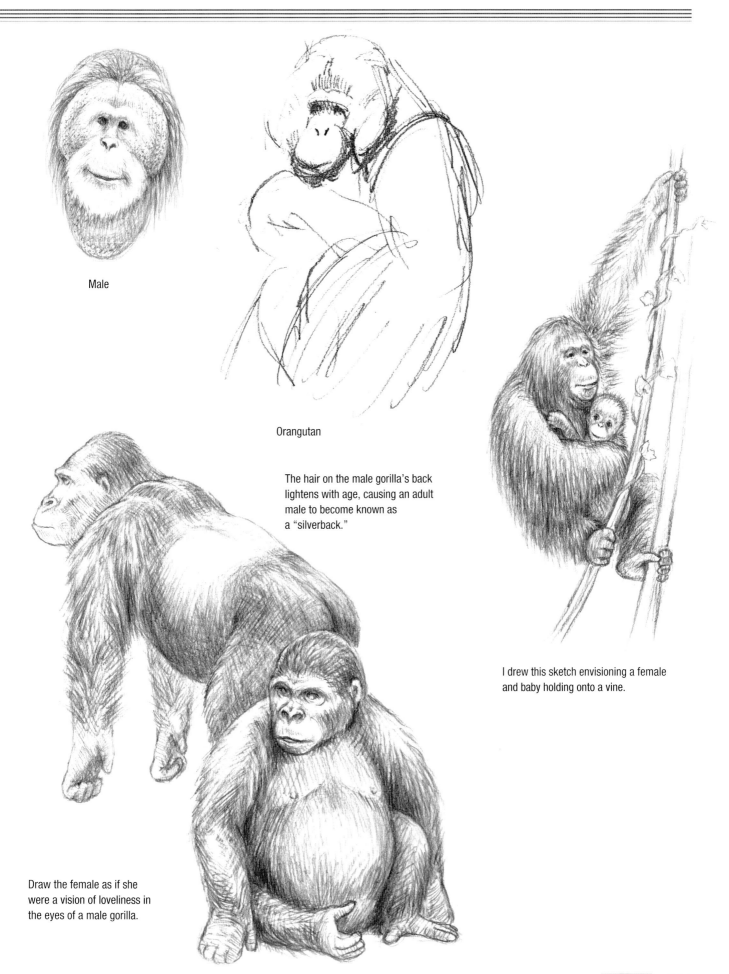

Male

Orangutan

The hair on the male gorilla's back lightens with age, causing an adult male to become known as a "silverback."

I drew this sketch envisioning a female and baby holding onto a vine.

Draw the female as if she were a vision of loveliness in the eyes of a male gorilla.

9. Giraffes

With the exception of some animals, the head-length, defined as the distance from the tip of the nose to the back of the head, and the neck length, defined as the distance from the back of the head to the scapulae, match on most animals. However, the giraffe's neck is more than twice its head-length.

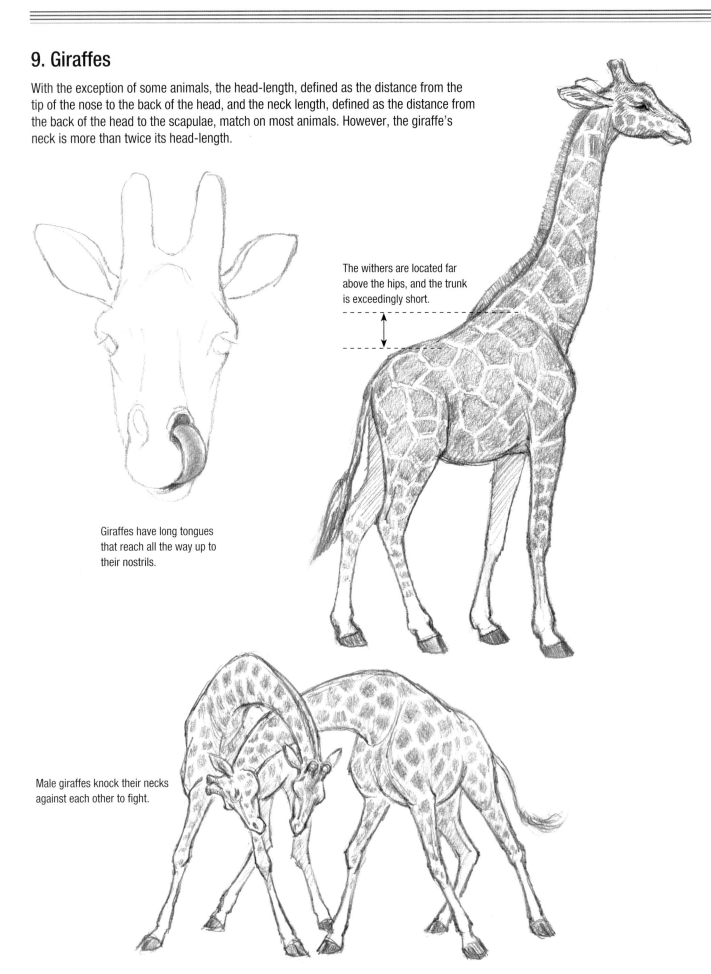

The withers are located far above the hips, and the trunk is exceedingly short.

Giraffes have long tongues that reach all the way up to their nostrils.

Male giraffes knock their necks against each other to fight.

10. Visual Oddities

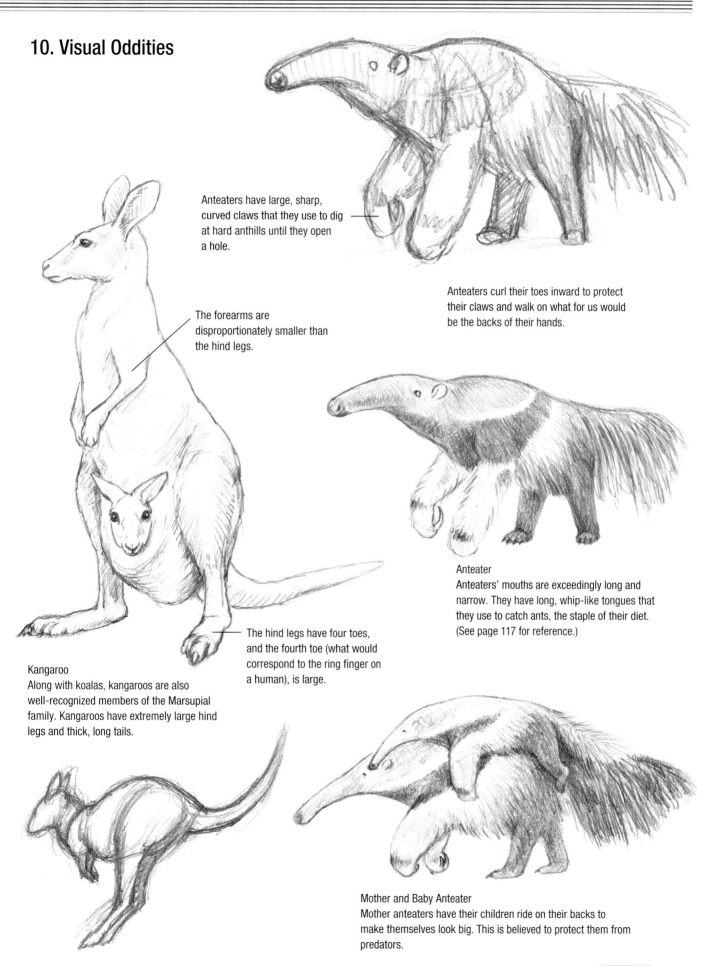

Anteaters have large, sharp, curved claws that they use to dig at hard anthills until they open a hole.

Anteaters curl their toes inward to protect their claws and walk on what for us would be the backs of their hands.

The forearms are disproportionately smaller than the hind legs.

Anteater
Anteaters' mouths are exceedingly long and narrow. They have long, whip-like tongues that they use to catch ants, the staple of their diet. (See page 117 for reference.)

The hind legs have four toes, and the fourth toe (what would correspond to the ring finger on a human), is large.

Kangaroo
Along with koalas, kangaroos are also well-recognized members of the Marsupial family. Kangaroos have extremely large hind legs and thick, long tails.

Mother and Baby Anteater
Mother anteaters have their children ride on their backs to make themselves look big. This is believed to protect them from predators.

11. Animals with Horns

The animals with horns most familiar to us are cattle. Domesticated cattle have descended from Zebus, which have spread throughout much of Asia and Africa, and the now-extinct Aurochs.

Cattle

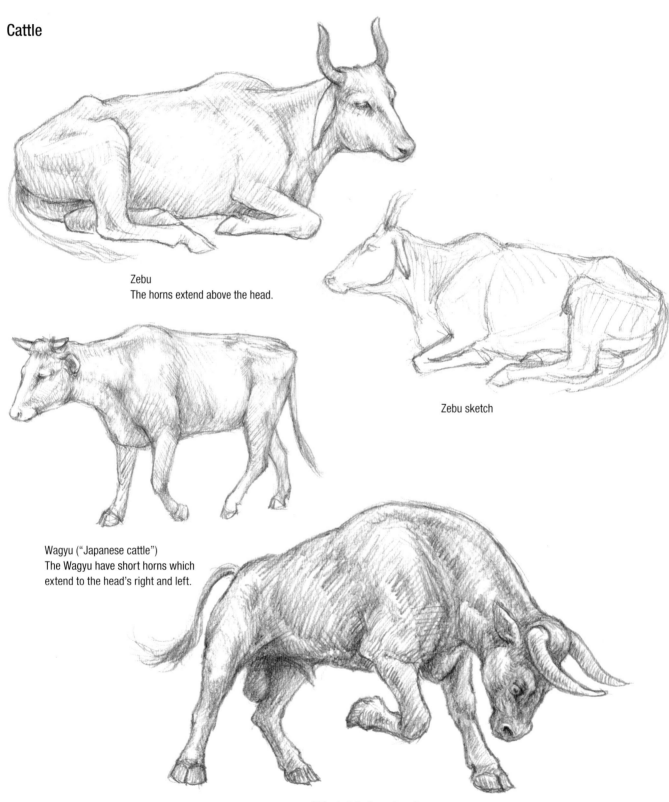

Zebu
The horns extend above the head.

Zebu sketch

Wagyu ("Japanese cattle")
The Wagyu have short horns which extend to the head's right and left.

This sketch shows how I
imagined an Aurochs appeared.

This sketch shows a milk cow. Humans breed cattle according to their uses. As a result, their horns and build have taken on many different forms.

Milk Cow
Since these cattle were bred to produce milk, they have developed hip region. However, they have an overall bony build.

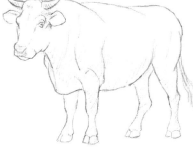

Beef Cow
Beef cows have short legs and abundant flesh, giving them a rounded build overall.

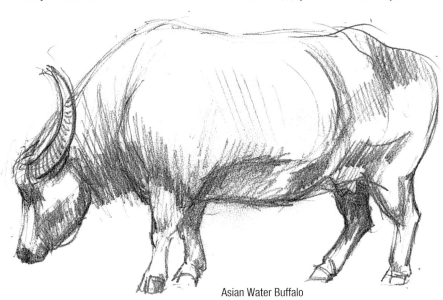

Asian Water Buffalo

Standing up and Sitting

Dogs and cats draw the front halves of their bodies toward the rear to sit.

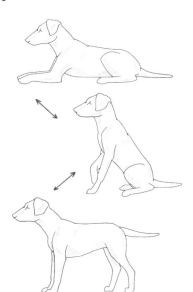

Next, they shift their weight to their forelegs to support their trunks and then rise up on their hind legs.

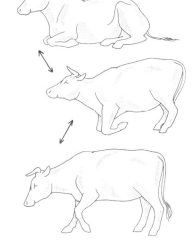

Cattle and other Bovinae push their front knees against the ground and then straighten their hind legs to raise their rears.

Next, they shift their bodies in the reverse direction and rise up on their forelegs.

* Animals follow the reverse process to recline. To lie down, horses bend their front knees and kneel like cattle. When horses stand up, they start with their forelegs like dogs. This is the sequence of action followed then there is no danger. However, in urgent situations where there is no danger, animals may use different sequences to rise.

Long Antlers to Short Horns

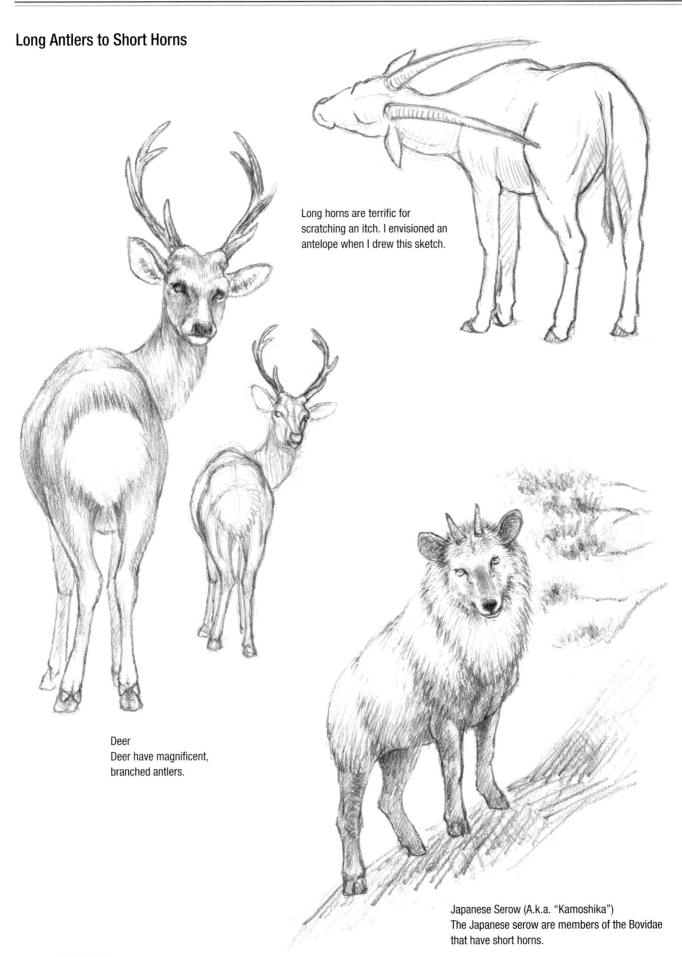

Long horns are terrific for scratching an itch. I envisioned an antelope when I drew this sketch.

Deer
Deer have magnificent, branched antlers.

Japanese Serow (A.k.a. "Kamoshika")
The Japanese serow are members of the Bovidae that have short horns.

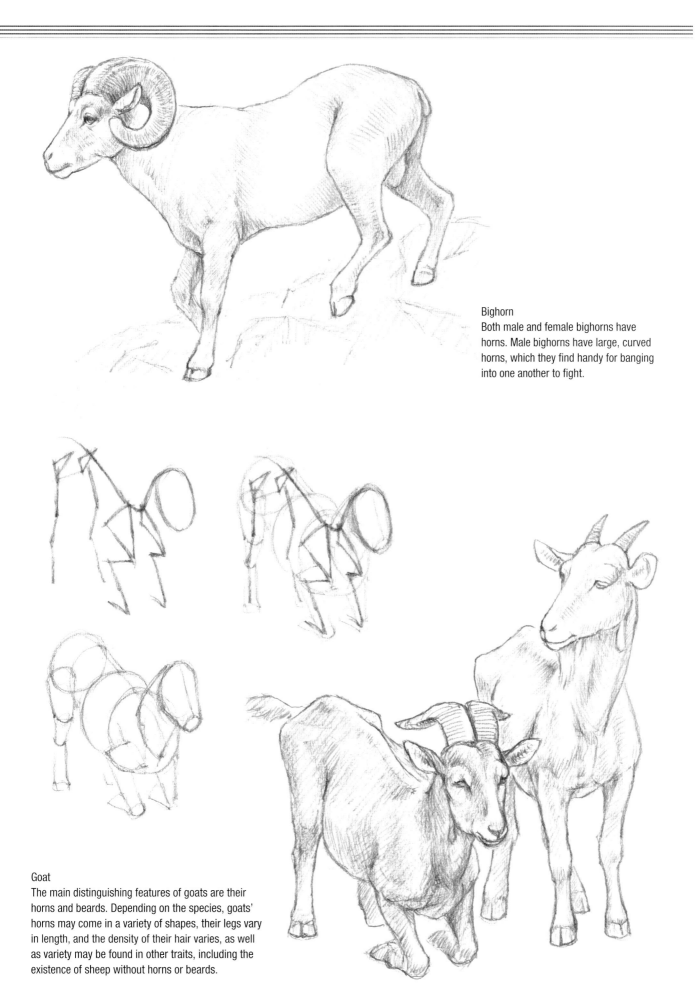

Bighorn
Both male and female bighorns have horns. Male bighorns have large, curved horns, which they find handy for banging into one another to fight.

Goat
The main distinguishing features of goats are their horns and beards. Depending on the species, goats' horns may come in a variety of shapes, their legs vary in length, and the density of their hair varies, as well as variety may be found in other traits, including the existence of sheep without horns or beards.

12. Squirrels and Hamsters

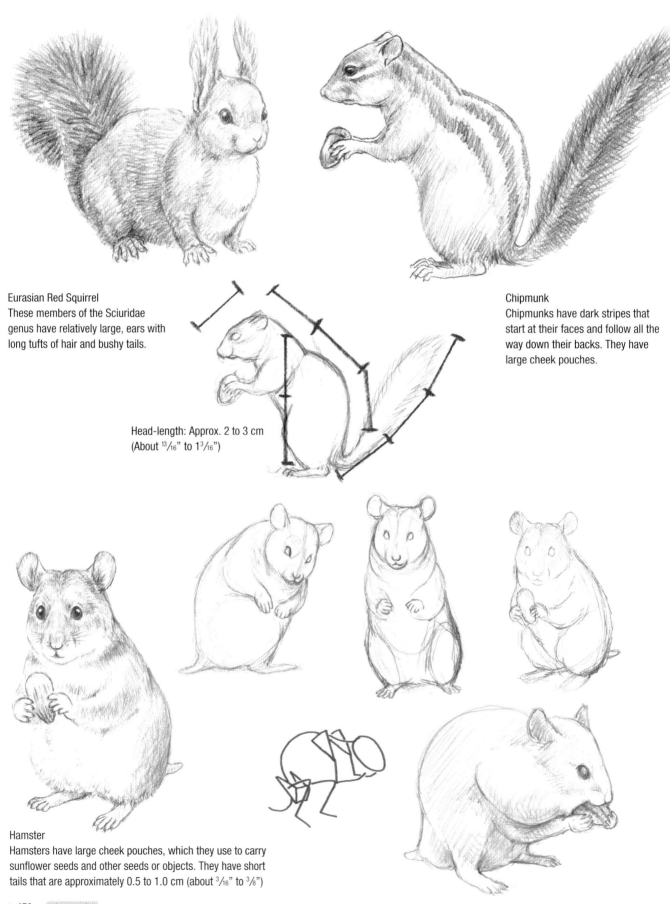

Eurasian Red Squirrel
These members of the Sciuridae genus have relatively large, ears with long tufts of hair and bushy tails.

Head-length: Approx. 2 to 3 cm
(About $^{13}/_{16}$" to $1^{3}/_{16}$")

Chipmunk
Chipmunks have dark stripes that start at their faces and follow all the way down their backs. They have large cheek pouches.

Hamster
Hamsters have large cheek pouches, which they use to carry sunflower seeds and other seeds or objects. They have short tails that are approximately 0.5 to 1.0 cm (about $^{3}/_{16}$" to $^{3}/_{8}$")

13. Foxes, Raccoon Dogs, and Lookalikes

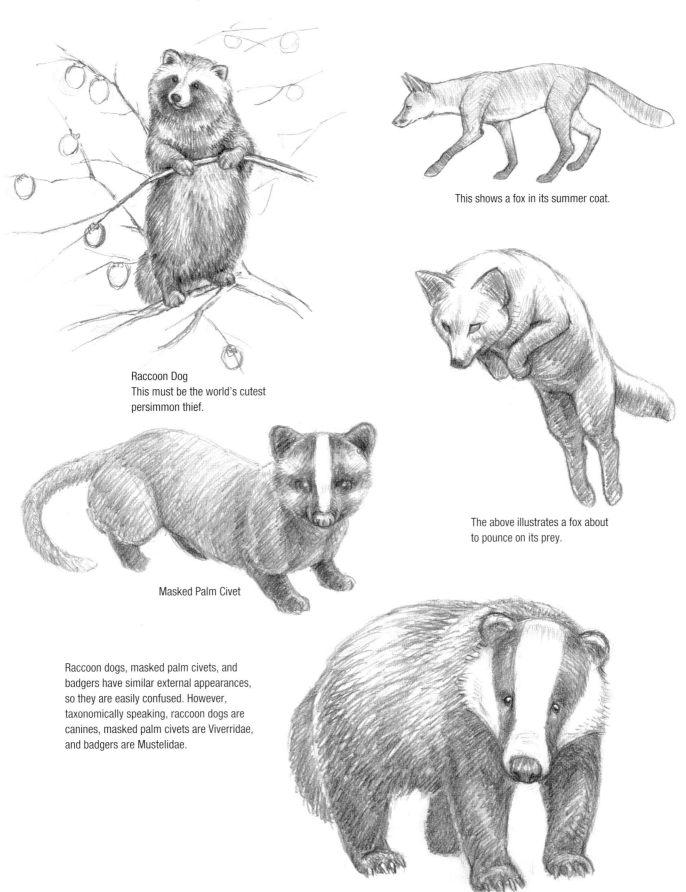

This shows a fox in its summer coat.

Raccoon Dog
This must be the world's cutest persimmon thief.

The above illustrates a fox about to pounce on its prey.

Masked Palm Civet

Raccoon dogs, masked palm civets, and badgers have similar external appearances, so they are easily confused. However, taxonomically speaking, raccoon dogs are canines, masked palm civets are Viverridae, and badgers are Mustelidae.

Birds

Birds have many body parts that differ from those of mammals. When drawing a bird, dividing it into a body unit, which includes the head, neck, chest, abdomen; wing units; and a leg unit would make the bird easier to compose.

1. Body Structure

referenceTo gain a good idea of how to pose and draw a bird, let's first discuss the structure of a bird's body.

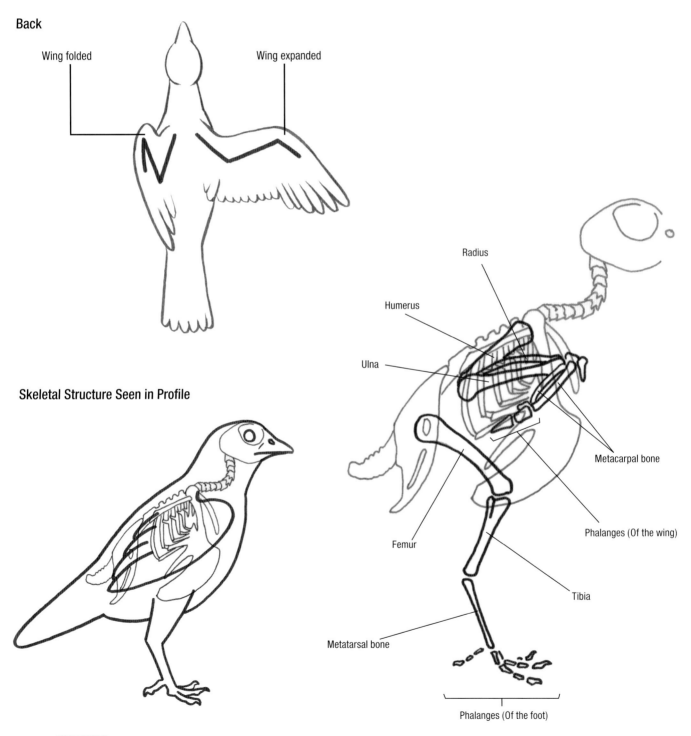

Back

Wing folded

Wing expanded

Skeletal Structure Seen in Profile

Radius

Humerus

Ulna

Metacarpal bone

Phalanges (Of the wing)

Femur

Tibia

Metatarsal bone

Phalanges (Of the foot)

Cockatiel

Tip

How to Make Birds Look Cute
Enlarge the eyes' dark pupils.
Have the beak's base (where it attaches
to the bird's face) curl up to make the
bird appear to be smiling.
Omit drawing claws. Give the bird
roundish forms overall.

This illustration shows a spot-billed duck
relocating her family. The duck is covered
in feathers, making its individual body
parts hard to distinguish. Use a skeletal
structure mock-up to determine where
the wings and the feet attach to the trunk.

2. Wing Structure

This joint corresponds to the wrist.

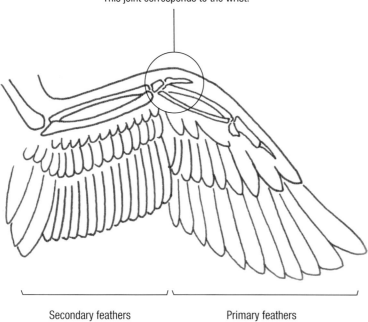

Secondary feathers Primary feathers

Soaring
When a bird soars through the air, the section of the wing from the wrist out angles slightly downward.

Flapping Wings

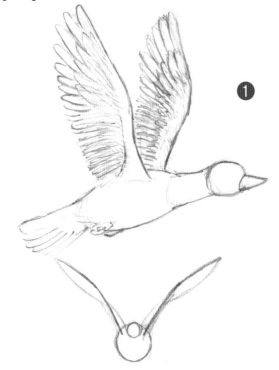

❶

When a bird flaps its wings to the greatest extent that it can, the primary feathers fan out.

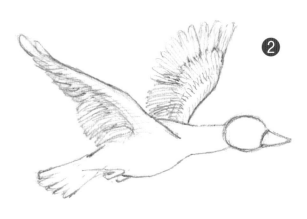

❷

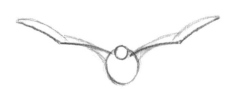

When a bird brings its wings down during a flap, the wrist moves downward before the primary feathers.

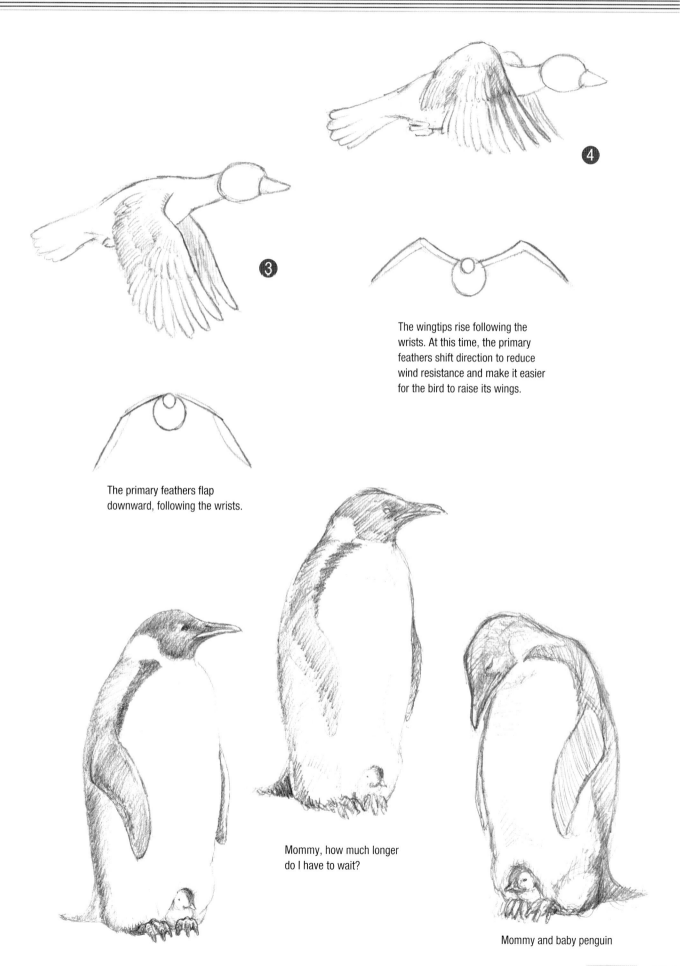

❹

❸

The wingtips rise following the wrists. At this time, the primary feathers shift direction to reduce wind resistance and make it easier for the bird to raise its wings.

The primary feathers flap downward, following the wrists.

Mommy, how much longer do I have to wait?

Mommy and baby penguin

Afterword

When I began to study painting, I would read every book there was on how to draw and paint animals. However, I could not contain my frustration with all of them. Naturally, I was also at fault for failing to interpret them properly. What I gained from that experience was that I wished a book like this one existed, so I decided to write one. Of course learning techniques for portraying animals is important. However, what brings the animals you draw to life is your attitude toward them. You need to ask yourself what aspect of the animal you intend to portray. Do you want to present the animal as cute? As interesting? Or, as gentle? Everything starts from that question.

Lastly, I would like to extend my most heartfelt gratitude to Toshio Masaoka, President of Azabu University, Motoki Sasaki, Assistant Professor at Obihiro University of Agriculture and Veterinary Medicine and many others for their help and encouragement during the production of this book.

Author's Profile

Mari Suzuki

Born in Tokyo, Japan
Graduated from Ferris Girls' Senior High School
Graduated from Azabu Veterinary College (Currently named Azabu University)
Completed studies with the Graduate School of Agriculture at the University of Tokyo
Completed a correspondence course (Painting Course) with Kodansha Famous Schools

Received a Japan Society for the Prevention of Cruelty to Animals award at a JSPCA Convention
Won an award in the Kodansha Famous Schools Child Art Grand Prix
1994 to 2002 Won awards at the Sokikai Show
1977 to 2001 Submitted artwork to group competitions
2003, 2007 Held one-woman shows of own artwork

Index